SlideGuide

for

Gardner's Art through the Ages
A Global History

Enhanced Thirteenth Edition
Volume I

Fred S. Kleiner

Questions Prepared by

Denise Johnson

WADSWORTH
CENGAGE Learning™

Australia • Brazil • Japan • Korea • Mexico • Singapore • Spain • United Kingdom • United States

© 2010 Wadsworth, Cengage Learning

ALL RIGHTS RESERVED. No part of this work covered by the copyright herein may be reproduced, transmitted, stored, or used in any form or by any means graphic, electronic, or mechanical, including but not limited to photocopying, recording, scanning, digitizing, taping, Web distribution, information networks, or information storage and retrieval systems, except as permitted under Section 107 or 108 of the 1976 United States Copyright Act, without the prior written permission of the publisher except as may be permitted by the license terms below.

For product information and technology assistance, contact us at
**Cengage Learning Customer & Sales Support,
1-800-354-9706**

For permission to use material from this text or product, submit all requests online at **www.cengage.com/permissions**
Further permissions questions can be emailed to
permissionrequest@cengage.com

ISBN-13: 978-1-4390-8595-0
ISBN-10: 1-4390-8595-1

Wadsworth
20 Channel Center Street
Boston, MA 02210
USA

Cengage Learning is a leading provider of customized learning solutions with office locations around the globe, including Singapore, the United Kingdom, Australia, Mexico, Brazil, and Japan. Locate your local office at **www.cengage.com/global**

Cengage Learning products are represented in Canada by Nelson Education, Ltd.

To learn more about Wadsworth, visit
www.cengage.com/wadsworth

Purchase any of our products at your local college store or at our preferred online store **www.CengageBrain.com**

NOTE: UNDER NO CIRCUMSTANCES MAY THIS MATERIAL OR ANY PORTION THEREOF BE SOLD, LICENSED, AUCTIONED, OR OTHERWISE REDISTRIBUTED EXCEPT AS MAY BE PERMITTED BY THE LICENSE TERMS HEREIN.

READ IMPORTANT LICENSE INFORMATION

Dear Professor or Other Supplement Recipient:

Cengage Learning has provided you with this product (the "Supplement") for your review and, to the extent that you adopt the associated textbook for use in connection with your course (the "Course"), you and your students who purchase the textbook may use the Supplement as described below. Cengage Learning has established these use limitations in response to concerns raised by authors, professors, and other users regarding the pedagogical problems stemming from unlimited distribution of Supplements.

Cengage Learning hereby grants you a nontransferable license to use the Supplement in connection with the Course, subject to the following conditions. The Supplement is for your personal, noncommercial use only and may not be reproduced, posted electronically or distributed, except that portions of the Supplement may be provided to your students IN PRINT FORM ONLY in connection with your instruction of the Course, so long as such students are advised that they may not copy or distribute

any portion of the Supplement to any third party. You may not sell, license, auction, or otherwise redistribute the Supplement in any form. We ask that you take reasonable steps to protect the Supplement from unauthorized use, reproduction, or distribution. Your use of the Supplement indicates your acceptance of the conditions set forth in this Agreement. If you do not accept these conditions, you must return the Supplement unused within 30 days of receipt.

All rights (including without limitation, copyrights, patents, and trade secrets) in the Supplement are and will remain the sole and exclusive property of Cengage Learning and/or its licensors. The Supplement is furnished by Cengage Learning on an "as is" basis without any warranties, express or implied. This Agreement will be governed by and construed pursuant to the laws of the State of New York, without regard to such State's conflict of law rules.

Thank you for your assistance in helping to safeguard the integrity of the content contained in this Supplement. We trust you find the Supplement a useful teaching tool.

Printed in Canada
1 2 3 4 5 6 7 14 13 12 11 10

Contents

Chapter 1

Art Before History

Goals

- Understand the origins of art in terms of time period, human development, and human activity. Explore origins of creativity, representation, and stylistic innovation in the Paleolithic Period.
- Describe the role of human and animal figures in Paleolithic art. Examine the materials and techniques of the earliest art making in the Paleolithic period.
- Illustrate differences between the Paleolithic and Neolithic art as a result of social and environmental changes.
- Understand and evaluate the types of art prevalent in the Neolithic period.

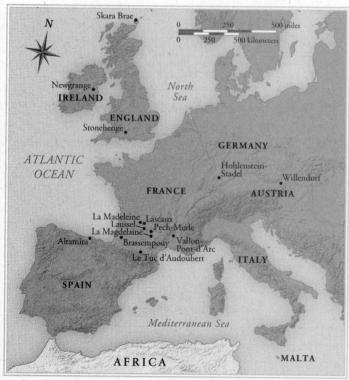

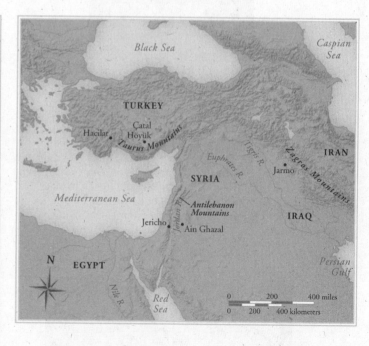

MAP 1-1 Prehistoric sites in Europe. (page 16)

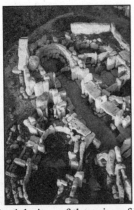

FIG. 01-01 Aerial view of the ruins of Hagar Qim, Malta, ca. 3200–2500 BCE. (page 14)

Lat.: 35°49′39.93″N Long.: 14°26′32.34″E

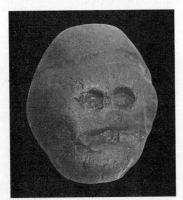

FIG. 01-02 Waterworn pebble resembling a human face, from Makapansgat, South Africa, ca. 3,000,000 BCE. Reddish brown jasperite, approx. 2 3/8″ wide. (page 16)

Lat.: 31°50′15.08″N Long.: 35°26′55.64″E

FIG. 01-03 Animal facing left, from the Apollo 11 Cave, Namibia, ca. 23,000 BCE. Charcoal on stone, approx. 5″ × 4 1/4″. State Museum of Namibia, Windhoek. (page 16)

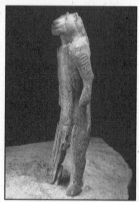

FIG. 01-04 Human with feline head, from
Hohlenstein-Stadel, Germany, ca. 30,000–28,000
BCE. Mammoth ivory, 11 5/8″ high. Ulmer
Museum, Ulm. (page 17)

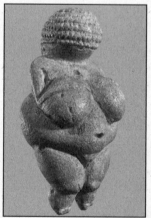

FIG. 01-05 Nude woman (*Venus of Willendorf*),
from Willendorf, Austria, ca. 28,000–25,000 BCE.
Limestone, approx. 4 1/4″ high. Naturhistorisches
Museum, Vienna. (page 17)

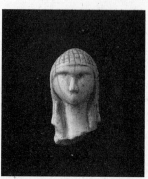

FIG. 01-05A Head of a woman, from the Grotte du
Pape, Brassempouy, France, ca. 25,000–20,000 BCE.
Ivory, 1 1/2″ high. Musée des Antiquités Nationales,
Saint-Germanin-en-Laye. (page 17)

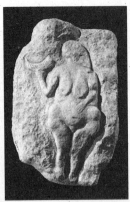

FIG. 01-06 Woman holding a bison horn, from Laussel, France, ca. 25,000–20,000 BCE. Painted limestone, 1′ 6″ high. Musée d'Aquitaine, Bordeaux. (page 18)

FIG. 01-06A Reclining woman, rock-cut relief on the right wall of the first corridor in the cave at La Magdeleine, France, ca. 12,000 BCE. 2′ 3 5/8″ long.

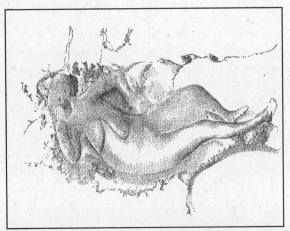

FIG. 01-06B Drawing of the reclining woman in the cave at La Magdeleine (Siegfried Giedion). (page 18)

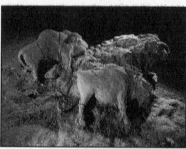

FIG. 01-07 Two bison, reliefs in a cave at Le Tuc d'Audoubert, France, ca. 15,000–10,000 BCE. Clay, each 2′ long. (page 19)

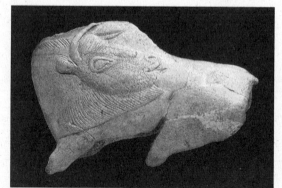

FIG. 01-08 Bison with turned head, fragmentary spearthrower, from La Madeleine, France, ca. 12,000 BCE. Reindeer horn, 4″ long. (page 19)

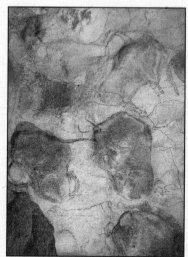

FIG. 01-09 Bison, detail of a painted ceiling in the cave at Altamira, Spain, ca. 12,000–11,000 BCE. Each bison 5′ long. (page 19)

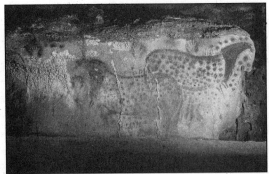

FIG. 01-10 Spotted horses and negative hand imprints, wall painting in the cave at Pech-Merle, France, ca. 22,000 BCE. 11′ 2″ long. (page 20)

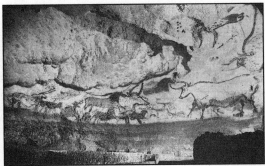

FIG. 01-11 Hall of the Bulls (left wall), in the cave at Lascaux, France, ca. 15,000–13,000 BCE. Largest bull 11′ 6″ long. (page 21)

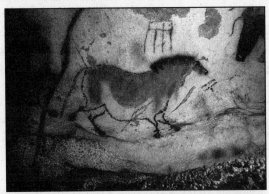

FIG. 01-11A "Chinese horse," detail of the left wall in the Axial Gallery of the cave at Lascaux, France, ca. 15,000–13,000 BCE. Horse, 4′ 11″ long. (page 21)

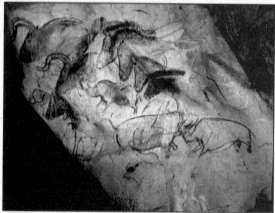

FIG. 01-12 Aurochs, horses, and rhinoceroses, wall painting in the Chauvet Cave, Vallon-Pont-d'Arc, France, ca. 30,000–28,000 or ca. 15,000–13,000 BCE. (page 22)

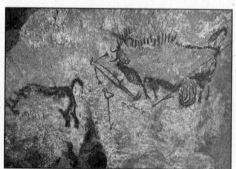

FIG. 01-13 Rhinoceros, wounded man, and disemboweled bison, painting in the well of the cave at Lascaux, France, ca. 15,000–13,000 BCE. Bison 3′ 8″ long. (page 23)

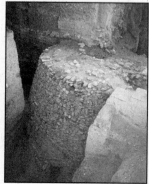

FIG. 01-14 Great stone tower built into the settlement wall, Jericho, ca. 8000–7000 BCE. (page 24)

Lat.: 31°50′15.08″N Long.: 35°26′55.64″E

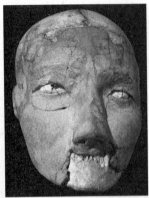

FIG. 01-14A Human skull with restored features, from Jericho, Jordan, ca. 7000–6000 BCE. Features modeled in plaster, painted, and inlaid with seashells. Life size. Archaeological Museum, Amman. (page 25)

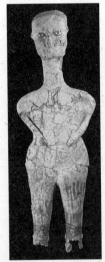

FIG. 01-15 Human figure, from Ain Ghazal, Jordan, ca. 6750–6250 BCE. Plaster, painted and inlaid with bitumen, 3′ 5 3/8″ high. Louvre, Paris. (page 25)

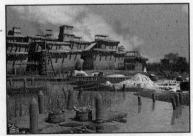

FIG. 01-16 Restored view of a section of Level VI, Çatal Höyük, Turkey, ca. 6000–5900 BCE (John Swogger). (page 25)

Lat.: 37°40′9.86″N Long.: 32°49′25.44″E

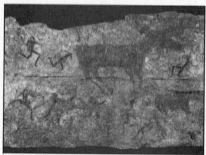

FIG. 01-17 Deer hunt, detail of a wall painting from Level III, Çatal Höyük, Turkey, ca. 5750 BCE. Museum of Anatolian Civilization, Ankara. (page 26)

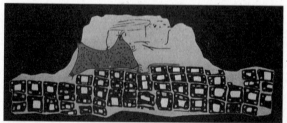

FIG. 01-18 Landscape with volcanic eruption(?), watercolor copy of a wall painting from Level VII, Çatal Höyük, Turkey, ca. 6150 BCE. (page 27)

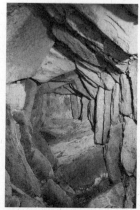

FIG. 01-19 Gallery leading to the main chamber of the passage grave, Newgrange, Ireland, ca. 3200–2500 BCE. (page 27)

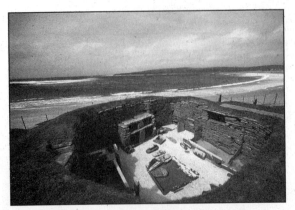

FIG. 01-19A House 1, Skara Brae, Scotland, ca. 3100–2500 BCE. (page 27)

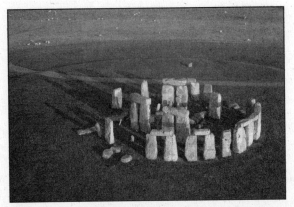

FIG. 01-20 Aerial view of Stonehenge, Salisbury Plain, England, ca. 2550–1600 BCE. Circle is 97′ in diameter; trilithons 24′ high. (page 28)

Lat.: 51°10′43.93″N Long.: 1°49′34.40″W

1. Describe the landscape where the Makapansgat pebble (FIG. 1-2) was found (31°50′15.08″N, 35°26′55.64″E). Why do experts believe that it was discovered in a distant location by a predecessor of modern humans and transported to this site?

2. In what region was the human figure depicted in FIG. 1-15 found buried?

3. What distinguishes the megalithic structure depicted in FIG. 1-20 and located at 51°10′43.93″N, 1°49′34.40″W?

4. Where is the Hall of the Bulls (FIG. 1-11) located?

5. The stone tower depicted in FIG. 1-14 and located at 31°50′15.08″N, 35°26′55.64″E is part of the fortification built to protect what Neolithic town?

6. Describe the distinguishing features of the sculpted bison depicted in FIG. 1-7?

7. Identify where the first prehistoric cave paintings found in the modern era are located and describe the circumstances under which they were found.

8. Describe the distinguishing features of the Neolithic town located at 37°40′9.86″N, 32°49′25.44″E and depicted in FIG. 1-16.

9. What features make the figural sculpture depicted in FIG. 1-4 remarkable?

10. Consider the size of the nude female figure known as the Venus of Willendorf (FIG. 1-5). For what reasons might the Paleolithic sculptor of this work have chosen this size? What does the size of this figure tell us about the lifestyle of the sculptor?

11. Describe the layout and method of construction used to build the megalithic temple of Hagar Qim, depicted in FIG. 1-1 and located at 35°49′39.93″N, 14°26′32.34″E.

Chapter 2

The Ancient Near East

Goals

- Understand the cultural changes in the *Neolithic Revolution* as they relate to art and architecture.
- Understand the concept of civilization and the importance of Sumer in the ancient Near East.
- Examine the artistic materials, techniques, subject matter, styles, and conventions developed in the ancient Near East.

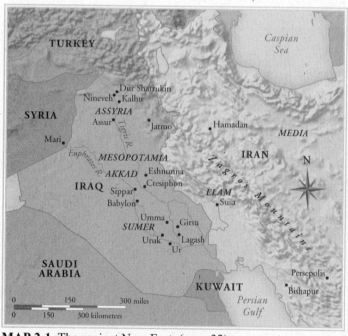

MAP 2-1 The ancient Near East. (page 32)

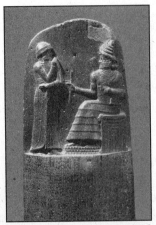

FIG. 02-01 Hammurabi and Shamash, detail of the stele of Hammurabi (FIG. 2-17), from Susa, Iran, ca. 1780 BCE. (page 30)

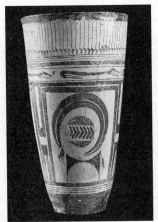

FIG. 02-01A Beaker with animal decoration, from Susa, Iran, ca. 4000 BCE. Painted ceramic, 11 3/8″ high. Louvre, Paris. (page 31)

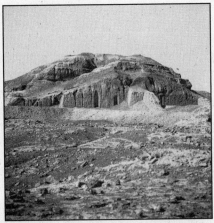

FIG. 02-02 White Temple and ziggurat, Uruk (modern Warka), Iraq, ca. 3200–3000 BCE. (page 32)

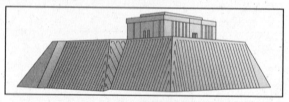

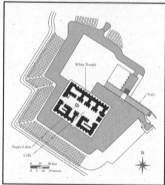

FIG. 02-03 Reconstruction drawing of the White Temple and ziggurat, Uruk (modern Warka), Iraq, ca. 3200–3000 BCE. (page 33)

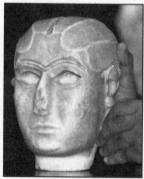

FIG. 02-04 Female head (Inanna?), from Uruk (modern Warka), Iraq, ca. 3200–3000 BCE. Marble, 8″ high. Iraq Museum, Baghdad. (page 34)

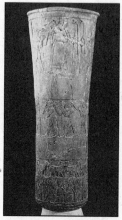

FIG. 02-05 Presentation of offerings to Inanna (Warka Vase), from Uruk (modern Warka), Iraq, ca. 3200–3000 BCE. Alabaster, 3′ 1/4″ high. Iraq Museum, Baghdad. (page 34)

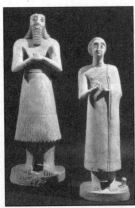

FIG. 02-06 Statuettes of two worshipers, from the Square Temple at Eshnunna (modern Tell Asmar), Iraq, ca. 2700 BCE. Gypsum inlaid with shell and black limestone, male figure 2′ 6″ high. Iraq Museum, Baghdad. (page 35)

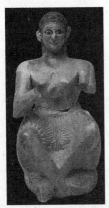

FIG. 02-06A Seated statuette of Urnanshe, from the Temple of Ishtar at Mari (modern Tell Hariri), Syria, ca. 2600–2500 BCE. Gypsum inlaid with shell and lapis lazuli, 10 1/4″ high. National Museum, Damascus. (page 35)

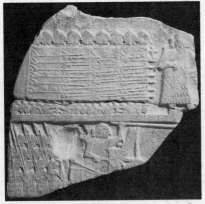

FIG. 02-07 Fragment of the victory stele of Eannatum *(Stele of the Vultures),* from Girsu (modern Telloh), Iraq, ca. 2600–2500 BCE. Limestone, fragment 2′ 6″ high, full stele 5′ 11″ high. Louvre, Paris. (page 36)

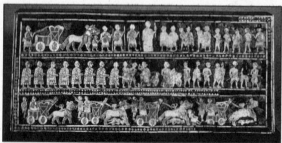

FIG. 02-08 War side of the *Standard of Ur,* from Tomb 779, Royal Cemetery, Ur (modern Tell Muqayyar), Iraq, ca. 2600 BCE. Wood inlaid with shell, lapis lazuli, and red limestone, 8″ × 1′ 7″. British Museum, London. (page 37)

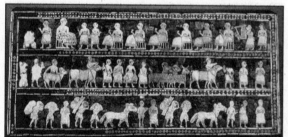

FIG. 02-09 Peace side (bottom) of the *Standard of Ur,* from Tomb 779, Royal Cemetery, Ur (modern Tell Muqayyar), Iraq, ca. 2600 BCE. Wood inlaid with shell, lapis lazuli, and red limestone, 8″ × 1′ 7″. British Museum, London. (page 37)

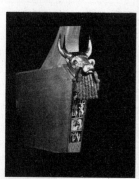

FIG. 02-10 Bull-headed lyre from Tomb 789 ("King's Grave"), Royal Cemetery, Ur (modern Tell Muqayyar), Iraq, ca. 2600 BCE. Lyre *(left):* Gold leaf and lapis lazuli over a wooden core, 5′ 5″ high. Sound box *(right):* Wood with inlaid gold, lapis lazuli, and shell, 1′ 7″ high. University of Pennsylvania Museum of Archaeology and Anthropology, Philadelphia. (page 38)

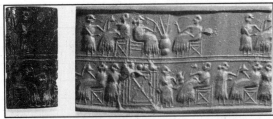

FIG. 02-11 Banquet scene, cylinder seal *(left)* and its modern impression *(right)*, from the Tomb of Pu-abi (tomb 800), Royal Cemetery, Ur (modern Tell Muqayyar), Iraq, ca. 2600 BCE. Lapis lazuli, 2″ high. British Museum, London. (page 39)

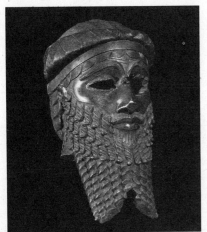

FIG. 02-12 Head of an Akkadian ruler, from Nineveh (modern Kuyunjik), Iraq, ca. 2250–2200 BCE. Copper, 1′ 2 3/8″ high. Iraq Museum, Baghdad. (page 40)

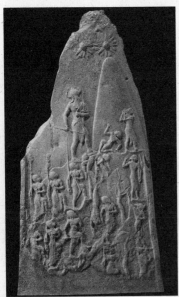

FIG. 02-13 Victory stele of Naram-Sin, from Susa, Iran, 2254–2218 BCE. Pink sandstone, 6′ 7″ high. Louvre, Paris. (page 40)

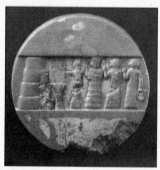

FIG. 02-14 Votive disk of Enheduanna, from Ur (modern Tell Muqayyar), Iraq, ca. 2300–2275 BCE. Alabaster, diameter 10″. University of Pennsylvania Museum of Archaeology and Anthropology, Philadelphia. (page 41)

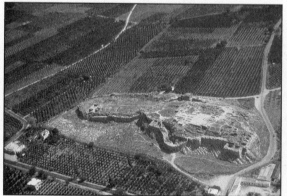

FIG. 02-15 Ziggurat (northeastern facade with restored stairs), Ur (modern Tell Muqayyar), Iraq, ca. 2100 BCE. (page 41)

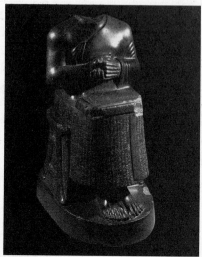

FIG. 02-16 Seated statue of Gudea holding temple plan, from Girsu (modern Telloh), Iraq, ca. 2100 BCE. Diorite, approx. 2′ 5″ high. Louvre, Paris. (page 42)

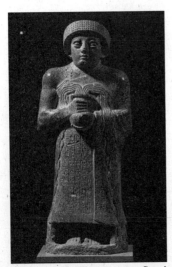

FIG. 02-16A Gudea holding an overflowing water jar, from the temple of Geshtinanna, Girsu (modern Telloh), Iraq, ca. 2100 BCE. Calcite, 2′ 3/8″ high. Louvre, Paris. (page 42)

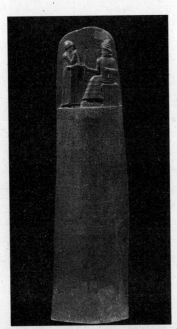

FIG. 02-17 Stele with law code of Hammurabi, from Susa, Iran, ca. 1780 BCE. Basalt, approx. 7′ 4″ high. Louvre, Paris. (page 43)

FIG. 02-17A Investiture of Zimri-Lim, mural painting from court 106 of the palace at Mari (modern Tell Hariri), Syria, ca. 1775–1760 BCE. Louvre, Paris. (page 43)

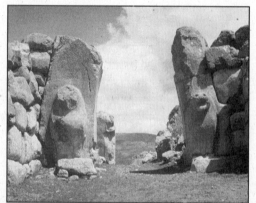

FIG. 02-18 Lion Gate, Hattusa (modern Boghazköy), Turkey, ca. 1400 BCE. (page 44)

Lat.: 40°0′36.31″N Long.: 34°36′36.22″E

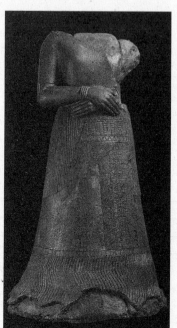

FIG. 02-19 Statue of Queen Napir-Asu, from Susa, Iran, ca. 1350–1300 BCE. Bronze and copper, 4′ 2 3/4″ high. Louvre, Paris. (page 44)

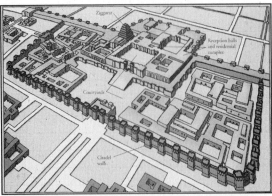

FIG. 02-20 Reconstruction drawing of the citadel of Sargon II, Dur Sharrukin (modern Khorsabad), Iraq, ca. 720–705 BCE (after Charles Altman). (page 45)

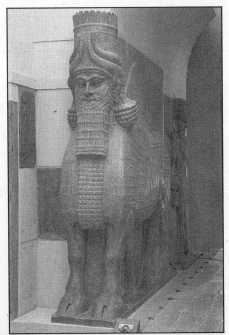

FIG. 02-21 Lamassu (winged, human-headed bull), from the citadel of Sargon II, Dur Sharrukin (modern Khorsabad), Iraq, ca. 720–705 BCE. Limestone, 13′ 10″ high. Louvre, Paris. (page 45)

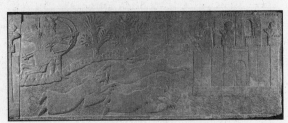

FIG. 02-22 Assyrian archers pursuing enemies, relief from the Northwest Palace of Ashurnasirpal II, Kalhu (modern Nimrud), Iraq, ca. 875–860 BCE. Gypsum, 2′ 10 5/8″ high. British Museum, London. (page 46)

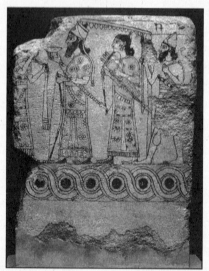

FIG. 02-22A Ashurnasirpal II with attendants and soldier, from the Northwest Palace of Ashurnasirpal II, Kalhu (modern Nimrud), Iraq, ca. 875–860 BCE. Glazed brick, 11 3/4″ high. British Museum, London. (page 46)

FIG. 02-23 Ashurbanipal hunting lions, relief from the North Palace of Ashurbanipal, Nineveh (modern Kuyunjik), Iraq, ca. 645–640 BCE. Gypsum, 5′ 4″ high. British Museum, London. (page 46)

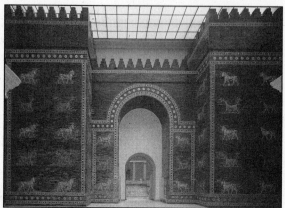

FIG. 02-24 Ishtar Gate (restored), Babylon, Iraq, ca. 575 BCE. Glazed brick. Staatliche Museen, Berlin. (page 47)

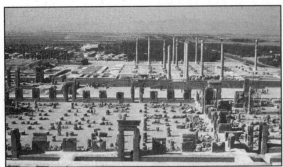

FIG. 02-25 Persepolis (apadana in the background), Iran, ca. 521–465 BCE. (page 49)

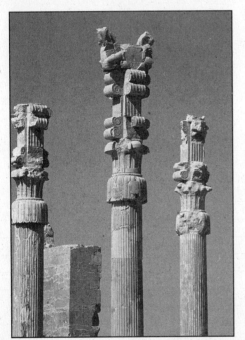

FIG. 02-25A Columns with animal protomes, from the apadana of the palace, Persepolis, Iran, ca. 521–465 BCE. Stone, 6′ 8″ high. Louvre, Paris. (page 48)

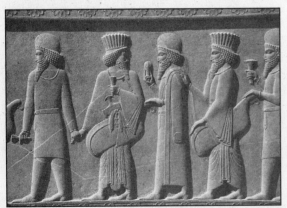

FIG. 02-26 Processional frieze (detail) on the terrace of the apadana, Persepolis, Iran, ca. 521–465 BCE. Limestone, 8′ 4″ high. (page 49)

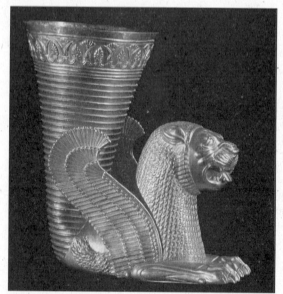

FIG. 02-26A Rhyton in the form of a winged lion, from Hamadan, fifth to third century BCE. Gold, 8 3/8″ high. Archaeological Museum, Tehran. (page 48)

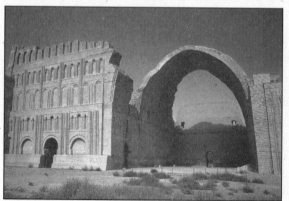

FIG. 02-27 Palace of Shapur I, Ctesiphon, Iraq, ca. 250 CE. (page 50)

Lat.: 33°5′37.42″N Long.: 44°34′51.77″E

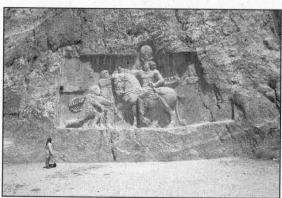

FIG. 02-28 Triumph of Shapur I over Valerian, rock-cut relief, Bishapur, Iran, ca. 260 CE. (page 50)

1. Describe the monument located at 30°57′46.97″N, 46°6′11.18″E and consider its function.

2. From what material is the facing of the Ishtar Gate (FIG. 2-24) composed?

3. What did the Assyrians probably call the colossal figure that guarded Sargon's palace (FIG. 2-21)? Describe this figure and discuss the conceptual nature of the representation.

4. What are the distinguishing features of the female head depicted in FIG. 2-4?

5. What did the seven-foot-high lions located at 40°0′36.31″N, 34°36′36.22″E guard?

6. In what citadel was the ceremonial and administrative complex at 29°56′3.03″N, 52°53′33.61″E located?

7. Describe the distinguishing features of the audience hall at the Palace of Shapur depicted in FIG. 2-27 and located at 33°5′37.42″N, 44°34′51.77″E.

8. Consider how the Head of an Akkadian ruler (FIG. 2-12) encapsulates the new concept of absolute ruler.

9. Where were the statuettes depicted in FIG. 2-6 found buried?

10. Why is the White Temple and ziggurat at Uruk (FIG. 2-2) unusual?

11. What geographic features significantly encouraged the development of civilizations in ancient Mesopotamia? (Use Google Earth coordinates, 35°10′16.35″N, 41°45′55.09″E to see the region, and zoom in and out to analyze the terrain.)

12. How did the geography and natural resources of the ancient Mesopotamian region influence the architecture of the civilizations that arose there? (Use Google Earth coordinates, 35°10′16.35″N, 41°45′55.09″E to see the region, and zoom in and out to analyze the terrain.)

Chapter 3

Egypt Under the Pharaohs

Goals

- Understand the evolution of Egyptian culture and its relationship to the Nile.
- Recognize stylistic conventions of Egyptian art.
- Describe Egyptian funerary art forms from these periods and state reasons for the development of these monuments.
- Understand architectural evolution from pyramid to the tomb temple and burial monuments of the Old and Middle Kingdoms.
- Discuss how Egyptian art changed as a result of the Hyksos' invasions.
- Understand aspects of the New Kingdom as reflected in its art.

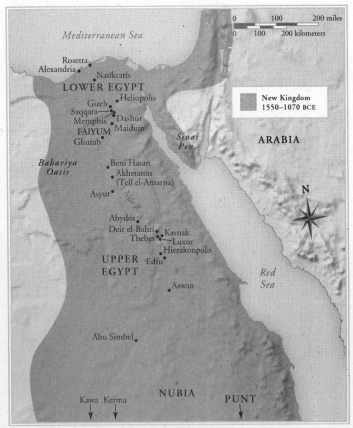

Map 3-1 Ancient Egypt. (page 54)

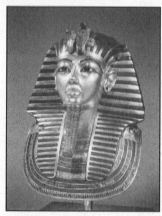

FIG. 03-01 Death mask of Tutankhamen, from the innermost coffin in his tomb at Thebes, Egypt, 18th Dynasty, ca. 1323 BCE. Gold with inlay of semiprecious stones, 1′ 9 1/4″ high. Egyptian Museum, Cairo. (page 52)

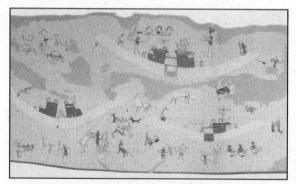

FIG. 03-02 People, boats, and animals, detail of a watercolor copy of a wall painting from tomb 100 at Hierakonpolis, Egypt, Predynastic, ca. 3500–3200 BCE. Paint on plaster, entire painting 16′ 4″ × 3′ 7 3/8″. Egyptian Museum, Cairo. (page 55)

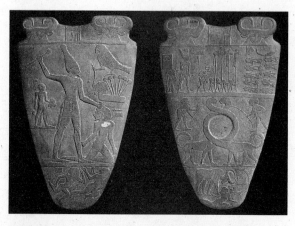

FIG. 03-03 Palette of King Narmer (*left,* back; *right,* front), from Hierakonpolis, Egypt, Predynastic, ca. 3000–2920 BCE. Slate, 2′ 1″ high. Egyptian Museum, Cairo. (page 55)

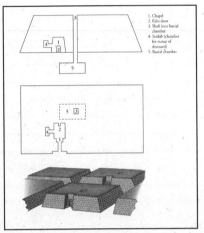

Lat.: 29°58'45.70"N Long.: 31°7'53.24"E

FIG. 03-04 Section *(top),* plan *(center),* and restored view *(bottom)* of typical Egyptian mastaba tombs. (page 56)

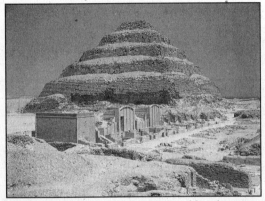

Lat.: 29°52'16.36"N Long.: 31°13'3.76"E

FIG. 03-05 Iмнотер, Stepped Pyramid and mortuary precinct of Djoser, Saqqara, Egypt, Third Dynasty, ca. 2630–2611 BCE. (page 58)

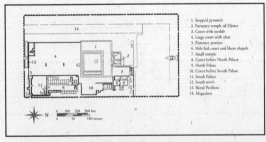

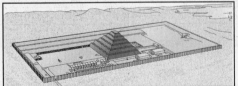

FIG. 03-06 Plan *(top)* and restored view *(bottom)* of the mortuary precinct of Djoser, Saqqara, Egypt, Third Dynasty, ca. 2630–2611 BCE. (page 58)

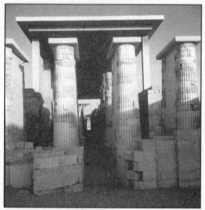

FIG. 03-06A Columnar entrance corridor to the mortuary precinct of Djoser, Saqqara, Egypt, Third Dynasty, ca. 2630–2611 BCE. (page 58)

FIG. 03-07 Detail of the facade of the North Palace of the mortuary precinct of Djoser, Saqqara, Egypt, Third Dynasty, ca. 2630–2611 BCE. (page 59)

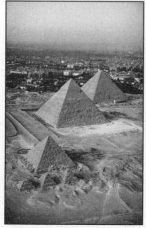

FIG. 03-08 Great Pyramids, Gizeh, Egypt, Fourth Dynasty. *From bottom:* Pyramids of Menkaure, ca. 2490–2472 BCE; Khafre, ca. 2520–2494 BCE; and Khufu, ca. 2551–2528 BCE. (page 59)

Lat.: 29°52′16.60″N Long.: 31°12′59.79″E

Lat.: 29°58′30.78″N Long.: 31°8′3.89″E

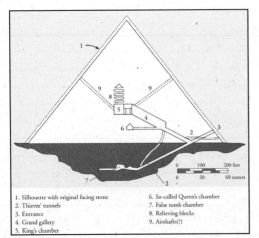

Lat.: 29°58′44.29″N Long.: 31°8′4.25″E

FIG. 03-09 Section of the Pyramid of Khufu, Gizeh, Egypt, Fourth Dynasty, ca. 2551–2528 BCE. (page 60)

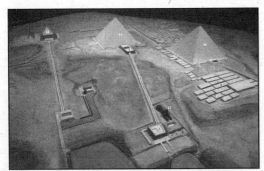

FIG. 03-10 Model of the Fourth Dynasty pyramid complex, Gizeh, Egypt. Harvard University Semitic Museum, Cambridge. 1) Pyramid of Menkaure, 2) Pyramid of Khafre, 3) mortuary temple of Khafre, 4) causeway, 5) Great Sphinx, 6) valley temple of Khafre, 7) Pyramid of Khufu, 8) pyramids of the royal family and mastabas of nobles (page 61)

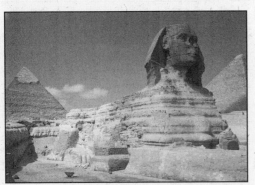

FIG. 03-11 Great Sphinx (with pyramid of Khafre in the background at left), Gizeh, Egypt, Fourth Dynasty, ca. 2520–2494 BCE. Sandstone, 65′ × 240′. (page 61)

Lat.: 29°58′30.81″N Long.: 31°8′15.55″E

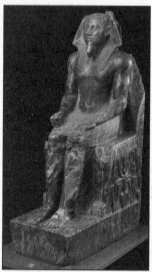

FIG. 03-12 Khafre enthroned, from Gizeh, Egypt, Fourth Dynasty, ca. 2520–2494 BCE. Diorite, 5′ 6″ high. Egyptian Museum, Cairo. (page 62)

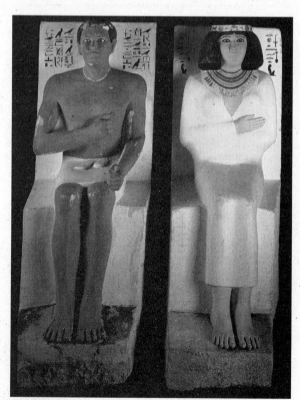

FIG. 03-12A Seated statues of Rahotep and Nofret, from their mastaba at Maidum, Egypt, Fourth Dynasty, ca. 2575–2550 BCE. Painted limestone, 3′ 11 5/8″ and 4′ high respectively. Egyptian Museum, Cairo. (page 62)

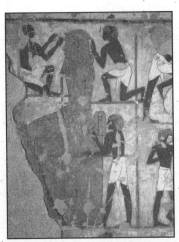

FIG. 03-12B Sculptors at work, detail of the south wall of the main hall of the funerary chapel of Rekhmire, Thebes, Egypt, 18th Dynasty, ca. 1425 BCE. (page 63)

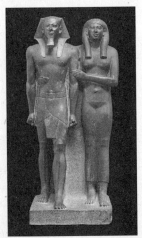

FIG. 03-13 Menkaure and Khamerernebty(?), from Gizeh, Egypt, Fourth Dynasty, ca. 2490–2472 BCE. Graywacke, approx. 4′ 6 1/2″ high. Museum of Fine Arts, Boston. (page 62)

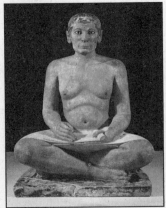

FIG. 03-14 Seated scribe, from Saqqara, Egypt, Fourth Dynasty, ca. 2500 BCE. Painted limestone, 1′ 9″ high. Louvre, Paris. (page 63)

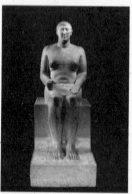

FIG. 03-14A Seated statue of Hemiunu, from his mastaba at Gizeh, Egypt, Fourth Dynasty, ca. 2550–2530 BCE. Painted limestone, 5′ 1 1/2″ high. Römer- und Pelizaeus-Museum, Hildesheim. (page 63)

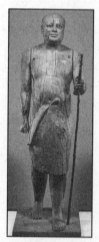

FIG. 03-14B Portrait statue of Ka-Aper, from his mastaba at Saqqara, Egypt, Fifth Dynasty, ca. 2450–2350 BCE. Wood, 3′ 7 1/4″ high. Egyptian Museum, Cairo. (page 64)

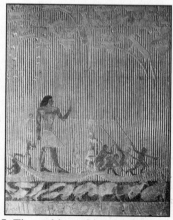

FIG. 03-15 Ti watching a hippopotamus hunt, relief in the mastaba of Ti, Saqqara, Egypt, Fifth Dynasty, ca. 2450–2350 BCE. Painted limestone, 4′ high. (page 64)

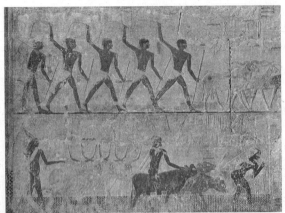

FIG. 03-16 Goats treading seed and cattle fording a canal, reliefs in the mastaba of Ti, Saqqara, Egypt, Fifth Dynasty, ca. 2450–2350 BCE. Painted limestone. (page 65)

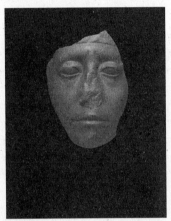

FIG. 03-17 Fragmentary head of Senusret III, 12th Dynasty, ca. 1860 BCE. Red quartzite, 6 1/2″ high. Metropolitan Museum of Art, New York. (page 65)

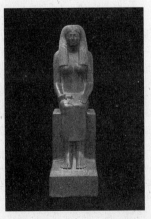

FIG. 03-17A Seated statue of Lady Sennuwy, from Kerma, Sudan, 12th Dynasty, ca. 1960–1916 BCE. Diorite, 5′ 7 3/4″ high. Museum of Fine Arts, Boston. (page 65)

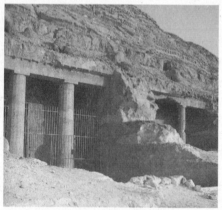

FIG. 03-18 Rock-cut tombs BH 3–5, Beni Hasan, Egypt, 12th Dynasty, ca. 1950–1900 BCE. (page 66)

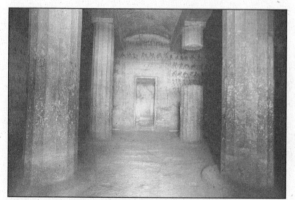

FIG. 03-19 Interior hall of the rock-cut tomb of Amenemhet (tomb BH 2), Beni Hasan, Egypt, 12th Dynasty, ca. 1950–1900 BCE. (page 66)

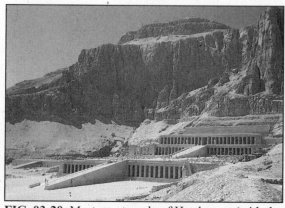

FIG. 03-20 Mortuary temple of Hatshepsut (with the Middle Kingdom mortuary temple of Mentuhotep II at left), Deir el-Bahri, Egypt, 18th Dynasty, ca. 1473–1458 BCE. (page 67)

Lat.: 25°44'16.36"N Long.: 32°36'26.72"E

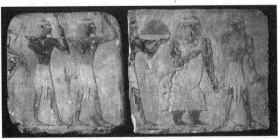

FIG. 03-20A King and queen of Punt and attendants, relief from the mortuary temple of Hatshepsut, Deir el-Bahri, Egypt, 18th Dynasty, ca. 1473–1458 BCE. Painted limestone, 1′ 3″ high. Egyptian Museum, Cairo. (page 67)

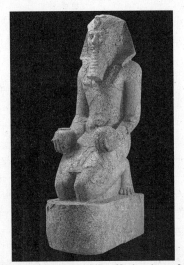

FIG. 03-21 Hatshepsut with offering jars, from the upper court of her mortuary temple, Deir el-Bahri, Egypt, 18th Dynasty, ca. 1473–1458 BCE. Red granite, 8′ 6″ high. Metropolitan Museum of Art, New York. (page 68)

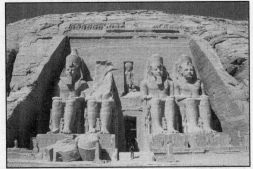

FIG. 03-22 Temple of Ramses II, Abu Simbel, Egypt, 19th Dynasty, ca. 1290–1224 BCE. Sandstone, colossi 65′ high. (page 69)

Lat.: 22°20′12.56″N Long.: 31°37′32.48″E

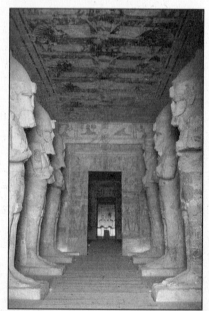

FIG. 03-23 Interior of the temple of Ramses II, Abu Simbel, Egypt, 19th Dynasty, ca. 1290–1224 BCE. Sandstone, pillar statues 32′ high. (page 69)

FIG. 03-24 Restored view of the temple of Amen-Re, Karnak, Egypt, begun 15th century BCE (Jean-Claude Golvin). (page 70)

Lat.: 25°43′4.44″N Long.: 32°39′29.68″E

FIG. 03-24A Aerial view of the temple of Amen-Re, Mut, and Khonsu (looking east), Luxor, Egypt, 18th dynasty, begun early 14th century BCE. (page 70)

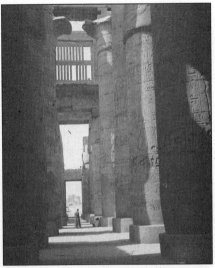

FIG. 03-25 Hypostyle hall, temple of Amen-Re, Karnak, Egypt, 19th Dynasty, ca. 1290–1224 BCE. (page 70)

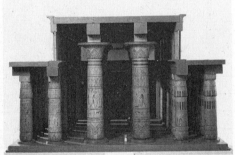

FIG. 03-26 Model of hypostyle hall, temple of Amen-Re, Karnak, Egypt, 19th Dynasty, ca. 1290–1224 BCE. Metropolitan Museum of Art, New York. (page 71)

Lat.: 25°43′6.38″N Long.: 32°39′28.46″E

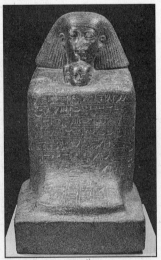

FIG. 03-27 Senmut with Princess Nefrura, from Thebes, Egypt, 18th Dynasty, ca. 1470–1460 BCE. Granite, 3′ 1/2″ high. Ägyptisches Museum, Berlin. (page 71)

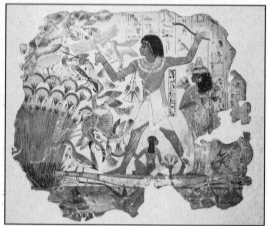

FIG. 03-28 Fowling scene, from the tomb of Nebamun, Thebes, Egypt, 18th Dynasty, ca. 1400–1350 BCE. Fresco on dry plaster, 2′ 8″ high. British Museum, London. (page 72)

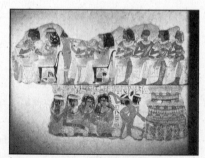

FIG. 03-29 Musicians and dancers, from the tomb of Nebamun, Thebes, Egypt, 18th Dynasty, ca. 1400–1350 BCE. Fresco on dry plaster, 1′ × 2′ 3″. British Museum, London. (page 72)

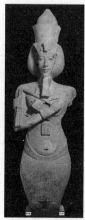

FIG. 03-30 Akhenaton, from the temple of Aton, Karnak, Egypt, 18th Dynasty, ca. 1353–1335 BCE. Sandstone, 13′ high. Egyptian Museum, Cairo. (page 73)

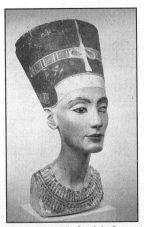

FIG. 03-31 THUTMOSE, Nefertiti, from Amarna, Egypt, 18th Dynasty, ca. 1353–1335 BCE. Painted limestone, 1′ 8″ high. Ägyptisches Museum, Berlin. (page 74)

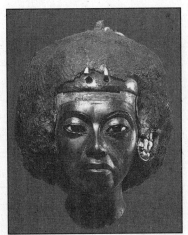

FIG. 03-32 Tiye, from Ghurab, Egypt, 18th Dynasty, ca. 1353–1335 BCE. Wood, with gold, silver, alabaster, and lapis lazuli, 3 3/4″ high. Ägyptisches Museum, Berlin. (page 74)

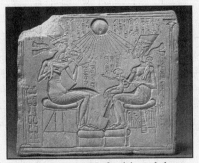

FIG. 03-33 Akhenaton, Nefertiti, and three daughters, from Amarna, Egypt, 18th Dynasty, ca. 1353–1335 BCE. Limestone, 1′ 1/4″ high. Ägyptisches Museum, Berlin. (page 75)

FIG. 03-34 Innermost coffin of Tutankhamen, from his tomb at Thebes, Egypt, 18th Dynasty, ca. 1323 BCE. Gold with inlay of enamel and semiprecious stones, 6′ 1″ long. Egyptian Museum, Cairo. (page 75)

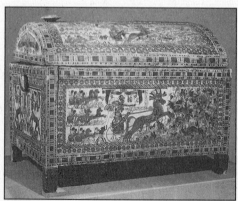

FIG. 03-35 Painted chest, from the tomb of Tutankhamen, Thebes, Egypt, 18th Dynasty, ca. 1333–1323 BCE. Wood, 1′ 8″ long. Egyptian Museum, Cairo. (page 76)

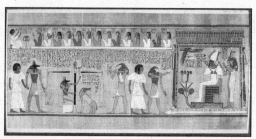

FIG. 03-36 Last judgment of Hu-Nefer, from his tomb at Thebes, Egypt, 19th Dynasty, ca. 1290–1280 BCE. Painted papyrus scroll, 1′ 6″ high. British Museum, London. (page 76)

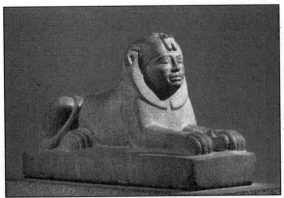

FIG. 03-37 Taharqo as a sphinx, from temple T, Kawa, Sudan, 25th Dynasty, ca. 680 BCE. Granite, 1′ 4″ × 2′ 4 3/4″. British Museum, London. (page 77)

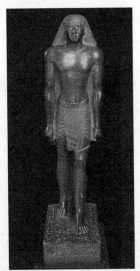

FIG. 03-37A Portrait statue of Mentuemhet, from Karnak, Egypt, 26th Dynasty, ca. 660–650 BCE. Granite, 4′ 5″ high. Egyptian Museum, Cairo. (page 77)

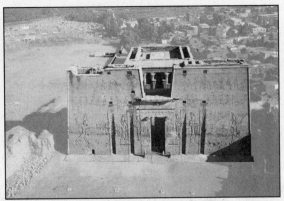

FIG. 03-38 Temple of Horus, Edfu, Egypt, ca. 237–47 BCE. (page 78)

Lat.: 24°58′40.99″N Long.: 32°52′24.49″E

1. What function did the mortuary precinct located at 29°52′16.36″N, 31°13′3.76″E serve? Explain how the structures surrounding Djoser's funerary temple were built and what they were meant to resemble.

2. Explore Queen Hatshepsut's mortuary temple, located at 25°44′16.36″N, 32°36′26.72″E. Describe how the temple reflects its environment and location.

3. What characterizes a hypostyle hall like the one found at the temple of Amen-Re (FIG. 3-26) located at 25°43′6.38″N, 32°39′28.46″E?

4. Explore King Djoser's mortuary precinct located at 29°52′16.60″N, 31°12′59.79″E. What are the royal tombs distinguishing features?

5. What does the artificial lake at the center of the temple of Amen-Re (located at 25°43′4.44″N, 32°39′29.68″E) symbolize?

6. Explain how the Great Pyramids at Gizeh (29°58′30.78″N, 31°8′3.89″E) were constructed. What social class were the laborers from? Why did they participate in these building projects?

7. What types of tombs are located at 29°58′45.70″N, 31°7′53.24″E? From what materials were these tombs constructed?

8. What type of monument is the Temple of Horus at Edfu (FIG. 3-38 and located at 24°58′40.99″N, 32°52′24.49″E)?

9. What natural feature dominates the geography of Ancient Egypt? (Use Google Earth coordinates 28°22′15.76″N, 31°8′19.78″E to see the region, and zoom in and out to analyze the terrain.)

10. What are the remarkable features of the monument located at 29°58′44.29″N, 31°8′4.25″E?

11. What King's funerary complex is the Great Sphinx (29°58′30.81″N, 31°8′15.55″E) believed to be a part of?

12. How were the colossal figures located at 22°20′12.56″N, 31°37′32.48″E constructed?

13. What are the Great Pyramids at Gizeh (29°58′30.78″N, 31°8′3.89″E) believed to symbolize?

Chapter 4

The Prehistoric Aegean

Goals

- Identify the geographic area known as the Aegean.
- Discuss the visual aspects and possible context of the Cycladic sculptures.
- Discuss the Minoan society and architecture.
- Understand visual aspects of Minoan art.
- Relate significant aspects of archeological excavations at Mycenae.
- Understand the link between culture and architecture of Mycenae.
- Discuss the relationship between Minoan and Mycenaean art and culture.

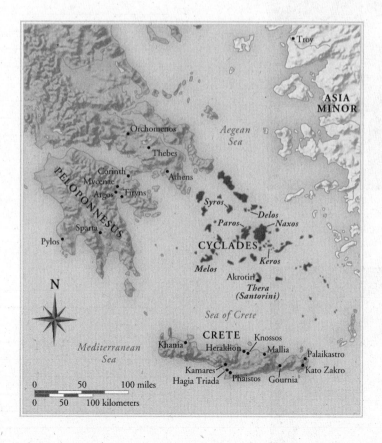

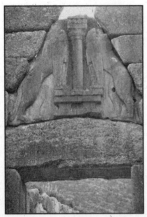

FIG. 04-01 Relieving triangle with confronting lions, detail of Lion Gate (FIG. 4-19), Mycenae, Greece, ca. 1300–1250 BCE. (page 80)

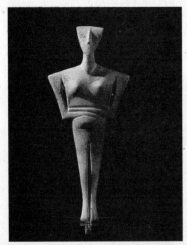

FIG. 04-02 Figurine of a woman, from Syros (Cyclades), Greece, ca. 2500–2300 BCE. Marble, 1′ 6″ high. National Archaeological Museum, Athens. (page 82)

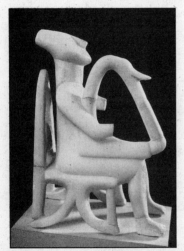

FIG. 04-03 Male lyre player, from Keros (Cyclades), Greece, ca. 2700–2500 BCE. Marble, 9″ high. National Archaeological Museum, Athens. (page 83)

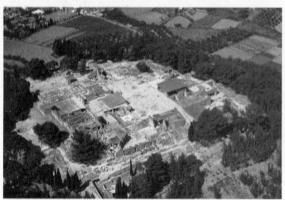

FIG. 04-04 Aerial view (looking northeast) of the palace at Knossos (Crete), Greece, ca. 1700–1400 BCE. (page 84)

Lat.: 35°17′52.93″N Long.: 25°9′48.38″E

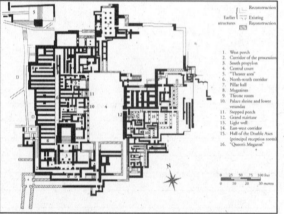

FIG. 04-05 Plan of the palace at Knossos (Crete), Greece, ca. 1700–1400 BCE. (page 84)

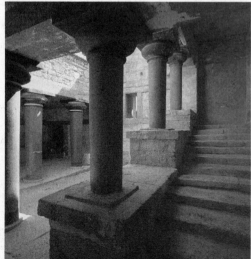

FIG. 04-06 Stairwell in the residential quarter of the palace at Knossos (Crete), Greece, ca. 1700–1400 BCE. (page 85)

FIG. 04-07 Minoan woman or goddess *(La Parisienne),* from the palace at Knossos (Crete), Greece, ca. 1450–1400 BCE. Fragment of a fresco, 10″ high. Archaeological Museum, Herakleion. (page 85)

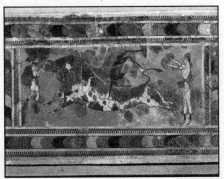

FIG. 04-08 Bull-leaping, from the palace at Knossos (Crete), Greece, ca. 1450–1400 BCE. Fresco, 2′ 8″ high, including border. Archaeological Museum, Herakleion. (page 86)

Lat.: 35°17′52.93″N Long.: 25°9′48.38″E

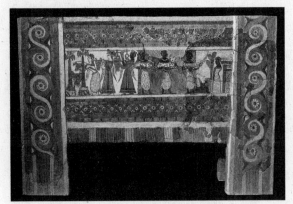

FIG. 04-08A Sarcophagus, from Hagia Triada (Crete), Greece, ca. 1450–1400 BCE. Painted limestone, 4′ 6″ long. Archaeological Museum, Herakleion. (page 86)

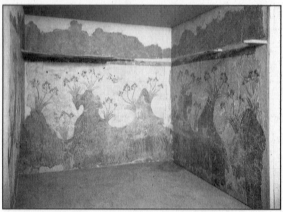

FIG. 04-09 Landscape with swallows *(Spring Fresco),* from room Delta 2, Akrotiri, Thera (Cyclades), Greece, ca. 1650 BCE. Fresco, 7′ 6″ high. National Archaeological Museum, Athens. (page 87)

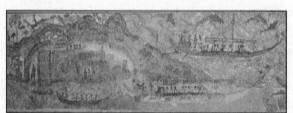

FIG. 04-09A Flotilla, detail of Miniature Ships Fresco, from room 5, West House, Akrotiri, Thera (Cyclades), Greece, ca. 1650 BCE. Fresco, 1′ 5″ high. National Archaeological Museum, Athens. (page 86)

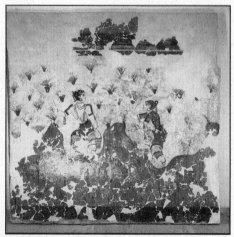

FIG. 04-09B Crocus gatherers, detail of the east wall of room 3 of building Xeste 3, Akrotiri, Thera (Cyclades), Greece, ca. 1650 BCE. Fresco, 8′ 1/8″ high. National Archaeological Museum, Athens. (page 86)

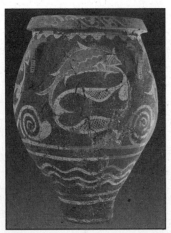

FIG. 04-10 Kamares-ware jar, from Phaistos (Crete), Greece, ca. 1800–1700 BCE. 1′ 8″ high. Archaeological Museum, Herakleion. (page 88)

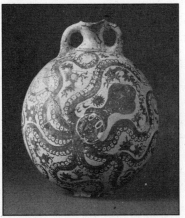

FIG. 04-11 Marine Style octopus jar, from Palaikastro (Crete), Greece, ca. 1500 BCE. 11″ high. Archaeological Museum, Herakleion. (page 88)

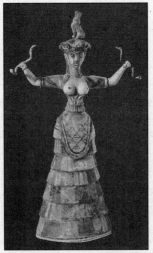

FIG. 04-12 *Snake Goddess,* from the palace at Knossos (Crete), Greece, ca. 1600 BCE. Faience, 1′ 1 1/2″ high. Archaeological Museum, Herakleion. (page 89)

FIG. 04-13 Young god(?), from Palaikastro (Crete), Greece, ca. 1500–1475 BCE. Ivory, gold, serpentine, and rock crystal, original height 1′ 7 1/2″. Archaeological Museum, Siteia. (page 89)

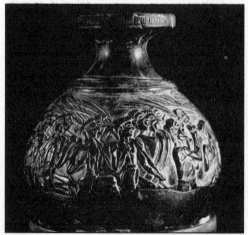

FIG. 04-14 *Harvesters Vase,* from Hagia Triada (Crete), Greece, ca. 1500 BCE. Steatite, originally with gold leaf, greatest diameter approx. 5″. Archaeological Museum, Herakleion. (page 90)

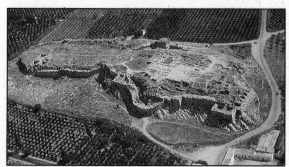

FIG. 04-15 Aerial view of the citadel at Tiryns, Greece, ca. 1400–1200 BCE. (page 90)

Lat.: 37°35′53.34″N Long.: 22°47′14.92″E

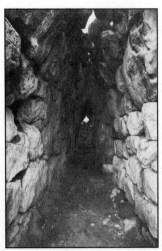

FIG. 04-16 Corbeled gallery in the walls of the citadel, Tiryns, Greece, ca. 1400–1200 BCE. (page 91)

FIG. 04-17 Three methods of spanning a passageway: (a) post and lintel, (b) corbeled arch, (c) arch. (page 91)

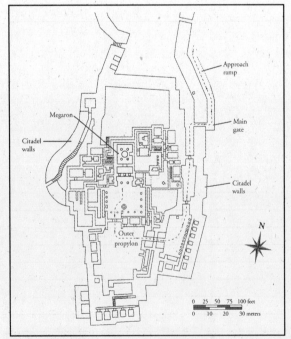

FIG. 04-18 Plan of the palace and southern part of the citadel, Tiryns, Greece, ca. 1400–1200 BCE. (page 92)

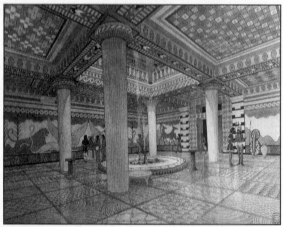

FIG. 04-18A Restored view of the megaron, Palace of Nestor, Pylos, ca. 1300 BCE (watercolor by Piet de Jong). (page 92)

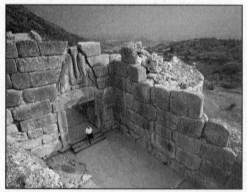

FIG. 04-19 Lion Gate, Mycenae, Greece, ca. 1300–1250 BCE. Limestone, relief panel 9′ 6″ high. (page 92)

Lat.: 37°39′5.93″N Long.: 22°51′26.90″E

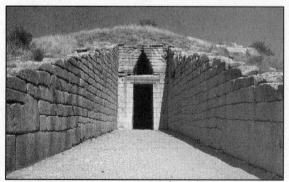

FIG. 04-20 Treasury of Atreus, Mycenae, Greece, ca. 1300–1250 BCE. (page 93)

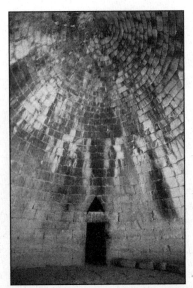

FIG. 04-21 Vault of the tholos of the Treasury of Atreus, Mycenae, Greece, ca. 1300–1250 BCE. (page 93)

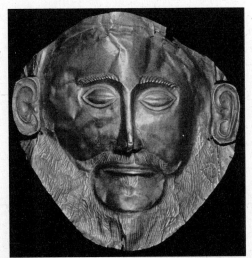

FIG. 04-22 Funerary mask, from Grave Circle A, Mycenae, Greece, ca. 1600–1500 BCE. Beaten gold, 1′ high. National Archaeological Museum, Athens. (page 94)

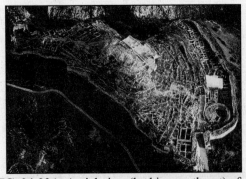

FIG. 04-22A Aerial view (looking southeast) of Grave Circle A, ca. 1600 BCE, and of the circuit walls, ca. 1300–1250 BCE, of Mycenae, Greece. (page 94)

FIG. 04-23 Inlaid dagger blade with lion hunt, from Grave Circle A, Mycenae, Greece, ca. 1600–1500 BCE. Bronze, inlaid with gold, silver, and niello, 9″ long. National Archaeological Museum, Athens. (page 95)

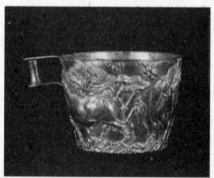

FIG. 04-23A Hunter capturing a bull, drinking cup from Vapheio, near Sparta, Greece, ca. 1600–1500 BCE. Gold, 3 1/2″ high. National Archaeological Museum, Athens. (page 94)

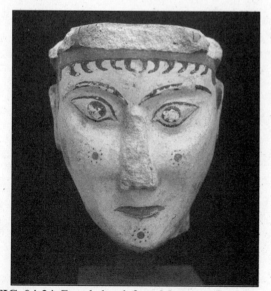

FIG. 04-24 Female head, from Mycenae, Greece, ca. 1300–1250 BCE. Painted plaster, 6 1/2″ high. National Archaeological Museum, Athens. (page 95)

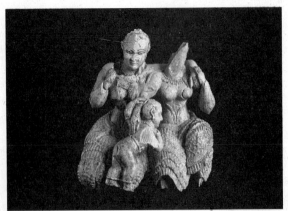

FIG. 04-24A Two goddesses(?) and a child, from Mycenae, Greece, ca. 1400–1250 BCE. Ivory, 2 3/4″ high. National Archaeological Museum, Athens. (page 95)

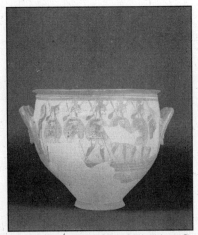

FIG. 04-25 *Warrior Vase,* from Mycenae, Greece, ca. 1200 BCE. 1′ 4″ high. National Archaeological Museum, Athens. (page 96)

1. Describe the layout of the palace at Knossos (located at 35°17′52.93″N, 25°9′48.38″E).

2. Describe the style of architecture exemplified by the citadel of Tiryns (located at 37°35′53.34″N, 22°47′14.92″E).

3. What function did the structure known as the Treasury of Atreus (FIG. 4-21) serve?

4. What are the islands found in the Aegean Sea at 37°22′19.61″N, 24°56′24.48″E (zoom out to see the complete group) known as?

5. Describe the distinguishing features of the Spring Fresco (FIG. 4-9)?

6. What purpose did the Lion Gate (located at 37°39′5.93″N, 22°51′26.90″E) serve?

7. Compare and contrast the Cycladic figure depicted in FIG. 4-2 with the statuette known as the "Snake Goddess" (FIG. 4-12). From what tradition do these figures apparently stem? What are they believed to represent?

8. With what Aegean island are Kamares Ware vessels such as FIG. 4-10 associated?

9. Identify the place that bull-leaping mural was painted (35°17′52.93″N, 25°9′48.38″E). Discuss the artistic conventions employed in the painting.

10. Describe the style and form of the figure playing the lyre from Syros (FIG. 4-3). What considerations factor into the dating of such a work?

Chapter 5

Ancient Greece

Goals

- Understand the diverse cultural influences on Greek artistic development.
- Discuss the evolution of the human figure and how it is represented in Greek art.
- Relate the development of temple architecture.
- Cite architectural components and terminology.
- Understand the impact of the conquest of the Greeks on their respective art forms.
- Discuss individual artists and their respective styles.

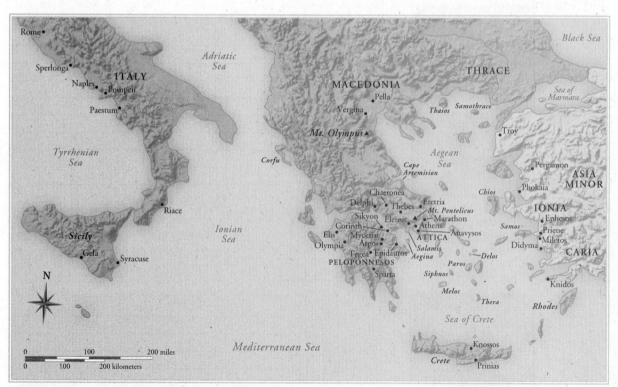

MAP 5-1 The Greek world. (page 100)

FIG. 05-01 The Persian king Darius III, detail of PHILOXENOS OF ERETRIA, *Battle of Issus* (FIG. 5-70), Roman mosaic copy of a painting ca. 310 BCE. Museo Archeologico Nazionale, Naples. (page 98)

FIG. 05-02 Geometric krater, from the Dipylon cemetery, Athens, Greece, ca. 740 BCE. 3′ 4 1/2″ high. Metropolitan Museum of Art, New York. (page 102)

FIG. 05-02A DIPYLON PAINTER, Geometric amphora with mourning scene, from the Dipylon cemetery, Athens, Greece, ca. 750 BCE. 5′ 1″ high. National Archaeological Museum, Athens. (page 102)

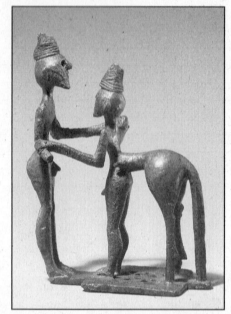

FIG. 05-03 Hero and centaur (Herakles and Nessos?), from Olympia, Greece, ca. 750–730 BCE. Bronze, 4 1/2″ high. Metropolitan Museum of Art, New York (gift of J. Pierpont). (page 103)

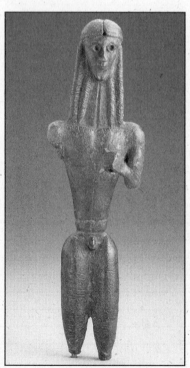

FIG. 05-04 *Mantiklos Apollo,* statuette of a youth dedicated by Mantiklos to Apollo, from Thebes, Greece, ca. 700–680 BCE. Bronze, 8″ high. Museum of Fine Arts, Boston. (page 103)

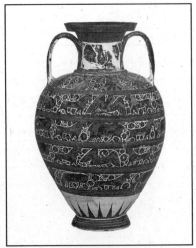

FIG. 05-05 Corinthian black-figure amphora with animal friezes, from Rhodes, Greece, ca. 625–600 BCE. 1′ 2″ high. British Museum, London. (page 104)

FIG. 05-06 Plan of Temple A, Prinias, Greece, ca. 625 BCE. (page 105)

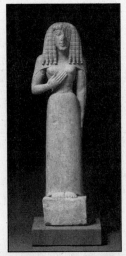

FIG. 05-07 *Lady of Auxerre,* ca. 650–625 BCE. Limestone, 2′ 1 1/2″ high. Louvre, Paris. (page 105)

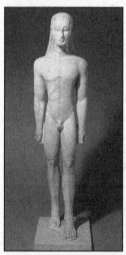

FIG. 05-08 Kouros, ca. 600 BCE. Marble, 6′ 1/2″ high. Metropolitan Museum of Art, New York. (page 106)

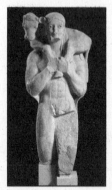

FIG. 05-09 Calf bearer, dedicated by Rhonbos on the Acropolis, Athens, Greece, ca. 560 BCE. Marble, restored height 5′ 5″; fragment 3′ 11 1/2″ high. Acropolis Museum, Athens. (page 107)

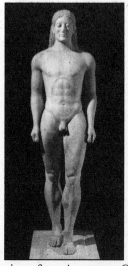

FIG. 05-10 Kroisos, from Anavysos, Greece, ca. 530 BCE. Marble, 6′ 4″ high. National Archaeological Museum, Athens. (page 107)

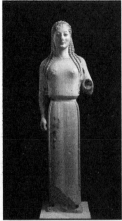

FIG. 05-11 *Peplos Kore,* from the Acropolis, Athens, Greece, ca. 530 BCE. Marble, 4′ high. Acropolis Museum, Athens. (page 108)

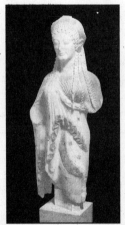

FIG. 05-12 Kore, from the Acropolis, Athens, Greece, ca. 520–510 BCE. Marble, 1′ 9″ high. Acropolis Museum, Athens. (page 108)

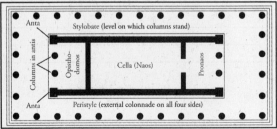

FIG. 05-13 Plan of a typical Greek peripteral temple. (page 109)

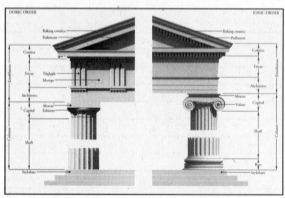

FIG. 05-14 Elevations of the Doric and Ionic orders. (page 10)

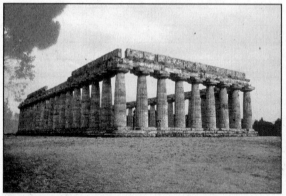

FIG. 05-15 Temple of Hera I ("Basilica"), Paestum, Italy, ca. 550 BCE. (page 111)

Lat.: 40°25′9.52″N Long.: 15°0′19.79″E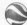

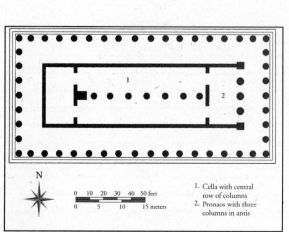

N

0 10 20 30 40 50 feet
0 5 10 15 meters

1. Cella with central row of columns
2. Pronaos with three columns in antis

FIG. 05-16 Plan of the Temple of Hera I, Paestum, Italy, ca. 550 BCE. (page 111)

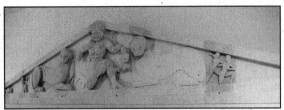

FIG. 05-17 West pediment from the Temple of Artemis, Corfu, Greece, ca. 600–580 BCE. Limestone, greatest height 9′ 4″. Archaeological Museum, Corfu. (page 112)

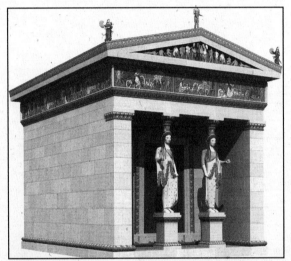

FIG. 05-18 Reconstruction drawing of the Siphnian Treasury, Delphi, Greece, ca. 530 BCE (John Burge). (page 113)

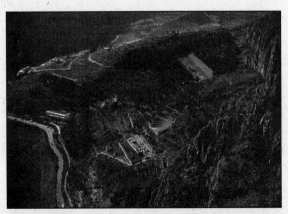

FIG. 05-18A Aerial view of the sanctuary of Apollo, Delphi, Greece. (page 113)

FIG. 05-19 Gigantomachy, detail of the north frieze of the Siphnian Treasury, Delphi, Greece, ca. 530 BCE. Marble, 2′ 1″ high. Archaeological Museum, Delphi. (page 113)

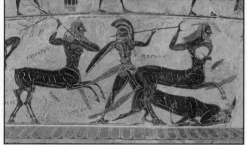

FIG. 05-20 KLEITIAS and ERGOTIMOS, *François Vase* (Athenian black-figure volute krater), from Chiusi, Italy, ca. 570 BCE. General view *(top)* and detail of centauromachy on other side of vase *(bottom).* 2′ 2″ high. Museo Archeologico, Florence. (page 114)

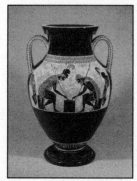

FIG. 05-21 EXEKIAS, Achilles and Ajax playing a dice game (detail from an Athenian black-figure amphora), from Vulci, Italy, ca. 540–530 BCE. Whole vessel 2′ high; detail 8 1/2″ high. Musei Vaticani Rome. (page 115)

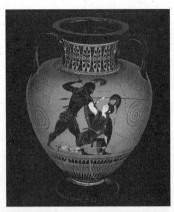

FIG. 05-21A EXEKIAS, Achilles killing Penthesilea (Athenian black-figure amphora), ca. 540–530 BCE. 1′ 4 3/8″ high. British Museum, London. (page 114)

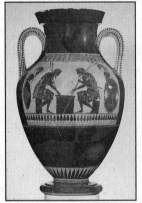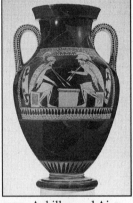

FIG. 05-22 ANDOKIDES PAINTER, Achilles and Ajax playing a dice game (Athenian bilingual amphora), from Orvieto, Italy, ca. 525–520 BCE. Black-figure side *(left)* and red-figure side *(right)*. 1′ 9″ high. Museum of Fine Arts, Boston. (page 113)

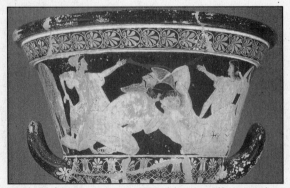

FIG. 05-23 EUPHRONIOS, Herakles wrestling Antaios (detail of an Athenian red-figure calyx krater), from Cerveteri, Italy, ca. 510 BCE. Whole vessel 1′ 7″ high. Detail 7 3/4″ high. Louvre, Paris. (page 116)

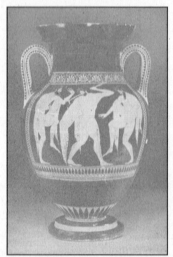

FIG. 05-24 EUTHYMIDES, Three revelers (Athenian red-figure amphora), from Vulci, Italy, ca. 510 BCE. 2′ high. Staatliche Antikensammlungen, Munich. (page 116)

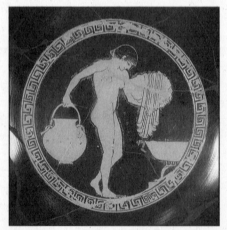

FIG. 05-24A ONESIMOS, Girl preparing to bathe (interior of an Athenian red-figure kylix), from Chiusi, Italy, ca. 490 BCE. Tondo 6″ in diameter. Musées Royaux des Beaux-Arts de Belgique, Brussels. (page 116)

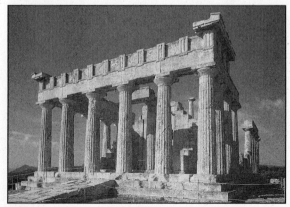

FIG. 05-25 Temple of Aphaia, Aegina, Greece, ca. 500–490 BCE. (page 117)

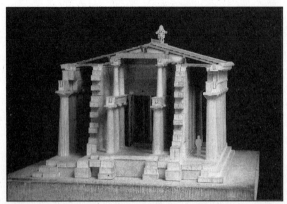

FIG. 05-26 Model of the Temple of Aphaia, Aegina, Greece, ca. 500–490 BCE. Glyptothek, Munich.

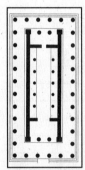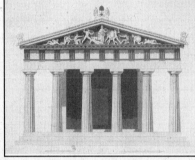

FIG. 05-27 Plan *(left)* and GUILLAUME-ABEL BLOUET's 1828 restored view of the facade *(right)* of the Temple of Aphaia, Aegina, Greece, ca. 500–490 BCE. (page 117)

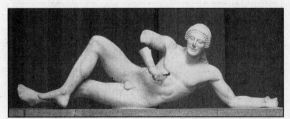

FIG. 05-28 Dying warrior, from the west pediment of the Temple of Aphaia, Aegina, Greece, ca. 490 BCE. Marble, 5′ 2 1/2″ long. Glyptothek, Munich. (page 118)

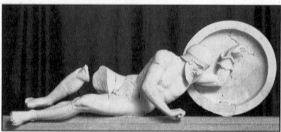

FIG. 05-29 Dying warrior, from the east pediment of the Temple of Aphaia, Aegina, Greece, ca. 480 BCE. Marble, 6′ 1″ long. Glyptothek, Munich. (page 118)

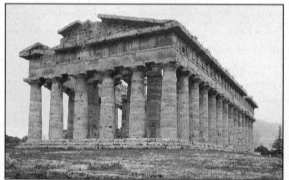

FIG. 05-30 Temple of Hera II, Paestum, Italy, ca. 460 BCE. (page 119)

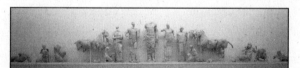

FIG. 05-31 East pediment from the Temple of Zeus, Olympia, Greece, ca. 470–456 BCE. Marble, 87′ wide. Archaeological Museum, Olympia. (page 119)

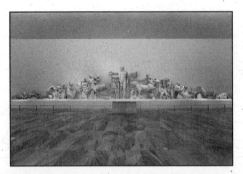

FIG. 05-31A Centauromachy, west pediment of the Temple of Zeus, Olympia, Greece, ca. 470–456 BCE. Marble, Apollo (central figure), 10′ 8″ high. Archaeological Museum, Olympia. (page 119)

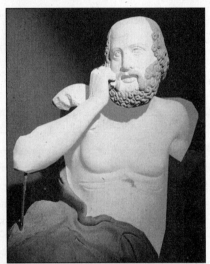

FIG. 05-32 Seer, from the east pediment of the Temple of Zeus, Olympia, Greece, ca. 470–456 BCE. Marble, full figure 4′ 6″ high; detail 3′ 2 1/2″ high. Archaeological Museum, Olympia. (page 120)

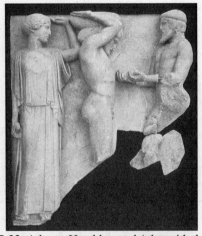

FIG. 05-33 Athena, Herakles, and Atlas with the apples of the Hesperides, metope from the Temple of Zeus, Olympia, Greece, ca. 470–456 BCE. Marble, 5′ 3″ high. Archaeological Museum, Olympia. (page 120)

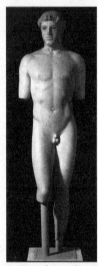

FIG. 05-34 *Kritios Boy,* from the Acropolis, Athens, Greece, ca. 480 BCE. Marble, 2′ 10″ high. Acropolis Museum, Athens. (page 121)

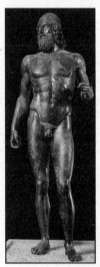

FIG. 05-35 Warrior, from the sea off Riace, Italy, ca. 460–450 BCE. Bronze, 6′ 6″ high. Museo Archeologico Nazionale, Reggio Calabria. (page 121)

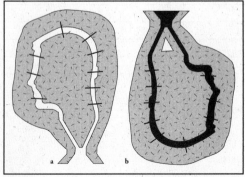

FIG. 05-36 Two stages of the lost-wax method of bronze casting (after Sean A. Hemingway). (page 122)

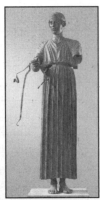

FIG. 05-37 Charioteer, from a group dedicated by Polyzalos of Gela in the sanctuary of Apollo, Delphi, Greece, ca. 470 BCE. Bronze, 5′ 11″ high. Archaeological Museum, Delphi. (page 122)

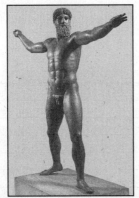

FIG. 05-38 Zeus (or Poseidon?), from the sea off Cape Artemision, Greece, ca. 460–450 BCE. Bronze, 6′ 10″ high. National Archaeological Museum, Athens. (page 123)

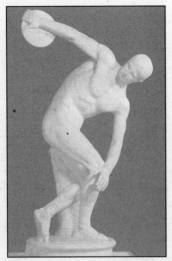

FIG. 05-39 MYRON, *Diskobolos (Discus Thrower)*. Roman marble copy of a bronze original of ca. 450 BCE, 5′ 1″ high. Museo Nazionale Romano—Palazzo Massimo alle Terme. (page 123)

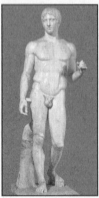

FIG. 05-40 Polykleitos, *Doryphoros (Spear Bearer)*. Roman marble copy from Pompeii, Italy, after a bronze original of ca. 450–440 BCE, 6′ 11″ high. Museo Archeologico Nazionale, Naples. (page 124)

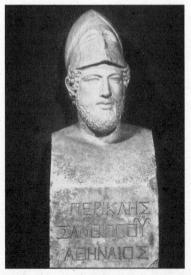

FIG. 05-41 Kresilas, Pericles. Roman marble herm copy of a bronze original of ca. 429 BCE. Full herm 6′ high; detail 4′ 6 1/2″ high. Musei Vaticani, Rome. (page 125)

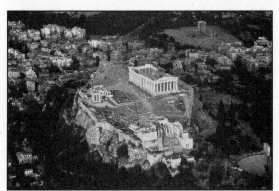

FIG. 05-42 Aerial view of the Acropolis looking southeast, Athens, Greece. (page 126)

Lat.: 37°58′17.38″N Long.: 23°43′34.40″E

77

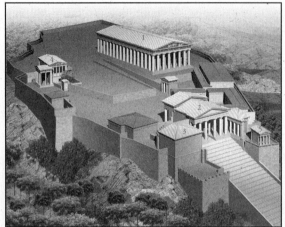

FIG. 05-43 Restored view of the Acropolis, Athens, Greece (John Burge). (1) Parthenon, (2) Propylaia, (3) pinakotheke, (4) Erechtheion, (5) Temple of Athena Nike. (page 126)

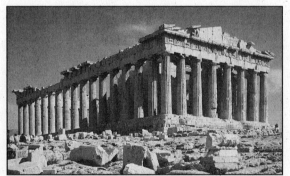

FIG. 05-44 IKTINOS and KALLIKRATES, Parthenon (Temple of Athena Parthenos, looking southeast), Acropolis, Athens, Greece, 447–438 BCE. (page 127)

Lat.: 37°58′17.34″N Long.: 23°43′35.67″E

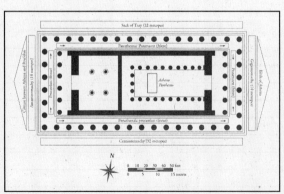

FIG. 05-45 Plan of the Parthenon, Acropolis, Athens, Greece, with diagram of the sculptural program (after Andrew Stewart), 447–432 BCE. (page 127)

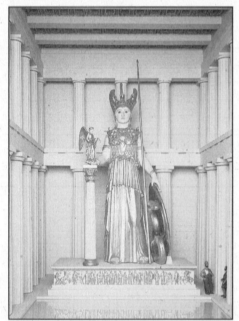

FIG. 05-46 PHIDIAS, *Athena Parthenos,* in the cella of the Parthenon, Acropolis, Athens, Greece, ca. 438 BCE. Model of the lost chryselephantine statue. Royal Ontario Museum, Toronto. (page 128)

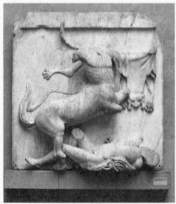

FIG. 05-47 Lapith versus centaur, metope from the south side of the Parthenon, Acropolis, Athens, Greece, ca. 447–438 BCE. Marble, 4′ 8″ high. British Museum, London. (page 128)

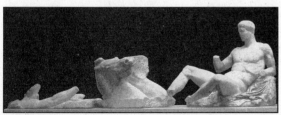

FIG. 05-48 Helios and his horses, and Dionysos (Herakles?), from the east pediment of the Parthenon, Acropolis, Athens, Greece, ca. 438–432 BCE. Marble, greatest height 4′ 3″. British Museum, London. (page 129)

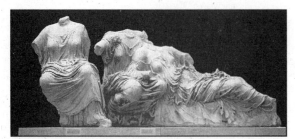

FIG. 05-49 Three goddesses (Hestia, Dione, and Aphrodite?), from the east pediment of the Parthenon, Acropolis, Athens, Greece, ca. 438–432 BCE. Marble, greatest height 4′ 5″. British Museum, London. (page 129)

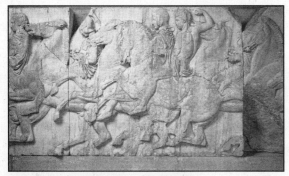

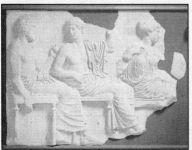

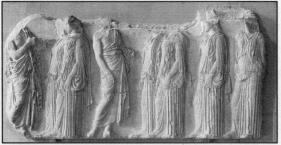

FIG. 05-50 Details of the Panathenaic Festival procession frieze, from the Parthenon, Acropolis, Athens, Greece, ca. 447–438 BCE. Marble, 3′ 6″ high. Horsemen of north frieze *(top)*, British Museum, London; seated gods and goddesses (Poseidon, Apollo, and Artemis) of east frieze *(center)*, Acropolis Museum, Athens; and elders and maidens of east frieze *(bottom)*, Louvre, Paris. (page 130)

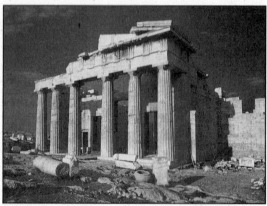

FIG. 05-51 MNESIKLES, Propylaia (looking southwest), Acropolis, Athens, Greece, 437–432 BCE. (page 131)

Lat.: 37°58′18.19″N Long.: 23°43′20.24″E

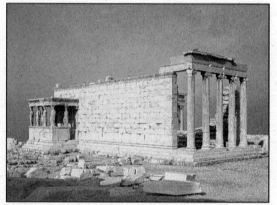

FIG. 05-52 Erechtheion (looking northwest), Acropolis, Athens, Greece, ca. 421–405 BCE. (page 131)

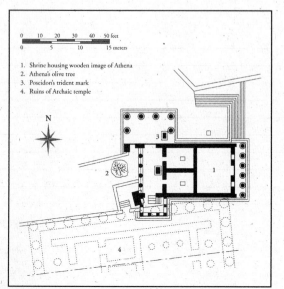

FIG. 05-53 Plan of the Erechtheion, Acropolis, Athens, Greece, ca. 421–405 BCE. (page 132)

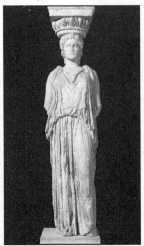

FIG. 05-54 Caryatid from the south porch of the Erechtheion, Acropolis, Athens, Greece, ca. 421–405 BCE. Marble, 7′ 7″ high. British Museum, London. (page 132)

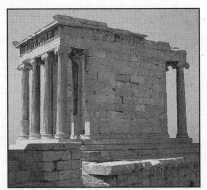

FIG. 05-55 KALLIKRATES, Temple of Athena Nike (looking southwest), Acropolis, Athens, Greece, ca. 427–424 BCE. (page 133)

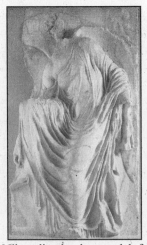

FIG. 05-56 Nike adjusting her sandal, from the south side of the parapet of the Temple of Athena Nike, Acropolis, Athens, Greece, ca. 410 BCE. Marble, 3′ 6″ high. Acropolis Museum, Athens. (page 133)

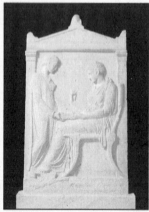

FIG. 05-57 Grave stele of Hegeso, from the Dipylon cemetery, Athens, Greece, ca. 400 BCE. Marble, 5′ 2″ high. National Archaeological Museum, Athens. (page 134)

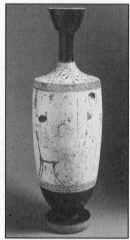

FIG. 05-58 ACHILLES PAINTER, Warrior taking leave of his wife (Athenian white-ground lekythos), from Eretria, Greece, ca. 440 BCE. 1′ 5″ high. National Archaeological Museum, Athens. (page 135)

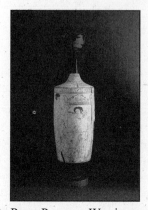

FIG. 05-58A REED PAINTER, Warrior seated at his tomb (Athenian white-ground lekythos), from Eretria, Greece, ca. 410–400 BCE. 1′ 7 1/4″ high. National Archaeological Museum, Athens. (page 134)

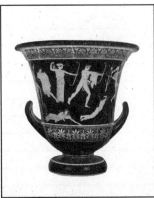

FIG. 05-59 NIOBID PAINTER, Artemis and Apollo slaying the children of Niobe (Athenian red-figure calyx krater), from Orvieto, Italy, ca. 450 BCE. 1′ 9″ high. Louvre, Paris. (page 135)

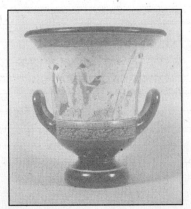

FIG. 05-60 PHIALE PAINTER, Hermes bringing the infant Dionysos to Papposilenos (Athenian white-ground calyx krater), from Vulci, Italy, ca. 440–435 BCE. 1′ 2″ high. Musei Vaticani, Rome. (page 136)

FIG. 05-61 Youth diving, painted ceiling of the Tomb of the Diver, Paestum, Italy, ca. 480 BCE. 3′ 4″ high. Museo Archeologico Nazionale, Paestum. (page 136)

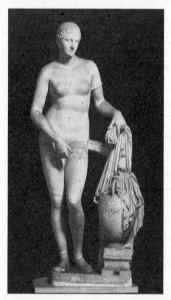

FIG. 05-62 Praxiteles, *Aphrodite of Knidos.*
Roman marble copy of an original of ca. 350–340 BCE.
6′ 8″ high. Musei Vaticani, Rome. (page 137)

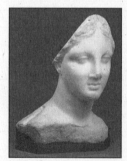

FIG. 05-62A Head of a woman, from Chios, Greece,
ca. 320–300 BCE. Marble, 1′ 2″ high. Museum of Fine
Arts, Boston. (page 137)

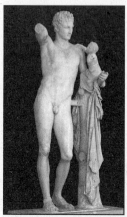

FIG. 05-63 Praxiteles(?), Hermes and the infant
Dionysos, from the Temple of Hera, Olympia,
Greece. Copy of a statue by Praxiteles of ca. 340 BCE
or an original work of ca. 330–270 BCE by a son or
grandson. Marble, 7′ 1″ high. Archaeological
Museum, Olympia. (page 138)

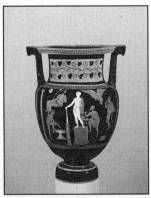

FIG. 05-63A Artist painting a marble statue of Herakles (Apulian red-figure column krater), ca. 350–320 BCE. 1′ 8 1/4″ high. Metropolitan Museum of Art, New York (Rogers Fund, 1950). (page 138)

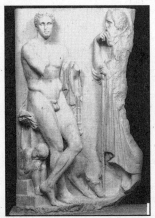

FIG. 05-64 Grave stele of a young hunter, found near the Ilissos River, Athens, Greece, ca. 340–330 BCE. Marble, 5′ 6″ high. National Archaeological Museum, Athens. (page 138)

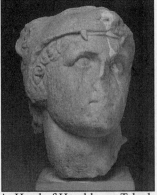

FIG. 05-64A Head of Herakles or Telephos, from the west pediment of the Temple of Athena Alea, Tegea, Greece, ca. 340 BCE. Marble, 1′ 1/2″ high. (Stolen from) Archaeological Museum, Tegea. (page 138)

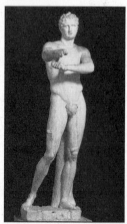

FIG. 05-65 LYSIPPOS, *Apoxyomenos (Scraper)*. Roman marble copy of a bronze original of ca. 330 BCE, 6′ 9″ high. Musei Vaticani, Rome. (page 139)

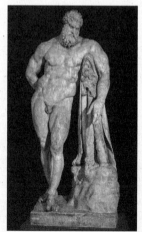

FIG. 05-66 LYSIPPOS, Weary Herakles *(Farnese Herakles)*. Roman marble copy from Rome, Italy, signed by GLYKON OF ATHENS, of a bronze original of ca. 320 BCE. 10′ 5″ high. Museo Archeologico Nazionale, Naples. (page 139)

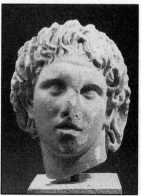

FIG. 05-67 Head of Alexander the Great, from Pella, Greece, third century BCE. Marble, 1′ high. Archaeological Museum, Pella. (page 140)

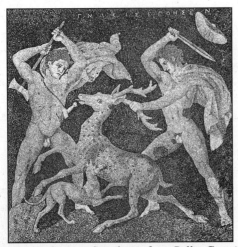

FIG. 05-68 GNOSIS, Stag hunt, from Pella, Greece, ca. 300 BCE. Pebble mosaic, figural panel 10′ 2″ high. Archaeological Museum, Pella. (page 140)

FIG. 05-69 Hades abducting Persephone, detail of a wall painting in tomb 1, Vergina, Greece, mid-fourth century BCE. 3′ 3 1/2″ high. (page 141)

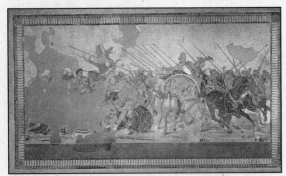

FIG. 05-70 PHILOXENOS OF ERETRIA, *Battle of Issus,* ca. 310 BCE. Roman copy *(Alexander Mosaic)* from the House of the Faun, Pompeii, Italy, late second or early first century BCE. Tessera mosaic, 8′ 10″ × 16′ 9″. Museo Archeologico Nazionale, Naples. (page 142)

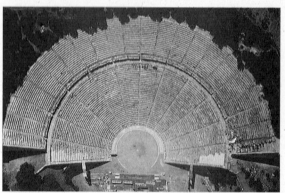

FIG. 05-71 POLYKLEITOS THE YOUNGER, Theater, Epidauros, Greece, ca. 350 BCE. (page 143)

Lat.: 37°38′32.95″N Long.: 23°8′45.69″E

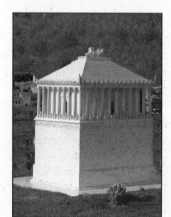

FIG. 05-71A Model of the tomb of Mausolos (Mausoleum), Halikarnassos, Turkey, ca. 353–340 BCE. Museum of Underwater Archaeology, Bodrum. (page 143)

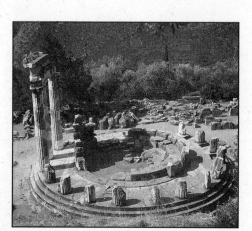

FIG. 05-72 THEODOROS OF PHOKAIA, Tholos, Delphi, Greece, ca. 375 BCE. (page 143)

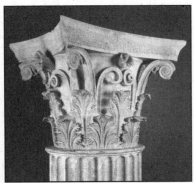

FIG. 05-73 POLYKLEITOS THE YOUNGER, Corinthian capital, from the tholos, Epidauros, Greece, ca. 350 BCE. Archaeological Museum, Epidauros. (page 144)

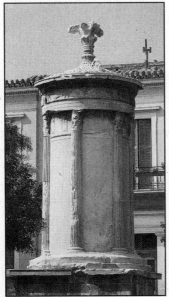

FIG. 05-74 Choragic Monument of Lysikrates, Athens, Greece, 334 BCE. (page 145)

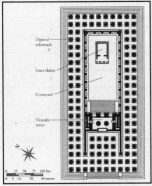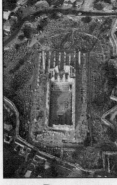

FIG. 05-75 PAIONIOS OF EPHESOS AND DAPHNIS OF MILETOS, Temple of Apollo, Didyma, Turkey, begun 313 BCE. Plan *(left)* and aerial view *(right)*. (page 145)

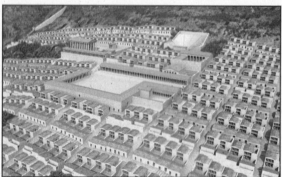

FIG. 05-76 Restored view of the city of Priene, Turkey, fourth century BCE and later (John Burge). (page 146)

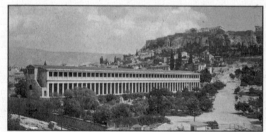

FIG. 05-77 Stoa of Attalos II, Agora, Athens, Greece, ca. 150 BCE (with the Acropolis in the background). (page 147)

Lat.: 37°58′30.59″N Long.: 23°43′27.84″E

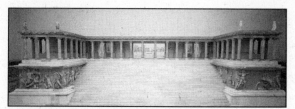

FIG. 05-78 Reconstructed west front of the Altar of Zeus, from Pergamon, Turkey, ca. 175 BCE. Staatliche Museen, Berlin. (page 147)

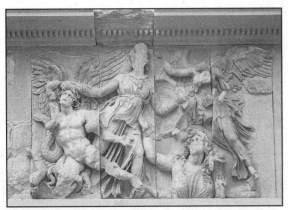

FIG. 05-79 Athena battling Alkyoneos, detail of the gigantomachy frieze, from the Altar of Zeus, Pergamon, Turkey, ca. 175 BCE. Marble, 7′ 6″ high. Staatliche Museen, Berlin. (page 148)

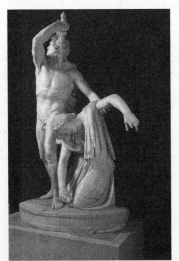

FIG. 05-80 EPIGONOS(?), Gallic chieftain killing himself and his wife. Roman marble copy of a bronze original of ca. 230–220 BCE, 6′ 11″ high. Museo Nazionale Romano—Palazzo Altemps, Rome. (page 148)

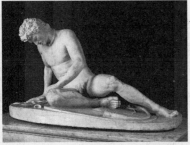

FIG. 05-81 EPIGONOS(?), Dying Gaul. Roman marble copy of a bronze original of ca. 230–220 BCE, 3′ 1/2″ high. Museo Capitolino, Rome. (page 149)

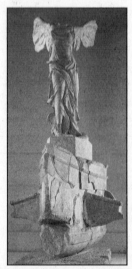

FIG. 05-82 Nike alighting on a warship *(Nike of Samothrace),* from Samothrace, Greece, ca. 190 BCE. Marble, figure 8′ 1″ high. Louvre, Paris. (page 149)

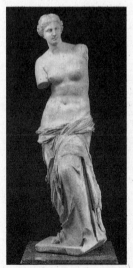

FIG. 05-83 ALEXANDROS OF ANTIOCH-ON-THE-MEANDER, Aphrodite *(Venus de Milo),* from Melos, Greece, ca. 150–125 BCE. Marble, 6′ 7″ high. Louvre, Paris. (page 150)

FIG. 05-83A Aphrodite, Eros, and Pan, from Delos, Greece, ca. 100 BCE. Marble, 4′ 4″ high. National Archaeological Museum, Athens. (page 150)

FIG. 05-84 Sleeping satyr *(Barberini Faun),* from Rome, Italy, ca. 230–200 BCE. Marble, 7′ 1″ high. Glyptothek, Munich. (page 150)

FIG. 05-84A Sleeping Eros, from Rhodes, ca. 150–100 BCE. Bronze, 2′ 9 1/2″ long. Metropolitan Museum of Art, New York (Rogers Fund, 1943). (page 151)

FIG. 05-85 Seated boxer, from Rome, Italy, ca. 100–50 BCE. Bronze, 4′ 2″ high. Museo Nazionale Romano–Palazzo Massimo alle Terme, Rome. (page 151)

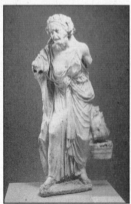

FIG. 05-86 Old market woman, ca. 150–100 BCE. Marble, 4′ 1/2″ high. Metropolitan Museum of Art, New York. (page 152)

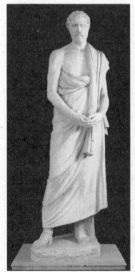

FIG. 05-87 POLYEUKTOS, Demosthenes. Roman marble copy of a bronze original of ca. 280 BCE. 6′ 7 1/2″ high. Ny Carlsberg Glyptotek, Copenhagen. (page 152)

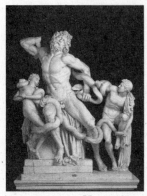

FIG. 05-88 ATHANADOROS, HAGESANDROS, and POLYDOROS OF RHODES, Laocoön and his sons, from Rome, Italy, early first century CE. Marble, 7′ 10 1/2″ high. Musei Vaticani, Rome. (page 153)

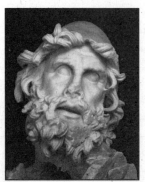

FIG. 05-89 ATHANADOROS, HAGESANDROS, and POLYDOROS OF RHODES, head of Odysseus, from Sperlonga, Italy, early first century CE. Marble, 2′ 1 1/4″ high. Museo Archeologico, Sperlonga. (page 154)

1. From what temple does the pediment group depicted in FIG. 5-31 come?

2. What features made the Parthenon (located at 37°58′17.34″N, 23°43′35.67″E) the ideal temple? In what ways does its form deviate from standard temple construction?

3. Identify and describe the Erechtheion's (FIG. 5-52) unusual features.

4. To what architectural order does the Temple of Hera II (FIG. 5-30) belong?

5. How was the Stoa of Attalos II (located at 37°58′30.59″N, 23°43′27.84″E) used?

6. Identify the structure located at 37°58′18.19″N, 23°43′30.24″E.

7. What term best describes the independent communities that comprised the ancient Greek world? (Use Google Earth coordinates, 39°42′3.43″N, 20°28′28.47″E to see the region, and zoom in and out to analyze the terrain.)

8. Discuss the remarkable qualities of the Temple of Hera I, located at 40°25′9.52″N, 15°0′19.79″E.

9. Identify the separate sections of the theater at Epidauros (located at 37°38′32.95″N, 23°8′45.69″E) and explain their use.

10. What was the centerpiece of Pericles' design for the Acropolis (37°58′17.38″N, 23°43′34.40″E)?

Chapter 6

South and Southeast Asia before 1200

Goals

- Understand the late Neolithic origins of Indian and Southeast Asian art and culture.
- Understand how the indigenous beliefs and the beginnings of Buddhism and Hinduism influenced the art and architecture.
- Identify hallmarks of architecture from Hindu and Buddhist monuments.
- Understand the artistic influence of Buddhism and Hinduism in Southeast Asia and the varying appearances of the human figure in art.
- Identify hallmarks of temple and monastic archiecture in Southeast Asia.
- Understand the role of the monarchs in Southeast Asia in the middle ages.

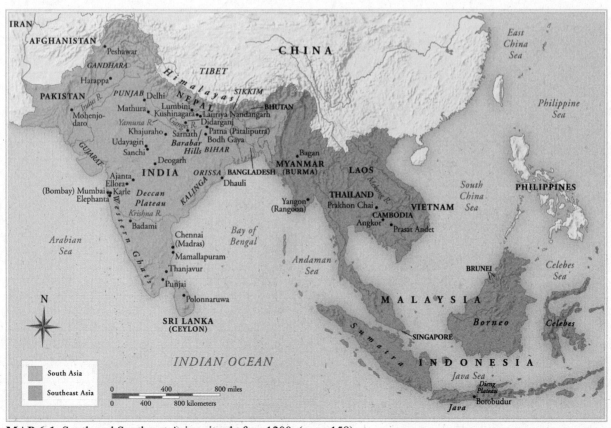

MAP 6-1 South and Southeast Asian sites before 1200. (page 158)

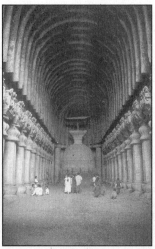

FIG. 06-01 Interior of the chaitya hall, Karle, India, ca. 50 CE. (page 156)

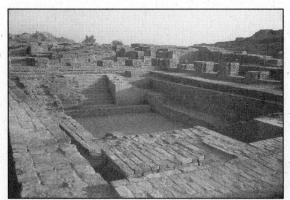

FIG. 06-02 Great Bath, Mohenjo-daro, Pakistan, ca. 2600–1900 BCE. (page 158)

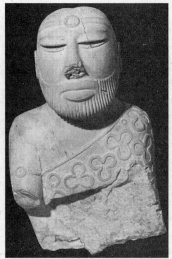

FIG. 06-03 Robed male figure, from Mohenjo-daro, Pakistan, ca. 2000–1900 BCE. Steatite, 6 7/8″ high. National Museum of Pakistan, Karachi. (page 159)

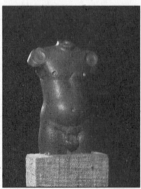

FIG. 06-04 Nude male torso, from Harappa, Pakistan, ca. 2000–1900 BCE. Red sandstone, 3 3/4″ high. National Museum, New Delhi. (page 159)

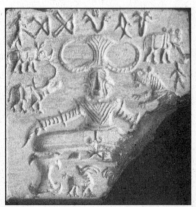

FIG. 06-05 Seal with seated figure in yogic posture, from Mohenjo-daro, Pakistan, ca. 2300–1750 BCE. Steatite coated with alkali and baked, 1 3/8″ × 1 3/8″. National Museum, New Delhi. (page 160)

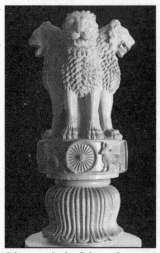

FIG. 06-06 Lion capital of the column erected by Ashoka at Sarnath, India, ca. 250 BCE. Polished sandstone, 7′ high. Archaeological Museum, Sarnath. (page 162)

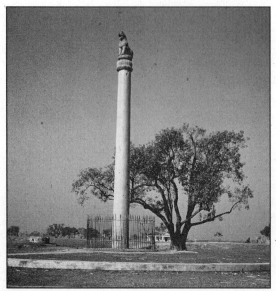

FIG. 06-06A Lion pillar, Lauriya Nandangarh, India, ca. 245 BCE. (page 161)

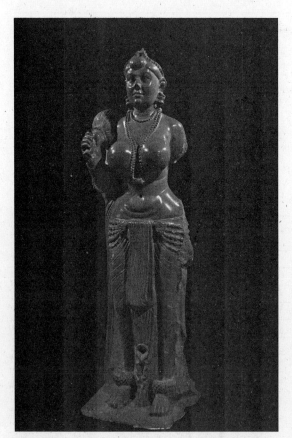

FIG. 06-06B Yakshi holding a fly whisk, from Didarganj, India, mid-third century BCE. Polished sandstone, 5′ 4 1/4″ high. Patna Museum, Patna. (page 162)

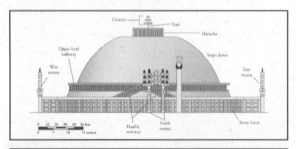

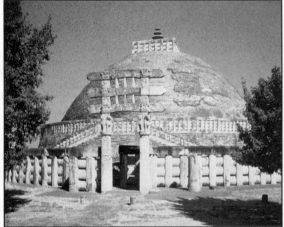

Lat.: 23°28′46.07″N Long.: 77°44′22.76″E

FIG. 06-07 Diagram *(top)* and view from the south *(bottom)* of the Great Stupa, Sanchi, India, third century BCE to first century CE. (page 159)

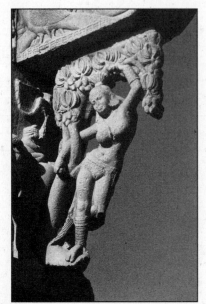

FIG. 06-08 Yakshi, detail of the east torana, Great Stupa, Sanchi, India, mid-first century BCE to early first century CE. Sandstone, 5′ high. (page 164)

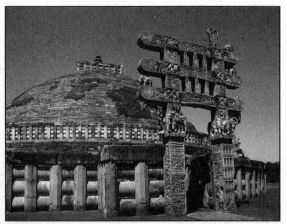

FIG. 06-08A East torana of the Great Stupa, Sanchi, India, mid-first century BCE to early first century CE. Sandstone, 34′ high. (page 164)

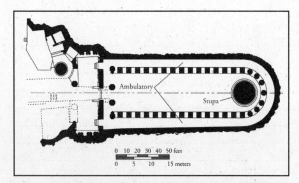

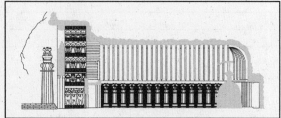

FIG. 06-09 Plan *(top)* and section *(bottom)* of the chaitya hall (FIG. 6-1), Karle, India, ca. 50 CE. (page 164)

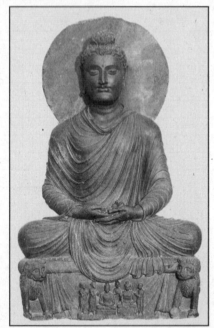

FIG. 06-10 Meditating Buddha, from Gandhara, Pakistan, second century CE. Gray schist, 3′ 7 1/2″ high. National Museums of Scotland, Edinburgh. (page 165)

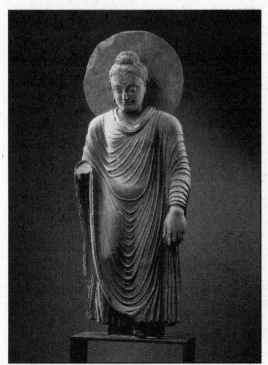

FIG. 06-10A Standing Buddha, from Gandhara, Pakistan, second to third century CE. Gray schist, 3′ 3″ high. Museum für Asiatische Kunst, Staatliche Museen zu Berlin, Berlin. (page 164)

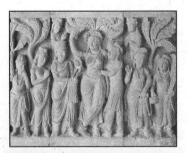

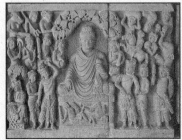

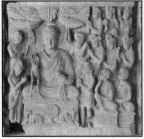
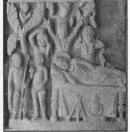

FIG. 06-11 The life and death of the Buddha, frieze from Gandhara, Pakistan, second century CE. Schist, 2′ 2 3/8″ × 9′ 6 1/8″. Freer Gallery of Art, Washington, D.C. (a) birth at Lumbini, (b) enlightenment at Bodh Gaya, (c) first sermon at Sarnath, (d) death at Kushinagara. (page 165)

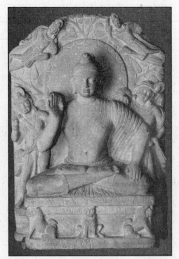

FIG. 06-12 Buddha seated on lion throne, from Mathura, India, second century CE. Red sandstone, 2′ 3 1/2″ high. Archaeological Museum, Muttra. (page 166)

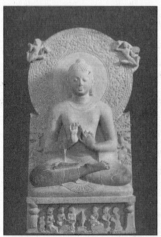

FIG. 06-13 Seated Buddha preaching first sermon, from Sarnath, India, second half of fifth century. Tan sandstone, 5′ 3″ high. Archaeological Museum, Sarnath. (page 166)

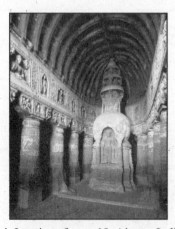

FIG. 06-14 Interior of cave 19, Ajanta, India, second half of fifth century. (page 167)

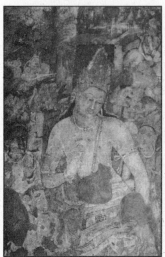

FIG. 06-15 Bodhisattva Padmapani, detail of a wall painting in cave 1, Ajanta, India, second half of fifth century. (page 167)

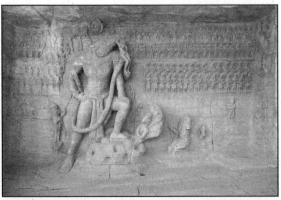

FIG. 06-16 Boar avatar of Vishnu rescuing the earth, cave 5, Udayagiri, India, early fifth century. Relief 13′ × 22′; Vishnu 12′ 8″ high. (page 168)

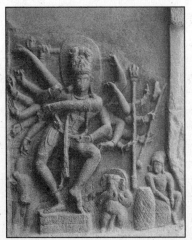

FIG. 06-17 Dancing Shiva, rock-cut relief in cave temple, Badami, India, late sixth century. (page 169)

Lat.: 15°55′5.27″N Long.: 75°41′5.38″E

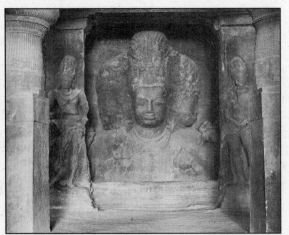

FIG. 06-18 Shiva as Mahadeva, cave 1, Elephanta, India, ca. 550–575. Basalt, Shiva 17′ 10″ high. (page 169)

Lat.: 18°57′40.18″N Long.: 72°56′6.73″E

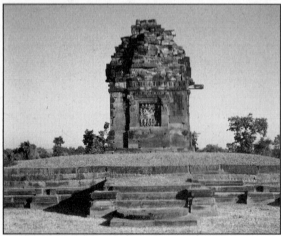

FIG. 06-19 Vishnu Temple (looking north), Deogarh, India, early sixth century. (page 170)

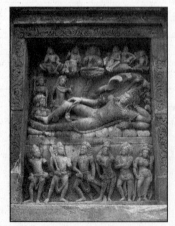

FIG. 06-20 Vishnu asleep on the serpent Ananta, relief panel on the south facade of the Vishnu Temple, Deogarh, India, early sixth century. (page 170)

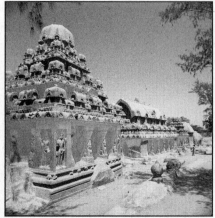

FIG. 06-21 Rock-cut rathas, Mamallapuram, India, second half of seventh century. From *left to right:* Dharmaraja, Bhima, Arjuna, and Draupadi rathas. (page 171)

Lat.: 12°36′31.84″N Long.: 80°11′23.06″E

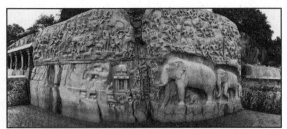

FIG. 06-21A Descent of the Ganges River (or Penance of Arjuna), rock-cut relief, Mamallapuram, India, first half of seventh century CE. Granite, 20′ high. (page 171)

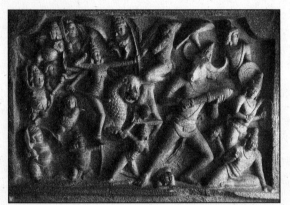

FIG. 06-21B Durga slaying the buffalo demon Manisha, rock-cut relief in the Mahishasuramardini cave, Mamallapuram, India, seventh century CE. Granite, 9′ high. (page 171)

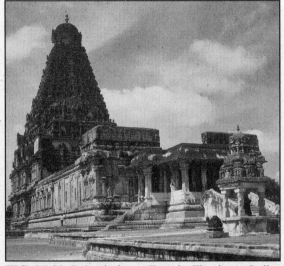

FIG. 06-22 Rajarajeshvara Temple, Thanjavur, India, ca. 1010. (page 172)

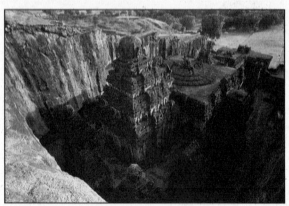

FIG. 06-22A Kailasanatha Temple (looking southwest), Ellora, India, second half of eighth century CE. (page 171)

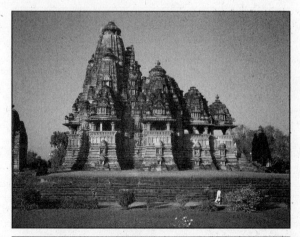

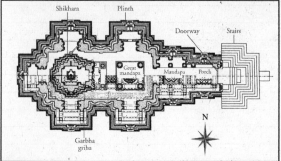

FIG. 06-23 Vishvanatha Temple (view looking north, and plan, _below_), Khajuraho, India, ca. 1000. (page 172)

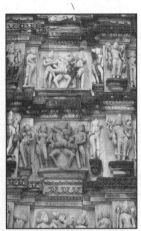

FIG. 06-24 Mithuna reliefs, detail of the north side of the Vishvanatha Temple, Khajuraho, India, ca. 1000. (page 173)

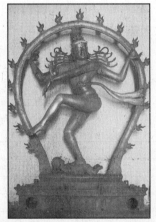

FIG. 06-25 Shiva as Nataraja, ca. 1000. Bronze. Naltunai Ishvaram Temple, Punjai. (page 173)

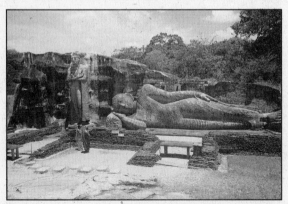

FIG. 06-26 Death of the Buddha (Parinirvana), Gal Vihara, near Polonnaruwa, Sri Lanka, 11th to 12th century. Granulite, Buddha 46′ long × 10′ high. (page 174)

Lat.: 7°55′58.29″N Long.: 81°0′29.11″E

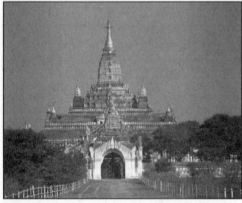

FIG. 06-26A Ananda Temple, Bagan, Myanmar, begun 1091. (page 174)

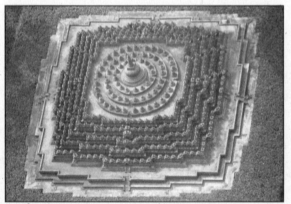

FIG. 06-27 Aerial view of Borobudur, Java, Indonesia, ca. 800. (page 175)

Lat.: 7°36′28.47″N Long.: 110°12′15.32″E

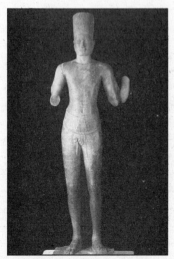

FIG. 06-28 Harihara, from Prasat Andet, Cambodia, early seventh century. Stone, 6′ 3″ high. National Museum, Phnom Penh. (page 175)

113

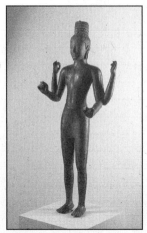

FIG. 06-28A Bodhisattva Maitreya, from Prakhon Chai, Thailand, eighth to ninth century CE. Bronze, 4′ 1/4″ high. Kimbell Art Museum, Fort Worth. (page 175)

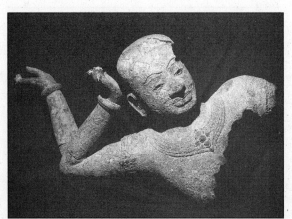

FIG. 06-29 Vishnu lying on the cosmic ocean, from the Mebon temple on an island in the western baray, Angkor, Cambodia, 11th century. Bronze, 8′ long. (page 176)

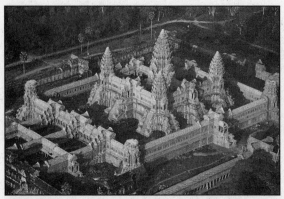

FIG. 06-30 Aerial view of Angkor Wat, Angkor, Cambodia, first half of 12th century. (page 177)

Lat.: 13°24′44.56″N Long.: 103°52′0.32″E

FIG. 06-31 King Suryavarman II holding court, detail of a stone relief, lowest gallery, south side, Angkor Wat, Angkor, Cambodia, first half of 12th century. (page 177)

Lat.: 13°24′44.56″N Long.: 103°52′0.32″E

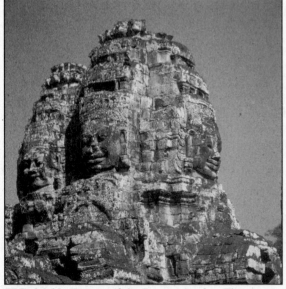

FIG. 06-32 Towers of the Bayon, Angkor Thom, Cambodia, ca. 1200. (page 178)

Lat.: 13°26′28.33″N Long.: 103°51′31.93″E

1. Describe the unique features of the Borobudur monument located at 7°36′28.47″S, 110°12′15.32″E.

2. Describe the terrain and location of the temple in which the Dancing Shiva located at 15°55′5.27″N, 75°41′5.38″E was carved.

3. Interpret the imagery and symbolism employed in the portable bronze sculpture of Shiva from the Naltunai Ishvaram Temple (FIG. 6-25).

4. What do the faces on the towers of the Bayon at Angkor Thom (13°26′28.33″N, 103°51′31.93″E) represent?

5. Discuss the structural elements of the Great Stupa (located at 23°28′46.07″N, 77°44′22.76″E). How do the purpose of this monument and the ways in which it is used dictate its form?

6. Consider the relief depicting King Suryavarman II (FIG. 6-31) found at Angkor Wat (located at 13°24′44.56″N, 103°52′0.32″E). How does this particular depiction along with other reliefs found at Angkor Wat relate to the function of this monument?

7. What type of monument is located at 12°36′31.84″N, 80°11′23.06″E in Mamallapuram, India?

8. What influence does the Parinirvana sculpture near Polonnaruwa, Sri Lanka (FIG. 6-26, located at 7°55′58.29″N, 81°0′29.11″E) exhibit?

9. Describe the location of the Shiva sculpture found in Cave 1 at 18°57'40.18"N, 72°56'6.73"E (FIG. 6-18) and discuss how its placement at the site expands the viewer's understanding of what it represents.

10. Compare and contrast the Rajarajeshvara Temple in Thanjavur (FIG. 6-22) with the Vishvanatha Temple in Khajuraho (FIG. 6-23). What architectural types do these two temples represent? Discuss the distinguishing characteristics of each type.

11. Explore Angkor Wat (located at 13°24'44.56"N, 103°52'0.32"E). What elements make this monument a distinctive Khmer temple?

Chapter 7

China and Korea to 1279

Goals

- Explore the broad geographic area encompassed by contemporary China and Korea.
- Examine the Neolithic and early dynastic beginnings of Chinese civilization and art.
- Understand the indigenous religious beliefs, early Daoism and Confucianism, and the later influence of Buddhism on art in China and Korea.
- Describe materials, techniques and stylistic qualities of Chinese and Korean art and architecture.
- Understand the changes in art related to the Silk Road and other eastern and western trade and conquests.
- Understand the artistic and cultural development of Korea apart from China.

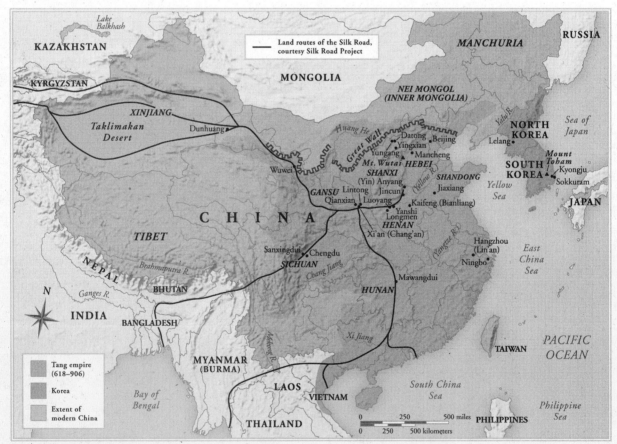

Map 7-1 China during the Tang dynasty. (page 182)

FIG. 07-01 Fan Kuan, *Travelers among Mountains and Streams,* Northern Song period, early 11th century. Hanging scroll, ink and colors on silk, 6′ 7 1/4″ × 3′ 4 1/4″. National Palace Museum, Talbei. (page 180)

FIG. 07-02 Yanshao Culture vases, from Gansu Province, China, mid-third millennium BCE. (page 182)

FIG. 07-03 Guang, probably from Anyang, China, Shang dynasty, 12th or 11th century BCE. Bronze, 6 1/2″ high. Asian Art Museum of San Francisco, San Francisco (Avery Brundage Collection). (page 183)

FIG. 07-04 Standing male figure, from pit 2, Sanxingdui, China, ca.1200–1050 BCE. Bronze, 8′ 5″ high, including base. Museum, Sanxingdui. (page 184)

FIG. 07-05 Bi disk with dragons, from Jincun(?), near Luoyang, China, Eastern Zhou dynasty, fourth to third century BCE. Nephrite, 6 1/2″ in diameter. Nelson-Atkins Museum of Art, Kansas City. (page 185)

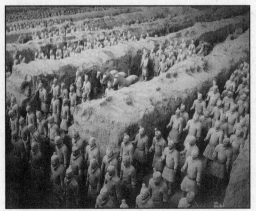

FIG. 07-06 Army of the First Emperor of Qin in pits next to his burial mound, Lintong, China, Qin dynasty, ca. 210 BCE. Painted terracotta, average figure 5′ 10 7/8″ high. (page 186)

Lat.: 34°22′54.60″N Long.: 109°15′15.15″E

FIG. 07-07 Funeral banner, from tomb 1 (tomb of the Marquise of Dai), Mawangdui, China, Han dynasty, ca. 168 BCE. Painted silk, 6′ 8 3/4″ × 3′ 1/4″. Hunan Provincial Museum, Changsha. (page 187)

FIG. 07-07A Incense burner (boshan), from the tomb of Prince Liu Sheng, Mancheng, China, Han dynasty, ca. 113 BCE. Bronze with gold inlay, 10 3/8″ high. Hebei Provincial Museum, Shijiazhuang. (page 187)

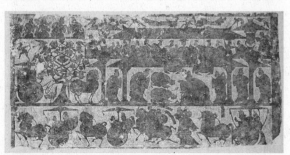

FIG. 07-08 The archer Yi(?) and a reception in a mansion, Wu family shrine, Jiaxiang, China, Han dynasty, 147–168 CE. Rubbing of a stone relief, 3′ × 5′. (page 187)

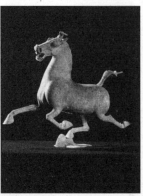

FIG. 07-08A Flying horse, from the tomb of Governor-General Zhang, Wuwei, China, Han dynasty, late second century CE. Bronze, 1′ 1 1/2″ high. Gansu Provincial Museum, Lanzhou. (page 188)

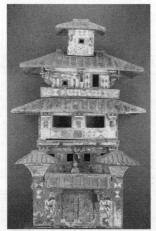

FIG. 07-09 Model of a house, Han dynasty, first century CE. Painted earthenware, 4′ 4″ high. Nelson-Atkins Museum of Art, Kansas City. (page 189)

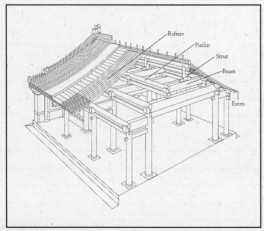

FIG. 07-10 Chinese raised-beam construction (after L. Lui). (page 189)

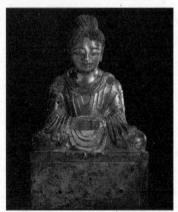

FIG. 07-11 Shakyamuni Buddha, from Hebei Province, Later Zhao dynasty, Period of Disunity, 338. Gilded bronze, 1′ 3 1/2″ high. Asian Art Museum of San Francisco, San Francisco (Avery Brundage Collection). (page 190)

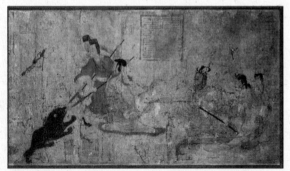

FIG. 07-12 Gu Kaizhi, *Lady Feng and the Bear,* detail of *Admonitions of the Instructress to the Court Ladies,* Period of Disunity, late fourth century. Handscroll, ink and colors on silk, entire scroll 9.3/4″ × 11′ 4 1/2″. British Museum, London. (page 191)

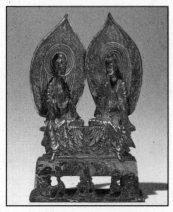

FIG. 07-13 Shakyamuni and Prabhutaratna, from Hebei Province, Northern Wei dynasty, 518. Gilded bronze, 10 1/4″ high. Musée Guimet, Paris. (page 192)

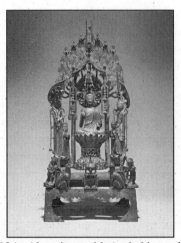

FIG. 07-13A Altarpiece with Amitabha and attendants, from Xian(?), China, Sui dynasty, 593 CE. Gilt bronze, 2′ 6 1/8″ high. Museum of Fine Arts, Boston (gift of Mrs. W. Scott Fitz and Edward Jackson Holmes, 1922). (page 192)

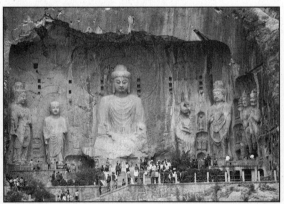

FIG. 07-14 Vairocana Buddha, disciples, and bodhisattvas, Fengxian Temple, Longmen Caves, Luoyang, China, Tang dynasty, completed 676. Limestone, Buddha 44′ high. (page 193)

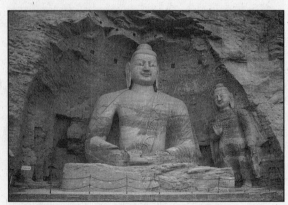

FIG. 07-14A Seated Buddha and standing bodhisattva, Cave 20, Yungang Grottoes, Datong, China, Northern Wei dynasty, ca. 460–470 CE. Sandstone, 45′ high. (page 192)

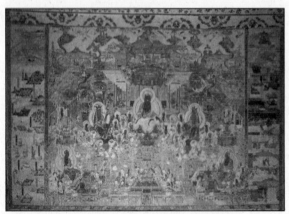

FIG. 07-15 *Paradise of Amitabha,* cave 172, Dunhuang, China, Tang dynasty, mid-eighth century. Wall painting 10′ high. (page 193)

FIG. 07-15A Bodhisattva Guanyin as the Guide of Souls, hanging scroll from Cave 17, Dunhuang, China, Tang dynasty, late 9th or early 10th century. Ink and colors on silk, 2′ 7 1/2″. British Museum, London. (page 193)

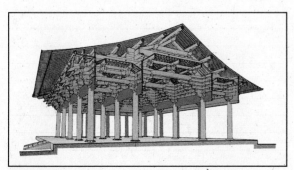

FIG. 07-16 Schematic cross-section and perspective drawing of east main hall, Foguang Si (Buddha Radiance Temple), Mount Wutai, China, Tang dynasty, ca. 857 (after L. Liu). (page 194)

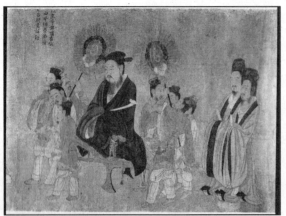

FIG. 07-17 Attributed to YAN LIBEN, *Emperor Xuan and Attendants,* detail of *The Thirteen Emperors,* Tang dynasty, ca. 650. Handscroll, ink and colors on silk, detail 1′ 8 1/4″ × 1′ 5 1/2″; entire scroll 17′ 5″ long. Museum of Fine Arts, Boston. (page 194)

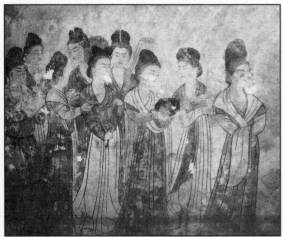

FIG. 07-18 Palace ladies, detail of a wall painting, tomb of Princess Yongtai, Qianxian, China, Tang dynasty, 706. Detail 5′ 10″ high. (page 195)

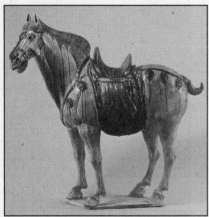

FIG. 07-19 Neighing horse, Tang dynasty, eighth to ninth century. Glazed earthenware, 1′ 8″ high. Victoria & Albert Museum, London. (page196)

FIG. 07-20 FAN KUAN, detail of *Travelers among Mountains and Streams* (FIG. 7-1), Northern Song period, early 11th century. Hanging scroll, ink and colors on silk, entire scroll 6′ 7 1/4″ × 3′ 4 1/4″; detail 2′ 10 1/4″ high. National Palace Museum, Taibei. (page 196)

FIG. 07-21 Attributed to HUIZONG, *Auspicious Cranes,* Northern Song period, 1112. Section of a handscroll, ink and colors on silk, 1′ 8 1/8″ × 4′ 6 3/8″. Liaoning Provincial Museum, Shenyang. (page 198)

FIG. 07-22 Meiping vase, from Xiuwi, China, Northern Song period, 12th century. Stoneware, Cizhou type, with sgraffito decoration, 1′ 7 1/2″ high. Asian Art Museum of San Francisco, San Francisco (Avery Brundage Collection). (page 198)

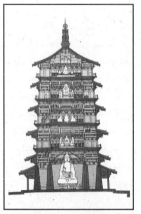

FIG. 07-23 View *(left)* and cross-section *(right;* after L. Liu) of Foguang Si Pagoda, Yingxian, China, Liao dynasty, 1056. (page 199)

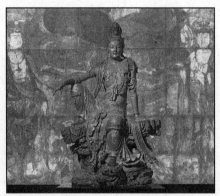

FIG. 07-23A Bodhisattva Guanyin seated on Potalaka, from Shanxi province, China, Liao dynasty, 11th or early 12th century. Painted wood, 7′ 11″ high. Nelson-Atkins Museum of Art, Kansas City. (page 199)

FIG. 07-24 MA YUAN, *On a Mountain Path in Spring,* Southern Song period, early 13th century. Album leaf, ink and colors on silk, 10 3/4″ × 17″. National Palace Museum, Taibei. (page 200)

FIG. 07-24A XIA GUI, four views from Twelve Views from A Thatched Hut, Southern Song dynasty, ca. 1200–1225. Handscroll, ink on silk, 11″ high. Nelson-Atkins Museum of Art, Kansas City. (page 200)

FIG. 07-25 LIANG KAI, *Sixth Chan Patriarch Chopping Bamboo,* Southern Song period, early 13th century. Hanging scroll, ink on paper, 2′ 5 1/4″ high. Tokyo National Museum, Tokyo. (page 201)

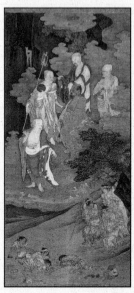

FIG. 07-26 ZHOU JICHANG, *Lohans Giving Alms to Beggars,* Southern Song period, ca. 1178. Hanging scroll, ink and colors on silk, 3′ 7 7/8″ × 1′ 8 7/8″. Museum of Fine Arts, Boston. (page 202)

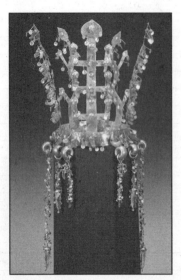

FIG. 07-27 Crown, from north mound of tomb 98, Hwangnamdong, near Kyongju, Korea, Three Kingdoms period, fifth to sixth century. Gold and jade, 10 3/4″ high. Kyongju National Museum, Kyongju. (page 203)

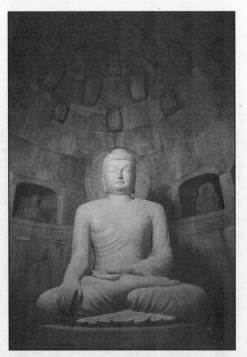

FIG. 07-28 Shakyamuni Buddha, in the rotunda of the cave temple, Sokkuram, Korea, Unified Silla Kingdom, 751–774. Granite, 11′ high. (page 204)

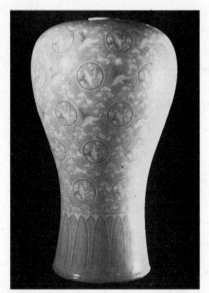

FIG. 07-29 Maebyong vase, Koryo dynasty, ca. 918–1000. Celadon with inlaid decoration, 1′ 4 1/2″ tall. Kansong Art Museum, Seoul. (page 204)

1. What kind of Buddha is represented at the the Longmen Caves in Luoyang, China (FIG. 7-14)?

2. Interpret the iconography and consider the arrangement of forms on the painted silk funeral banner from the tomb of Dai depicted in FIG. 7-7.

3. Discuss the location of the terracotta army (FIG. 7-6) and consider why these figures were buried at 34°22′54.60″N, 109°15′15.15″E?

4. Identify the materials used to create the crown depicted in FIG. 7-27. Where might the technique of working such materials have come?

5. Describe the scene depicted in FIG. 7-12 from the Admonitions of the Instructress to the Court Ladies handscroll. What Confucian principles does it represent?

6. Identify the material and describe the technique by which the Tang dynasty Neighing Horse (FIG. 7-19) was made?

7. What distinguishes the Foguang Si Pagoda (FIG. 7-23)?

8. From what material was this Shakyamuni Buddha (FIG. 7-11) made? What notion does this material communicate?

9. Describe and explain the remarkable features of the wall painting, Paradise of Amitabha (FIG. 7-15).

10. Compare and contrast the Shakyamuni Buddha (FIG. 7-28) in the cave temple at Sokkuram, the Vairocana Buddha (FIG. 7-14) at the Longmen Caves and the Parinirvana Buddha (FIG. 6-26) of Sri Lanka. Consider and explain each representation of the Buddha. How were these figures constructed?

Chapter 8

Japan Before 1333

Goals

- Examine early Japanese visual arts indigenous to Japan and influenced by China and Korea.
- Explore Shinto pre-Buddhist beliefs and related architecture.
- Understand the arrival and development of Buddhism and its influence on architecture and art.
- Evaluate the forms of Japanese temple construction.
- Understand the forms and styles of Japanese court art.
- Examine the political, social and religious art of the Kamakura period.

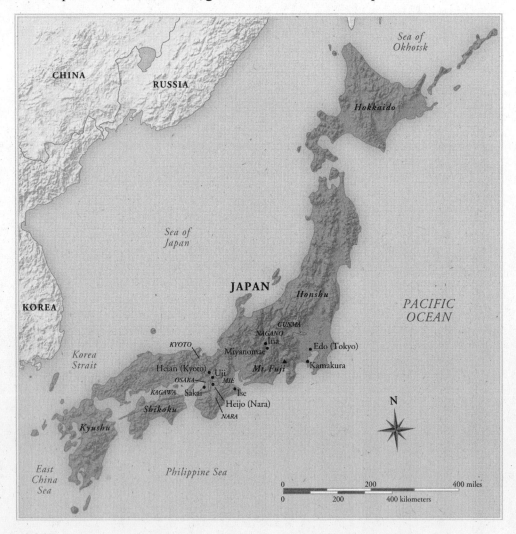

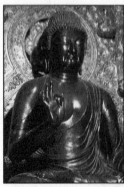

FIG. 08-01 Detail of Yakushi, Yakushi triad (FIG. 8-8), kondo, Yakushiji, Nara Prefecture, Japan, Nara period, late seventh or early eighth centurty CE. Bronze, detail 3′ 10″ high. (page 206)

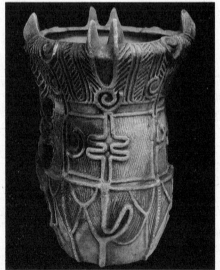

FIG. 08-02 Vessel, from Miyanomae, Nagano Prefecture, Japan, Middle Jomon period, 2500–1500 BCE. Earthenware, 1′ 11 2/3″ high. Tokyo National Museum, Tokyo. (page 208)

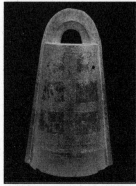

FIG. 08-03 Dotaku with incised figural motifs, from Kagawa Prefecture, Japan, late Yayoi period, 100–300 CE. Bronze, 1′ 4 7/8″ high. Tokyo National Museum, Tokyo. (page 209)

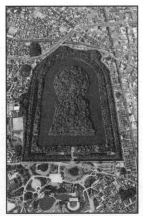

FIG. 08-04 Tomb of Emperor Nintoku, Sakai, Osaka Prefecture, Japan, Kofun period, late fourth to early fifth century. (page 209)

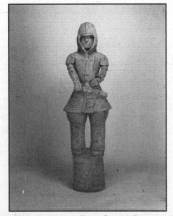

FIG. 08-05 Haniwa warrior, from Gunma Prefecture, Japan, Kofun period, fifth to mid-sixth century. Low-fired clay, 4′ 3 1/4″ high. Tokyo National Museum, Tokyo. (page 210)

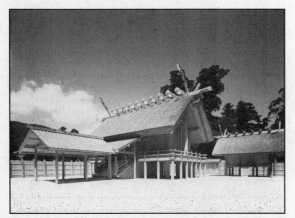

FIG. 08-06 Main hall, Amaterasu shrine, Ise, Mie Prefecture, Japan, Kofun period or later; rebuilt in 1993. (page 211)

Lat.: 34°27′17.57″N Long.: 136°43′33.34″E

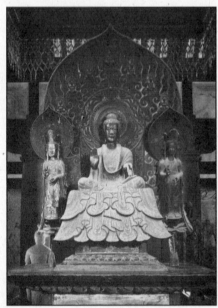

FIG. 08-07 Tori Busshi, Shaka triad, kondo, Horyuji, Nara Prefecture, Japan, Asuka period, 623. Bronze, central figure 5′ 9 1/2″ high. (page 212)

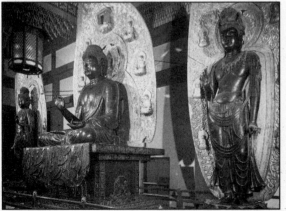

FIG. 08-08 Yakushi triad, kondo, Yakushiji, Nara Prefecture, Japan, Nara period, late seventh or early eighth century. Bronze, central figure 8′ 4″ high, including base and mandorla. (page 213)

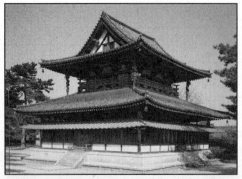

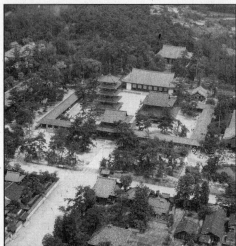

FIG. 08-09 Kondo *(top)* and aerial view of the temple complex *(bottom),* Horyuji, Nara Prefecture, Japan, Nara period, ca. 680. (page 213)

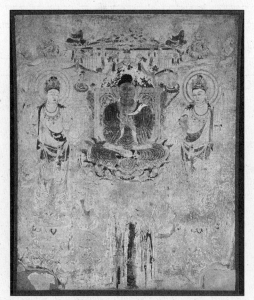

FIG. 08-10 Amida triad, wall painting formerly in the kondo, Horyuji, Nara Prefecture, Japan, Nara period, ca. 710. Ink and colors, 10′ 3″ × 8′ 6″. Horyuji Treasure House, Nara (page 214)

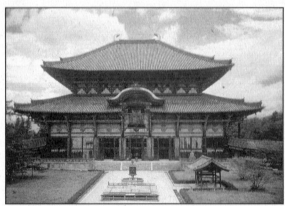

FIG. 08-11 Daibutsuden, Todaiji, Nara, Japan, Nara period, 743; rebuilt ca. 1700. (page 214)

Lat.: 34°41′19.76″N Long.: 135°50′24.56″E

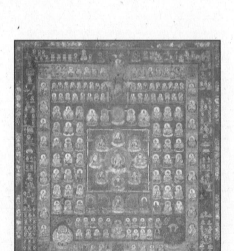

FIG. 08-12 Taizokai (Womb World) mandara, Kyoogokokuji (Toji), Kyoto, Japan, Heian period, second half of ninth century. Hanging scroll, color on silk, 6′ × 5′ 5/8″. (page 215)

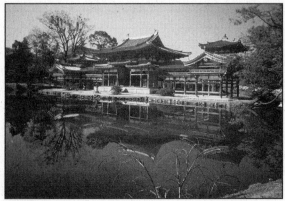

FIG. 08-13 Phoenix Hall, Byodoin, Uji, Kyoto Prefecture, Japan, Heian period, 1053. (page 215)

Lat.: 34°53′21.69″N Long.: 135°48′28.17″E

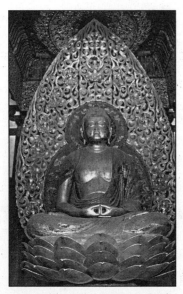

FIG. 08-13A Jocho, Seated Amida, Heian period, 1053. Gilded and lacquered wood, 9′ 8″ high. Phoenix Hall, Byodoin, Uji. (page 216)

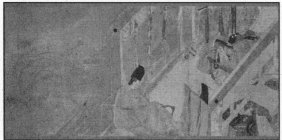

FIG. 08-14 *Genji Visits Murasaki,* from the Minori chapter, *Tale of Genji,* Heian period, first half of 12th century. Handscroll, ink and color on paper, 8 5/8″ high. Goto Art Museum, Tokyo. (page 217)

FIG. 08-14A Fujiwara No Sadanobu, album leaf, from the Ishiyama-gire, Heian period, early 12th century. Ink with gold and silver on decorated paper collage, 8″ X 6 3/8″. Freer Gallery of Art, Smithsonian Institution, Washington, D.C. (page 216)

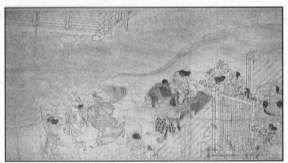

FIG. 08-15 The flying storehouse, from *Legends of Mount Shigi,* Heian period, late 12th century. Handscroll, ink and colors on paper, 1′ 1/2″ high. Chogosonshiji, Nara. (page 218)

Lat.: 34°53′21.69″N Long.: 135°48′28.17″E

FIG. 08-16 Portrait statue of the priest Shunjobo Chogen, Todaiji, Nara, Japan, Kamakura period, early 13th century. Painted cypress wood, statue 2′ 8 3/8″ high; detail 1′ 9″ high. (page 219)

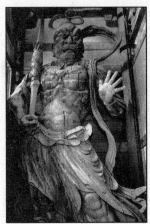

FIG. 08-16A Unkei, Agyo, Kamakura period, 1203. Painted wood, 27′ 5″ high. Nandaimon, Todaiji, Nara. (page 218)

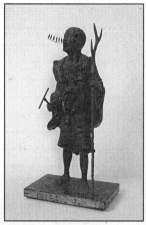

FIG. 08-16B KOSHO, *Portrait statue of the priest Kuya preaching,* Kamakura period, early 13th century. Painted wood with inlaid eyes, 3′ 10 1/4″ high. Rokuharamitsuji, Kyoto.

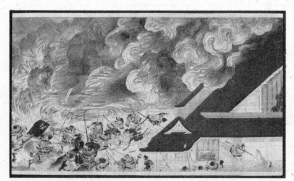

FIG. 08-17 *Night Attack on the Sanjo Palace,* from *Events of the Heiji Period,* Kamakura period, 13th century. Handscroll, ink and colors on paper, 1′ 4 1/4″ high; complete scroll 22′ 10″ long. Museum of Fine Arts, Boston (Fenollosa-Weld Collection). (page 220)

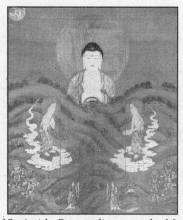

FIG. 08-18 *Amida Descending over the Mountains,* Kamakura period, 13th century. Hanging scroll, ink and colors on silk, 4′ 3 1/8″ × 3′ 10 1/2″. Zenrinji, Kyoto. (page 220)

1. How were images of Amida, such as the example depicted in FIG. 8-18, used by Pure Land Buddhists? Explain the symbolism and imagery employed in this particular work.

2. How does the composition of the The Burning of the Sanjo Palace handscroll scene (FIG. 8-17) extend the viewer's experience of the narrative?

3. Describe the monument located at 34°33′49.47″N, 135°29′16.00″E. What type of structure is it, and what earlier practices and influences are apparent in its form?

4. What kind of illustration is the Taizokai of Ryokai Mandara (FIG. 8-12)? Describe its composition and explain what it represents.

5. Explain the relationship between the architectural for of the Phoenix Hall of the Byodoin (located at 34°53′21.69″N, 135°48′28.17″E) with the depiction of the Buddha's palace in his Pure Land from the Paradise of Amitabha wall painting (FIG. 7-15).

6. Compare and contrast the Buddha triads in the Horyuji kondo (FIG. 8-7) and in the Yakushiji kondo (FIG. 8-8). What do these works depict, and what influences does each exhibit?

7. How do the location, use and ritual construction of the shrine located at 34°27′17.57″N, 136°43′33.34″E (FIG. 8-6) reflect the Shinto beliefs and practices?

8. Explain the function and style of the warrior figure depicted in FIG. 8-5. What type of Japanese sculpture is it?

9. Why was the construction of Todaiji (FIG. 8-11), its Great Buddha and its temple, located at 34°41′19.76″N, 135°50′24.56″E, so historically important?

10. From what material was the figure of the priest Shunjobo Chogen (FIG. 8-16) made? Describe the distinguishing features of this work.

Chapter 9

The Etruscans

Goals

- Identify the geographic area of the Etruscan people.
- Examine the possible origins of Etruscan art and culture.
- Understand how and why the architecture and art of the Etruscans is different from that of the Greeks.
- Understand the funerary customs of the Etruscans.

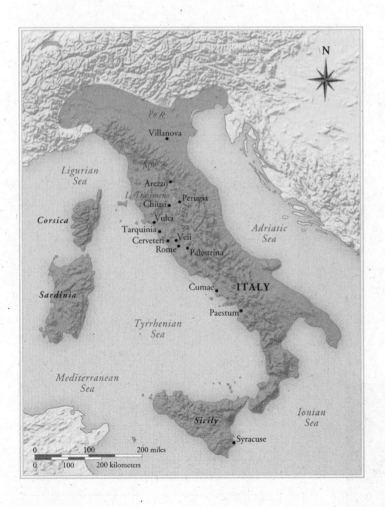

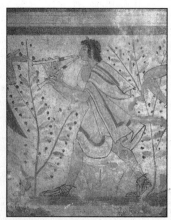

FIG. 09-01 Double-flute player, detail of a mural painting in the Tomb of the Leopards, Tarquinia, Italy, ca. 480–470 BCE. Detail 3′ 3 1/2″ high. (page 222)

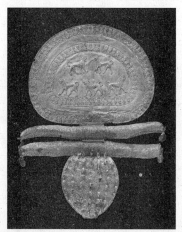

FIG. 09-02 Fibula with Orientalizing lions, from the Regolini-Galassi Tomb, Cerveteri, Italy, ca. 650–640 BCE. Gold, 1′ 1/2″ high. Musei Vaticani, Rome. (page 224)

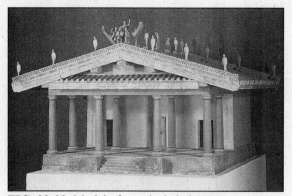

FIG. 09-03 Model of a typical sixth-century BCE Etruscan temple as described by Vitruvius. Istituto di Etruscologia e di Antichità Italiche, Università di Roma, Rome. (page 225)

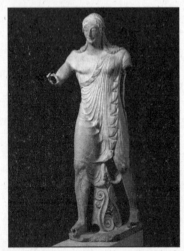

FIG. 09-04 Apulu (Apollo), from the roof of the Portonaccio temple, Veii, Italy, ca. 510–500 BCE. Painted terracotta, 5′ 11″ high. Museo Nazionale di Villa Giulia, Rome. (page 226)

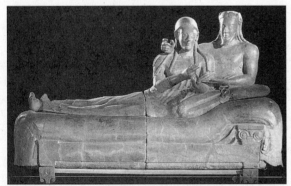

FIG. 09-05 Sarcophagus with reclining couple, from Cerveteri, Italy, ca. 520 BCE. Painted terracotta 3′ 9 1/2″ × 6′ 7″. Museo Nazionale di Villa Giulia, Rome. (page 227)

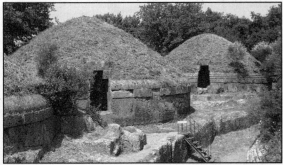

FIG. 09-06 Tumuli in the Banditaccia necropolis, Cerveteri, Italy, seventh to second centuries BCE. (page 228)

Lat.: 42°0′27.95″N Long.: 12°6′19.04″E

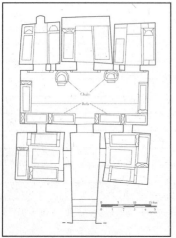

FIG. 09-07 Plan of the Tomb of the Shields and Chairs, Cerveteri, Italy, second half of the sixth century BCE. (page 228)

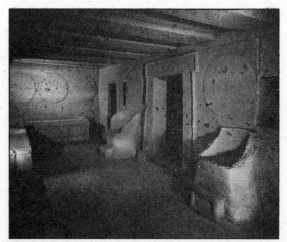

FIG. 09-07A Interior of the Tomb of the Shields and Chairs, Banditaccia necropolis, Cerveteri, Italy, ca. 550–500 BCE. (page 228)

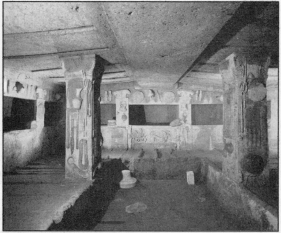

FIG. 09-08 Interior of the Tomb of the Reliefs, Cerveteri, Italy, third century BCE. (page 229)

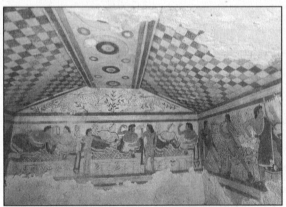

FIG. 09-09 Interior of the Tomb of the Leopards, Tarquinia, Italy, ca. 480–470 BCE. (page 229)

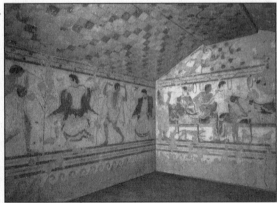

FIG. 09-09A Interior of the Tomb of the Triclinium, from the Monterozzi necropolis, Tarquinia, Italy, ca. 480–470 BCE. Fresco, side walls 8′ high. Museo Nazionale Archeologico, Tarquinia. (page 230)

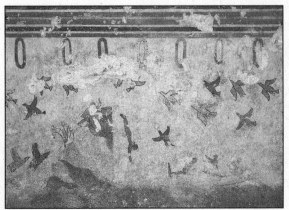

FIG. 09-10 Diving and fishing, detail of a mural painting in the Tomb of Hunting and Fishing, Tarquinia, Italy, ca. 530–520 BCE. Detail, 5′ 6 1/2″ high. (page 230)

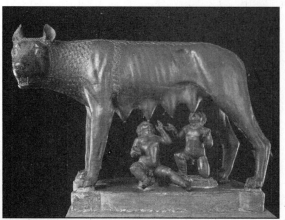

FIG. 09-11 *Capitoline Wolf,* from Rome, Italy, ca. 500–480 BCE. Bronze, 2′ 7 1/2″ high. Musei Capitolini, Rome. (page 231)

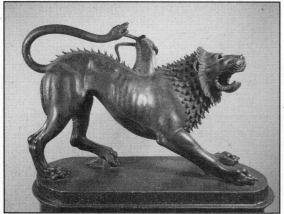

FIG. 09-12 *Chimera of Arezzo,* from Arezzo, Italy, first half of fourth century BCE. Bronze, 2′ 7 1/2″ high. Museo Archeologico Nazionale, Florence. (page 231)

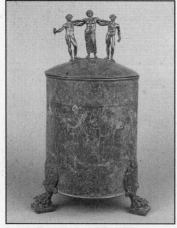

FIG. 09-13 NOVIOS PLAUTIOS, *Ficoroni Cista,* from Palestrina, Italy, late fourth century BCE. Bronze 2′ 6″ high. Museo Nazionale di Villa Giulia, Rome. (page 232)

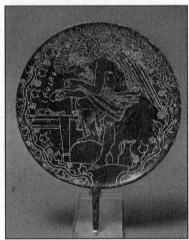

FIG. 09-13A Chalchas examining a liver, engraving on the back of a mirror, from Vulci, ca. 400–375 BCE. Bronze, 7″ diameter. Musei Vaticani, Rome. (page 232)

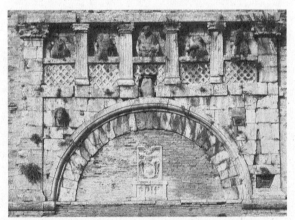

FIG. 09-14 Porta Marzia (Gate of Mars), Perugia, Italy, second century BCE. (page 233)

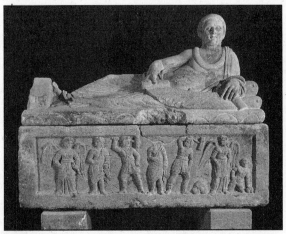

FIG. 09-15 Sarcophagus of Lars Pulena, from Tarquinia, Italy, early second century BCE. Tufa, 6′ 6″ long. Museo Archeologico Nazionale, Tarquinia. (page 233)

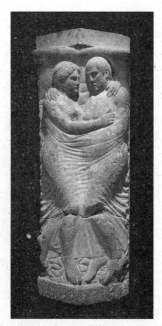

FIG. 09-15A Sarcophagus lid with portraits of
Ramtha Visnai and Arnth Tetnies, from the Ponte
Rotto necropolis, Vulci, Italy, ca. 350–300 BCE.
Nenfro, 7′ 1 3/4″ long. Museum of Fine Arts, Boston
(gift of Mr. and Mrs. Cornelius C. Vermeule III).
(page 233)

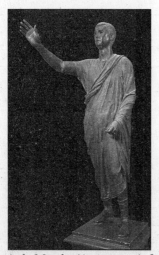

FIG. 09-16 Aule Metele *(Arringatore),* from
Cortona, near Lake Trasimeno, Italy, early first
century BCE. Bronze, 5′ 7″ high. Museo Archeologico
Nazionale, Florence. (page 234)

1. What purpose did the Ficoroni Cista (FIG. 9-13) serve?

2. What features distinguish the Tomb of the Reliefs (FIG. 9-8)? What purpose did the decorative elements in this tomb serve?

3. What factors make the decorative elements embedded in the Porta Marzia (FIG. 9-14) noteworthy?

4. Identify and describe the area of modern Italy that is considered by contemporary historians to have been the heartland of the Etruscans? (Use Google Earth coordinates, 41°52′18.98″N, 12°34′2.57″E to see the region, and zoom in and out to analyze the terrain.)

5. Consider the history and form of the Capitoline Wolf (FIG. 9-11). What story does the sculpture depict and how was it created?

6. Describe the sarcophagus with reclining couple found at Cerveteri (FIG. 9-5). What function did this work serve? What features mark it as uniquely Etruscan?

7. Explore the Banditaccia necropolis located at 42°0′27.95″N, 12°6′19.04″E. Describe the form of a typical tomb at this site (FIG. 9-6).

8. Compare and contrast the diving and fishing mural from Tarquinia (FIG. 9-10) with the hippopotamus hunt mural found in the tomb of Ti (FIG. 3-15). How were these murals created? What funerary purpose may these images have served?

9. Compare and contrast the Etruscan Apulu figure (FIG. 9-4) with the Greek Calf Bearer (FIG. 5-9)? From what materials were these statues made? What function did these works serve? Describe the features and expressions of each of the figures.

10. What did the underground tomb chambers of Cerveteri, as exemplified by the Tomb of the Shields and Seats (FIG. 9-7) resemble?

11. What factors unified the cities of Etruria (see 41°52′18.98″N, 12°34′2.57″E and zoom out to see the city labels)? Did they have a common government, language, or history?

Chapter 10

The Roman Empire

Goals

- Understand the great innovations of Roman architecture and how these innovations contributed to the expanse of the Roman Empire.
- Explore Pompeii for its information about Roman art and architecture.
- Examine the types, methods, and subject matter of Roman wall painting.
- Understand what Roman portraiture says about Roman society.
- Understand the political nature of Roman art and architecture, especially as it communicates ideas of power for the emperor and empire.
- Examine changes in Roman art and architecture as a result of expansion of the Roman Empire and the incorporation of the conquered cultures.

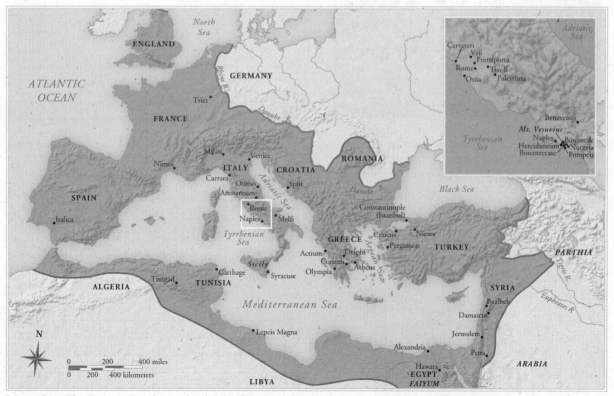

Map 10-1 The Roman Empire at the death of Trajan in 117 ce. (page 238)

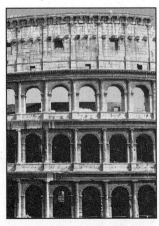

FIG. 10-01 Detail of the facade of the Colosseum (Flavian Amphitheater), Rome, Italy, ca. 70–80 CE. (page 236)

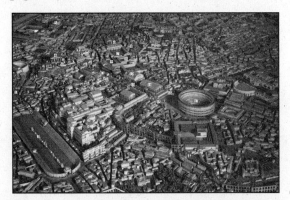

FIG. 10-02 Model of the city of Rome during the early fourth century CE. Museo della Civiltà Romana, Rome. (1) Temple of Portunus, (2) Circus Maximus, (3) Palatine Hill, (4) Temple of Jupiter Capitolinus, (5) Pantheon, (6) Column of Trajan, (7) Forum of Trajan, (8) Markets of Trajan, (9) Forum of Julius Caesar, (10) Forum of Augustus, (11) Forum Romanum, (12) Basilica Nova, (13) Arch of Titus, (14) Temple of Venus and Roma, (15) Arch of Constantine, (16) Colossus of Nero, (17) Colosseum. (page 238)

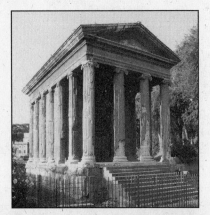

FIG. 10-03 Temple of Portunus (Temple of "Fortuna Virilis"), Rome, Italy, ca. 75 BCE. (page 240)

Lat.: 41°53′21.27″N Long.: 12°28′51.03″E

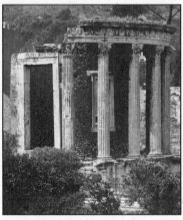

FIG. 10-04 Temple of Vesta(?), Tivoli, Italy, early first century BCE. (page 240)

Lat.: 41°58′0.03″N Long.: 12°48′1.80″E

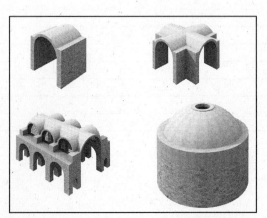

FIG. 10-05 Restored view of the Sanctuary of Fortuna Primigenia, Palestrina, Italy, late second century, BCE (John Burge). (page 240)

Lat.: 41°50′23.77″N Long.: 12°53′32.63″E

FIG. 10-06 Roman concrete construction. (a) barrel vault, (b) groin vault, (c) fenestrated sequence of groin vaults, (d) hemispherical dome with oculus (John Burge). (page 241)

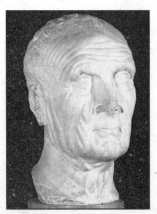

FIG. 10-07 Head of an old man, from Osimo, mid-first century BCE. Marble, life-size. Palazzo del Municipio, Osimo. (page 242)

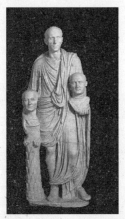

FIG. 10-07A Man with portrait busts of his ancestors, from Rome, late first century BCE. Marble, 5′ 5″ high. Musei-Capitolini–Centro Montemartini, Rome. (page 242)

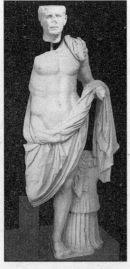

FIG. 10-08 Portrait of a Roman general, from the Sanctuary of Hercules, Tivoli, Italy, ca. 75–50 BCE. Marble, 6′ 2″ high. Museo Nazionale Romano–Palazzo Massimo alle Terme, Rome. (page 242)

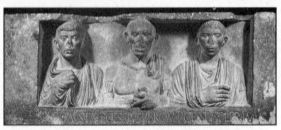

FIG. 10-09 Funerary relief with portraits of the Gessii, from Rome(?), Italy, ca. 30 BCE. Marble, 2′ 1 1/2″ high. Museum of Fine Arts, Boston. (page 243)

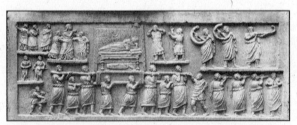

FIG. 10-10 Relief with funerary procession, from Amiternum, Italy, second half of first century BCE. Limestone, 2′ 2″ high. Museo Nazionale d'Abruzzo, L'Aquila. (page 243)

FIG. 10-11 Denarius with portrait of Julius Caesar 44 BCE. Silver, diameter 3/4″. American Numismatic Society, New York. (page 244)

FIG. 10-11A Head of Pompey the Great, mid-first-century CE copy from the Via Salaria, Rome, Italy, of a portrait of ca. 55–50 BCE. Marble, 9 3/4″ high. Ny Carlsberg Glyptotek, Copenhagen. (page 244)

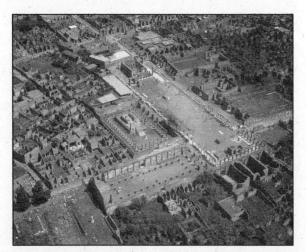

Lat.: 40°44′57.70″N Long.: 14°29′5.22″E

FIG. 10-12 Aerial view of the forum (looking northeast), Pompeii, Italy, second century BCE and later. (1) forum, (2) Temple of Jupiter (Capitolium), (3) basilica. (page 244)

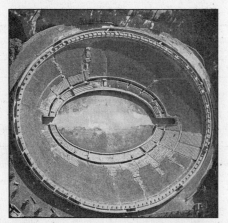

Lat.: 40°45′4.40″N Long.: 14°29′42.30″E

FIG. 10-13 Aerial view of the amphitheater, Pompeii, Italy, ca. 70 BCE. (page 245)

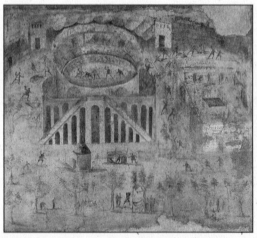

FIG. 10-14 Brawl in the Pompeii amphitheater, wall painting from House I,3,23, Pompeii, Italy, ca. 60–79 CE. Fresco, 5′ 7″ × 6′ 1″. Museo Archeologico Nazionale, Naples. (page 246)

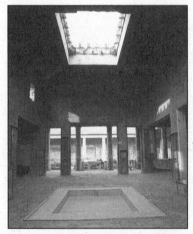

FIG. 10-15 Atrium of the House of the Vettii, Pompeii, Italy, second century, BCE, rebuilt 62–79 CE. (page 246)

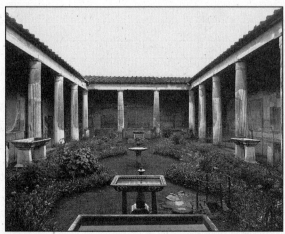

FIG. 10-15A Peristyle of the House of the Vettii, Pompeii, Italy, second century BCE, rebuilt ca. 62–79 CE. (page 246)

Lat.: 40°45′7.47″N Long.: 14°29′3.91″E

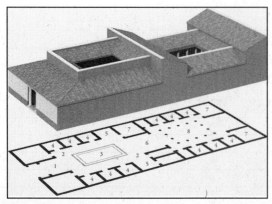

FIG. 10-16 Restored view and plan of a typical Roman house of the Late Republic and Early Empire (John Burge). (1) fauces, (2) atrium, (3) impluvium, (4) cubiculum, (5) ala, (6) tablinum, (7) triclinium, (8) peristyle. (page 247)

FIG. 10-17 First Style wall painting in the fauces of the Samnite House, Herculaneum, Italy, late second century BCE. (page 248)

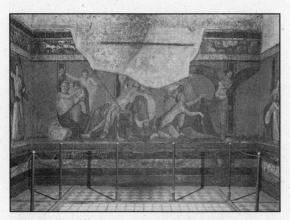

FIG. 10-18 Dionysiac mystery frieze, Second Style wall paintings in room 5 of the Villa of the Mysteries, Pompeii, Italy, ca. 60–50 BCE. Fresco, frieze 5′ 4″ high. (page 249)

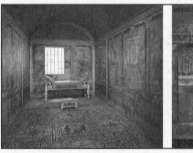

FIG. 10-19 Second Style wall paintings (general view, *left,* and detail of tholos, *right*) from cubiculum M of the Villa of Publius Fannius Synistor, Boscoreale, Italy, ca. 50–40 BCE. Fresco, 8′ 9″ high. Metropolitan Museum of Art, New York. (page 249)

FIG. 10-20 Gardenscape, Second Style wall paintings, from the Villa of Livia, Primaporta, Italy, ca. 30–20 BCE. Fresco, 6′ 7″ high. Museo Nazionale Romano-Palazzo Massimo alle Terme, Rome. (page 250)

FIG. 10-21 Detail of a Third Style wall painting, from cubiculum 15 of the Villa of Agrippa Postumus, Boscotrecase, Italy, ca. 10 BCE, Fresco, 7′ 8″ high. Metropolitan Museum of Art, New York. (page 250)

FIG. 10-22 Fourth Style wall paintings in room 78 of the Domus Aurea (Golden House) of Nero, Rome, Italy, 64–68 CE. (page 251)

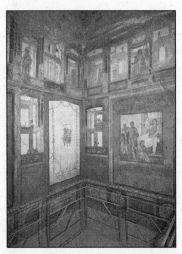

FIG. 10-23 Fourth Style wall paintings in the Ixion Room (triclinium P) of the House of the Vettii, Pompeii, Italy, ca. 70–79 CE. (page 252)

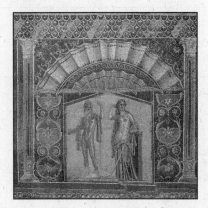

FIG. 10-24 Neptune and Amphitrite, wall mosaic in the summer triclinium of the House of Neptune and Amphitrite, Herculaneum, Italy, ca. 62–79 CE. (page 253)

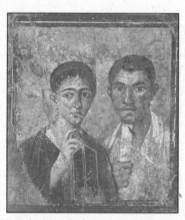

FIG. 10-25 Portrait of a husband and wife, wall painting from House VII,2,6, Pompeii, Italy, ca. 70–79 CE. Fresco, 1′ 11″ × 1′ 8 1/2″. Museo Archeologico Nazionale, Naples. (page 253)

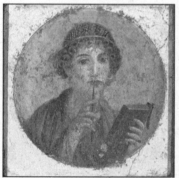

FIG. 10-25A Woman with stylus and writing tablet, from a house in Insula Occidentale VI, Pompeii, Italy, ca. 55–70 CE. Fresco, 1′ 1/4″ diameter. Museo Nazionale Archeologico, Naples. (page 253)

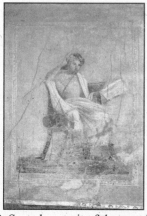

FIG. 10-25B Seated portrait of the poet Menander, detail of a Fourth Style mural painting in exedra 23 of the House of the Menander, Pompeii, ca. 62–79 CE. (page 253)

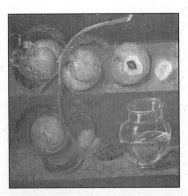

FIG. 10-26 Still life with peaches, detail of a Fourth Style wall painting, from Herculaneum, Italy, ca. 62–79 CE. Fresco, 1′ 2″ × 1′ 1 1/2″. Museo Archeologico Nazionale, Naples. (page 253)

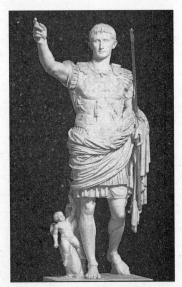

FIG. 10-27 Portrait of Augustus as general, from Primaporta, Italy, early-first-century CE copy of a bronze original of ca. 20 BCE. Marble 6′ 8″ high. Musei Vaticani, Rome. (page 254)

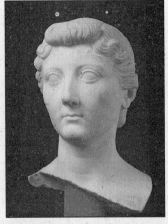

FIG. 10-28 Portait bust of Livia, from Arsinoe, Egypt, early first century CE. Marble, 1′ 1 1/2″ high. Ny Carlsberg Glyptotek, Copenhagen. (page 255)

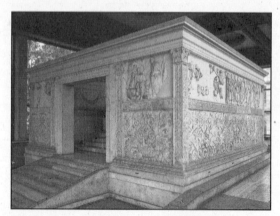

FIG. 10-29 Ara Pacis Augustae (Altar of Augustan Peace; looking northeast), Rome, Italy, 13–9 BCE. (page 256)

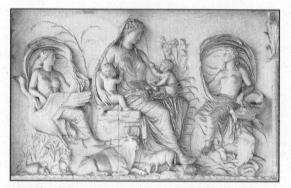

FIG. 10-30 Female personification (Tellus?), panel from the east facade of the Ara Pacis Augustae, Rome, Italy, 13–9 BCE. Marble, 5′ 3″ high. (page 256)

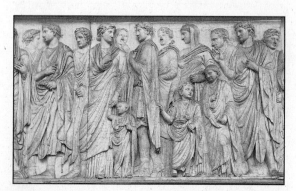

FIG. 10-31 Procession of the imperial family, detail of the south frieze of the Ara Pacis Augustae, Rome, Italy, 13–9 BCE. Marble 5′ 3″ high. (page 257)

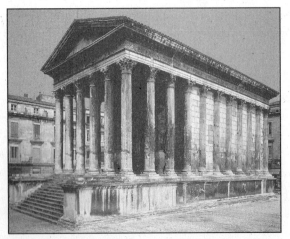

FIG. 10-32 Maison Carrée, Nîmes, France, ca. 1–10 CE. (page 257)

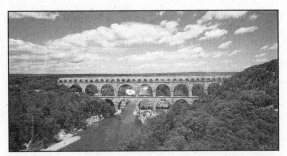

FIG. 10-33 Pont-du-Gard, Nîmes, France, ca. 16 BCE. (page 258)

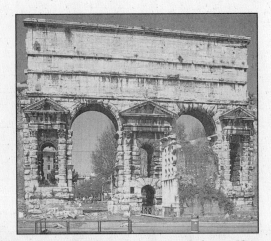

FIG. 10-34 Porta Maggiore, Rome, Italy, ca. 50 CE. (page 258)

Lat.: 41°53′29.18″N Long.: 12°30′54.77″E

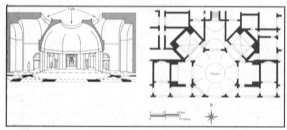

FIG. 10-35 Severus and Celer, section *(left)* and plan *(right)* of the octagonal hall of the Domus Aurea (Golden House) of Nero, Rome, Italy, 64–68 CE. (page 259)

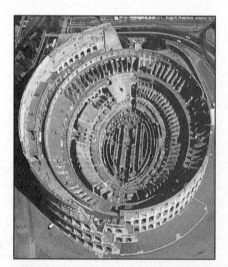

FIG. 10-36 Aerial view of the Colosseum (Flavian Amphitheater), Rome, Italy, ca. 70–80 CE. (page 260)

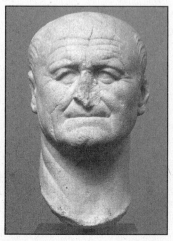

FIG. 10-37 Portrait of Vespasian, ca. 75–79 CE. Marble, 1′ 4″ high. Ny Carlsberg Glyptotek, Copenhagen. (page 261)

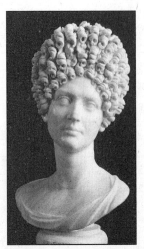

FIG. 10-38 Portrait bust of a Flavian woman, from Rome, Italy, ca. 90 CE. Marble, 2′ 1″ high. Musei Capitolini, Rome. (page 261)

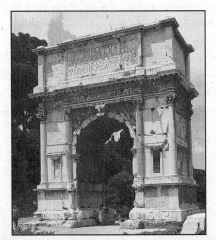

FIG. 10-39 Arch of Titus, Rome, Italy, after 81 CE. (page 262)

Lat.: 41°53′26.44″N Long.: 12°29′19.34″E

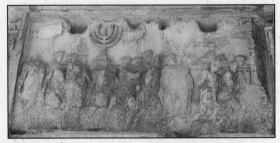

FIG. 10-40 Spoils of Jerusalem, relief panel from the Arch of Titus, Rome, Italy, after 81 CE. Marble, 7′ 10″ high. (page 263)

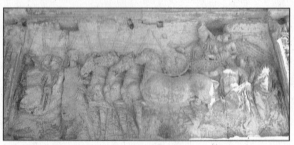

FIG. 10-41 Triumph of Titus, relief panel from the Arch of Titus, Rome, Italy, after 81 CE. Marble, 7′ 10″ high. (page 263)

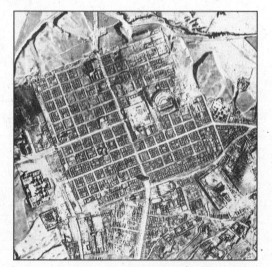

FIG. 10-42 Aerial view of Timgad (Thamugadi), Algeria, founded 100 CE. (page 264)

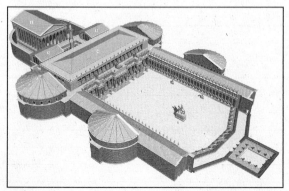

FIG. 10-43 APOLLODORUS OF DAMASCUS, Forum of Trajan, Rome, Italy, dedicated 112 CE (James E. Packer and John Burge). (1) Temple of Trajan, (2) Column of Trajan, (3) libraries, (4) Basilica Ulpia, (5) forum, (6) equestrian statue of Trajan. (page 264)

Lat.: 41°53′43.38″N Long.: 12°29′4.81″E

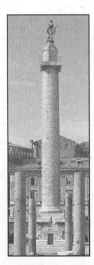

FIG. 10-44 Column of Trajan, Forum of Trajan, Rome, Italy dedicated 112 CE. (page 265)

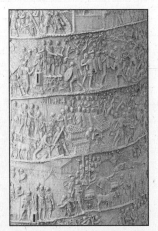

FIG. 10-44A Detail of three bands of the spiral frieze of the Column of Trajan, Forum of Trajan, Rome, Italy, dedicated 112 CE. (page 265)

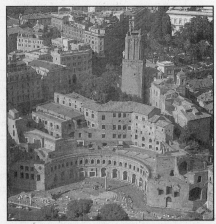

FIG. 10-45 APOLLODORUS OF DAMASCUS, aerial view of the Markets of Trajan, Rome, Italy, ca. 100–112 CE. (page 266)

Lat.: 41°53′43.38″N Long.: 12°29′9.71″E

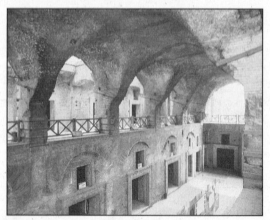

FIG. 10-46 APOLLODORUS OF DAMASCUS, interior of the great hall, Markets of Trajan, Rome, Italy, ca. 100–112 CE. (page 266)

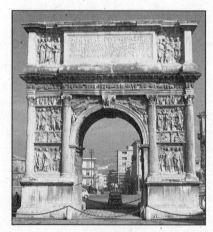

FIG. 10-47 Arch of Trajan, Benevento, Italy, ca. 114–118 CE. (page 267)

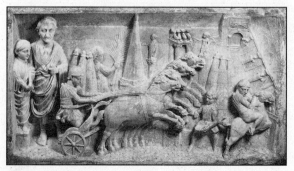

FIG. 10-47A Funerary relief of an official in the Circus Maximus, Rome, from Ostia, Italy, ca. 110–130 CE. Marble, 1′ 8″ high. Musei Vaticani, Rome. (page 267)

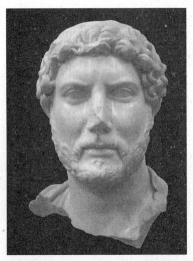

FIG. 10-48 Portrait bust of Hadrian, from Rome, ca. 117–120 CE. Marble, 1′ 4 3/4″ high. Museo Nazionale Romano–Palazzo Massimo alle Terme, Rome. (page 267)

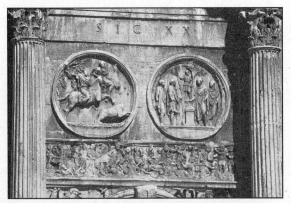

FIG. 10-48A Lion hunt and sacrifice to Diana, tondi from a lost monument of ca. 130–138 CE reused on the Arch of Constantine (FIG. 10-75), Rome, Italy, 312–315. Marble, tondi 6′ 6″ diameter. (page 267)

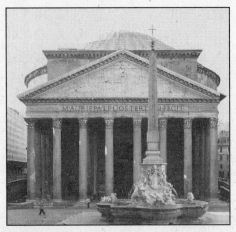

FIG. 10-49 Pantheon, Rome, Italy, 118–125 CE. (page 267)

Lat.: 1°53′54.96″N Long.: 12°28′37.05″E

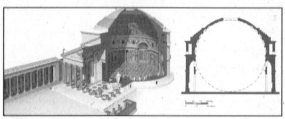

FIG. 10-50 Restored cutaway view *(left)* and lateral section *(right)* of the Pantheon, Rome, Italy, 118–125 CE. (John Burge). (page 268)

Lat.: 1°53′54.96″N Long.: 12°28′37.05″E

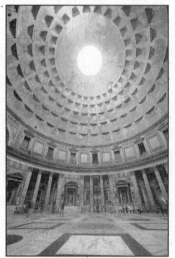

Lat.: 1°53′54.96″N Long.: 12°28′37.05″E

FIG. 10-51 Interior of the Pantheon, Rome, Italy, 118–125 CE. (page 268)

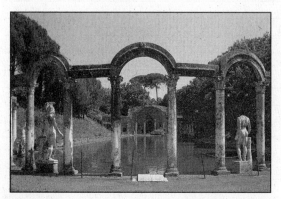

FIG. 10-52 Canopus and Serapeum, Hadrian's Villa, Tivoli, Italy, ca. 125–128 CE. (page 269)

Lat.: 41°56′17.84″N Long.: 12°46′33.82″E

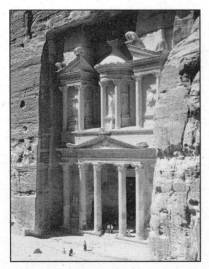

FIG. 10-53 Al-Khazneh ("Treasury"), Petra, Jordan, second century CE. (page 270)

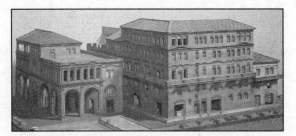

FIG. 10-54 Model of an insula, Ostia, Italy, second century CE. Museo della Civiltà Romana, Rome. (page 270)

Lat.: 41°45′17.09″N Long.: 12°17′20.97″E

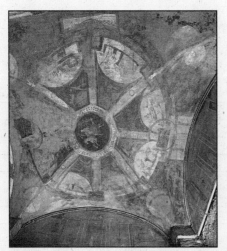

FIG. 10-54A Ceiling and mural paintings, room 4, Insula of the Painted Vaults, Ostia, Italy, early third century CE. (page 270)

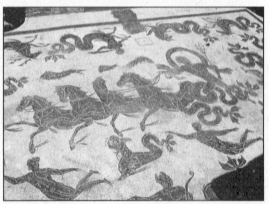

FIG. 10-55 Neptune and creatures of the sea, detail of a floor mosaic in the Baths of Neptune, Ostia, Italy, ca. 140 CE. (page 271)

Lat.: 41°45′23.57″N Long.: 12°17′33.07″E

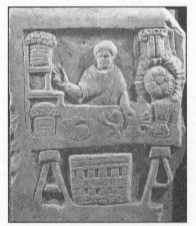

FIG. 10-56 Funerary relief of a vegetable vendor, from Ostia, Italy, second half of second century CE. Painted terracotta, 1′ 5″ high. Museo Ostiense, Ostia. (page 271)

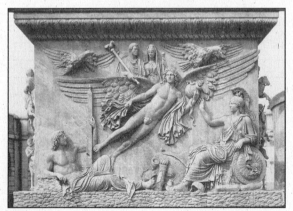

FIG. 10-57 Apotheosis of Antoninus Pius and Faustina, pedestal of the Column of Antoninus Pius, Rome, Italy, ca. 161 CE. Marble, 8′ 1 1/2″ high. Musei Vaticani, Rome. (page 272)

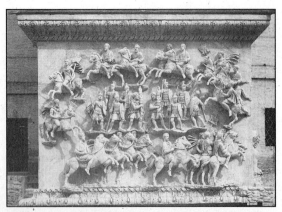

FIG. 10-58 Decursio, pedestal of the Column of Antoninus Pius, Rome, Italy, ca. 161 CE. Marble, 8′ 1 1/2″ high. Musei Vaticani, Rome. (page 272)

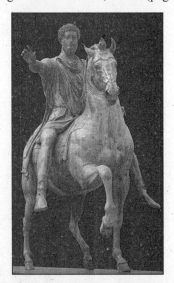

FIG. 10-59 Equestrian statue of Marcus Aurelius, from Rome, Italy, ca. 175 CE. Bronze, 11′ 6″ high. Musei Capitolini, Rome. (page 273)

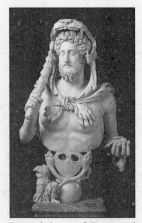

FIG. 10-59A Portrait bust of Commodus in the guise of Hercules, from the Esquiline Hill, Rome, Italy, ca. 190–192 CE. Marble, 4′ 4 3/8″ high. Musei Capitolini–Palazzo dei Conservatori, Rome. (page 273)

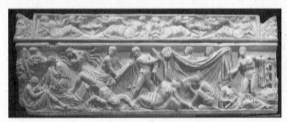

FIG. 10-60 Sarcophagus with the myth of Orestes, ca. 140–150 CE. Marble, 2′ 7 1/2″ high. Cleveland Museum of Art, Cleveland. (page 274)

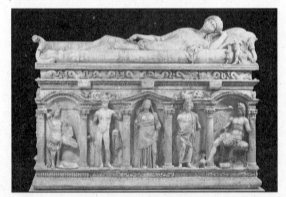

FIG. 10-61 Asiatic sarcophagus with kline portrait of a woman, from Rapolla, near Melfi, Italy, ca. 165–170 CE. Marble, 5′ 7″ high. Museo Nazionale Archeologico del Melfese, Melfi. (page 274)

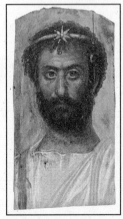

FIG. 10-62 Mummy portrait of a priest of Serapis, from Hawara (Faiyum), Egypt, ca. 140–160 CE. Encaustic on wood, 1′ 4 3/4″ × 8 3/4″. British Museum, London. (page 275)

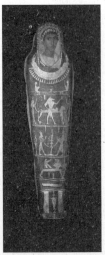

FIG. 10-62A Mummy of Artemidorus, from Hawara, Egypt, ca. 100–120. Portrait, encaustic on wood; mummy case, stucco with gold leaf, 5′ 7 1/4″ high. British Museum, London. (page 275)

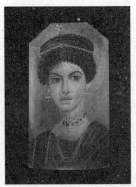

FIG. 10-62B Mummy portrait of a young woman, from Hawara, Egypt, ca. 110–120 CE. Encaustic on wood, 1′ 5 1/4″ X 1′ 1 3/8″. Royal Museum of Scotland, Edinburgh. (page 275)

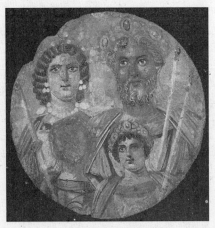

FIG. 10-63 Painted portrait of Septimius Severus and his family, from Egypt, ca. 200 CE. Tempera on wood, 1′ 2″ diameter. Staatliche Museen, Berlin. (page 276)

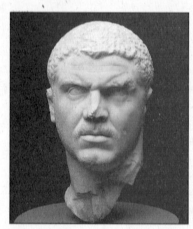

FIG. 10-64 Portait of Caracalla, ca. 211–217 CE. Marble, 1′ 2″ high. Metropolitan Museum of Art, New York. (page 276)

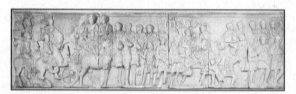

FIG. 10-65 Chariot procession of Septimius Severus, relief from the attic of the Arch of Septimius Severus, Lepcis Magna, Libya, 203 CE. Marble, 5′ 6″ high. Castle Museum, Tripoli. (page 277)

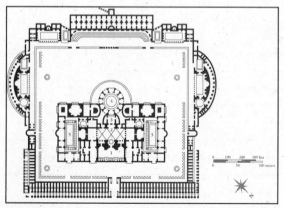

FIG. 10-66 Plan of the Baths of Caracalla, Rome, Italy, 212–216 CE. (1) natatio, (2) frigidarium, (3) tepidarium, (4) caldarium, (5) palaestra. (page 277)

Lat.: 41°52′43.79″N Long.: 12°29′32.57″E

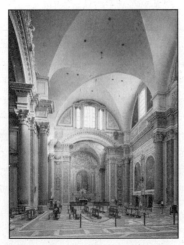

FIG. 10-67 Frigidarium, Baths of Diocletian, Rome, ca. 298–306 CE (remodeled by MICHELANGELO as the nave of Santa Maria degli Angeli, 1563). (page 278)

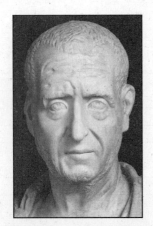

FIG. 10-68 Portrait bust of Trajan Decius, 249–251 CE. Marble, full bust 2′ 7″ high, Musei Capitolini, Rome. (page 279)

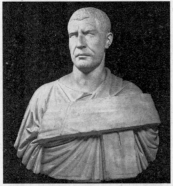

FIG. 10-68A Portrait bust of Philip the Arabian, from Porcigliano, Italy, 244–249 CE. Marble, 2′ 4″ high. Musei Vaticani, Rome. (page 278)

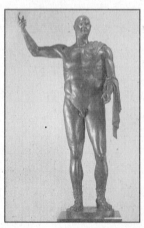

FIG. 10-69 Heroic portrait of Trebonianus Gallus, from Rome, Italy, 251–253 CE. Bronze, 7′ 11″ high. Metropolitan Museum of Art, New York. (page 279)

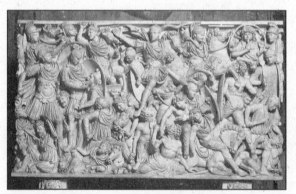

FIG. 10-70 Battle of Romans and barbarians *(Ludovisi Battle Sarcophagus),* from Rome, Italy, ca. 250–260 CE. Marble, 5′ high. Museo Nazionale Romano–Palazzo Altemps, Rome. (page 279)

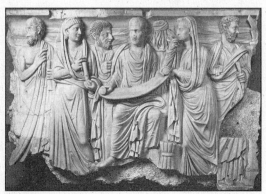

FIG. 10-71 Sarcophagus of a philosopher, ca. 270–280 CE. Marble, 4′ 11″ high. Musei Vaticani, Rome. (page 280)

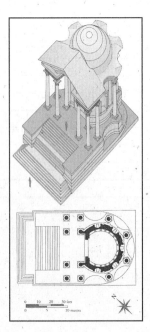

FIG. 10-72 Restored view *(top)* and plan *(bottom)* of the Temple of Venus, Baalbek, Lebanon, third century CE. (page 281)

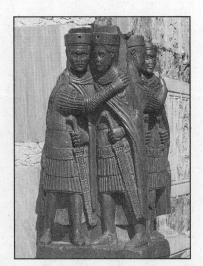

FIG. 10-73 Portraits of the four tetrarchs, from Constantinople, ca. 305 CE. Porphyry, 4′ 3″ high. Saint Mark's, Venice. (page 281)

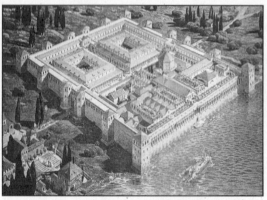

FIG. 10-74 Restored view of the palace of Diocletian, Split, Croatia, ca. 298–306. (page 282)

Lat.: 43°30′29.84″N Long.: 16°26′24.33″E

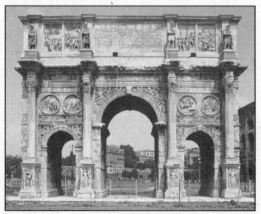

FIG. 10-75 Arch of Constantine (south side), Rome, Italy, 312–315 CE. (page 283)

Lat.: 41°53′23.17″N Long.: 12°29′26.69″E

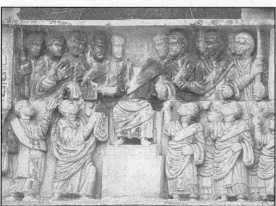

FIG. 10-76 Distribution of largesse, detail of the north frieze of the Arch of Constantine, Rome, Italy, 312–315 CE. Marble, 3′ 4″ high. (page 283)

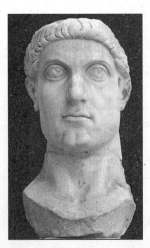

FIG. 10-77 Portrait of Constantine, from the Basilica Nova, Rome, Italy, ca. 315–330 CE. Marble, 8′ 6″ high. Musei Capitolini, Rome. (page 284)

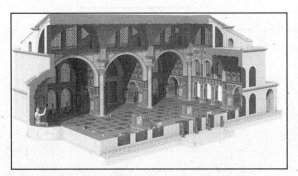

FIG. 10-78 Restored cutaway view of the Basilica Nova, Rome, Italy, ca. 306–312 CE. (John Burge). (page 284)

Lat.: 41°53′30.11″N Long.: 12°29′17.78″E

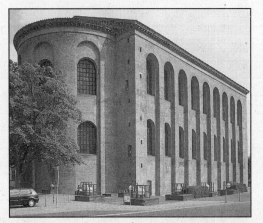

FIG. 10-79 Aula Palatina (exterior), Trier, Germany, early fourth century CE. (page 285)

Lat.: 49°45′12.54″N Long.: 6°38′37.24″E

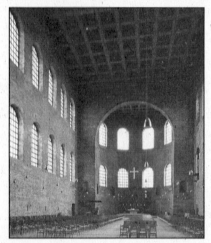

Lat.: 49°45′12.54″N Long.: 6°38′37.24″E

FIG. 10-80 Aula Palatina (interior), Trier, Germany, early fourth century CE. (page 285)

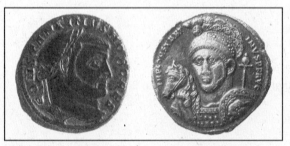

FIG. 10-81 Coins with portraits of Constantine. Nummus *(left),* 307 CE. Billon, diameter 1″. American Numismatic Society, New York. Medallion *(right),* ca 315 CE. Silver, diameter 1″. Staatliche Münzsammlung, Munich. (page 286)

1. What was the central feature of a typical Roman domus, such as the House of the Vettii that is located at 40°45′7.47″N, 14°29′3.91″E?

2. Explain how the Sanctuary of Fortuna, located at 41°50′23.77″N, 12°53′32.63″E, incorporates the land it is built upon into its architectural scheme?

3. What type of structure did the floor mosaic depicted in FIG. 10-55 and located at 41°45′23.57″N, 12°17′33.07″E adorn?

4. What building material made the construction of the multilevel Markets of Trajan, located at 41°53′43.38″N, 12°29′9.71″E, possible?

5. What kind of structure does the Palace of Diocletian, located at 43°30′29.84″N, 16°26′24.33″E and depicted in FIG. 10-74, resemble?

6. What function did the Arch of Titus, located at 41°53′26.44″N, 12°29′19.34″E, serve?

7. What geographic feature is the Temple of "Fortuna Virilis" (41°53′21.27″N, 12°28′51.03″E) located near? What god is this temple dedicated to?

8. What kind of structures does the Porta Maggiore gate (41°53′29.18″N, 12°30′54.77″E) house?

9. Explore the exterior and interior features of the Pantheon, located at 1°53'54.96"N, 12°28'37.05"E and depicted in FIG. 10-49, 10-50 & 10-51. Explain how the Pantheon demonstrates the capabilities of concrete as a building material and a means for shaping space.

10. Identify and discuss the traditional features of the Aula Palatina (located at 49°45'12.54"N, 6°38'37.24"E).

11. Consider the Arch of Constantine, located at 41°53'23.17"N, 12°29'26.69"E. How does Constantine's triumphal arch differ from the arches erected by previous emperors?

12. What kind of structural device did the Romans use to keep the amphitheater at Pompeii, located at 40°45'4.40"N, 14°29'42.30"E, standing?

13. How did the insula at Ostia (located at 41°45'17.09"N, 12°17'20.97"E) differ from the House of the Vettii at Pompeii (see 40°45'7.47"N, 14°29'3.91"E)?

14. Consider the floorplan of the Baths of Caracalla, located at 41°52'43.79"N, 12°29'32.57"E. How did the design of this building facilitate its use? What were some of its significant features?

15. Identify and describe the structure located at 41°53'25.24"N, 12°29'32.42"E?

16. What features distinguish the Basilica Nova (located at 41°53'30.11"N, 12°29'17.78"E)?

17. Compare and contrast the Roman Temple of Vesta (?) located at 41°58′0.03″N, 12°48′1.80″E with the Greek Tholos at Delphi (FIG. 5-72). What Greek elements did the Romans incorporate in their version of the round table? What innovations did the Romans make in the temple design and construction?

18. What features distinguish the Canopus and Serapeum at Hadrian's Villa (41°56′17.84″N, 12°46′33.82″E)?

19. Identify the structures that make up the Forum of Trajan (located at 41°53′43.38″N, 12°29′4.81″E).

20. Identify the separate areas of Pompeii's forum, located at 40°44′57.70″N, 14°29′5.22″E, and explain their use.

Chapter 11

Late Antiquity

Goals

- Understand the influence of religion in the art of the Roman Empire in Late Antiquity.
- Examine the art forms and architecture of Late Antiquity.
- Understand the concept of "synchonism" in early Christian art.
- Understand the different media used to create early Christian art.
- Know and cite artistic and architectural terminology from the period.

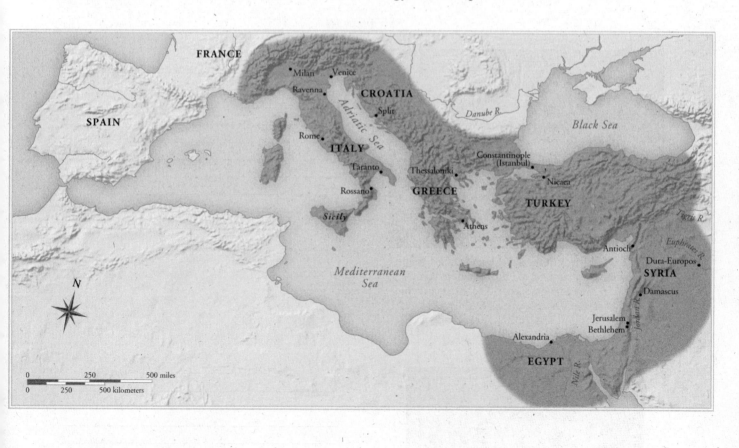

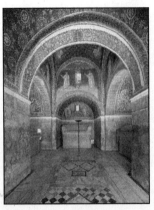

FIG. 11-01 Interior of the Mausoleum of Galla Placidia, Ravenna, Italy, ca. 425. (page 288)

Lat.: 44°25′15.64″N Long.: 12°11′49.54″E

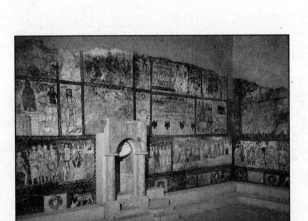

FIG. 11-02 Interior of the synagogue, Dura-Europos, Syria, with wall paintings of Old Testament themes, ca. 245–256. Tempera on plaster. Reconstruction in National Museum, Damascus. (page 290)

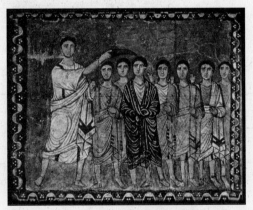

FIG. 11-03 Samuel anoints David, detail of the mural paintings in the synagogue, Dura-Europos, Syria, ca. 245–256. Tempera on plaster, 4′ 7″ high. (page 291)

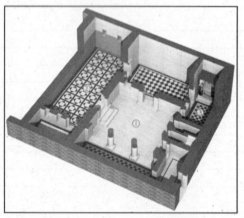

FIG. 11-04 Restored cutaway view of the Christian community house, Dura-Europos, Syria, ca. 240–256 (John Burge). (1) former courtyard of private house, (2) meeting hall, (3) baptistery. (page 291)

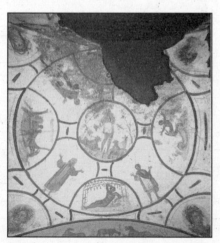

FIG. 11-05 The Good Shepherd, the story of Jonah, and orants, painted ceiling of a cubiculum in the Catacomb of Saints Peter and Marcellinus, Rome, Italy, early fourth century. (page 292)

FIG. 11-05A Cubiculum N, Via Dino Compagni Catacomb, Via Latina, Rome, Italy, ca. 320–360. (page 292)

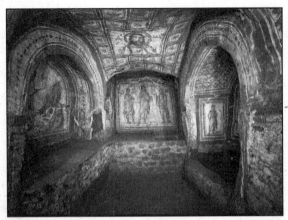

FIG. 11-05B Cubiculum Leonis, Catacomb of Commodilla, Via Ostiense, Rome, Italy, ca. 370–385. (page 292)

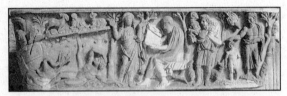

FIG. 11-06 Sarcophagus with philosopher, orant, and Old and New Testament scenes, ca. 270. Marble, 1′ 11 1/4″ × 7′ 2″. Santa Maria Antiqua, Rome. (page 293)

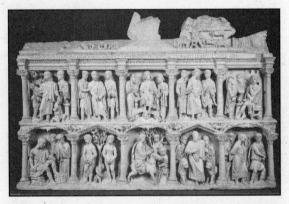

FIG. 11-07 Sarcophagus of Junius Bassus, from Rome, Italy, ca. 359. Marble, 3′ 10 1/2″ × 8′. Museo Storico del Tesoro della Basilica di San Pietro, Rome. (page 294)

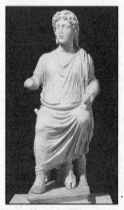

FIG. 11-08 Christ seated, from Civita Latina, Italy, ca. 350–375. Marble, 2′ 4 1/2″ high. Museo Nazionale Romano–Palazzo Massimo alle Terme, Rome. (page 295)

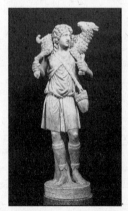

FIG. 11-08A Christ as Good Shepherd, ca. 300–350. Marble, 3′ 1/4″ high. Musei Vaticani, Rome. (page 295)

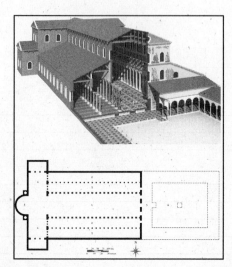

FIG. 11-09 Restored cutaway view *(top)* and plan *(bottom)* of Old Saint Peter's, Rome, Italy, begun ca. 319 (John Burge). (1) nave, (2) aisle, (3) apse, (4) transept, (5) narthex, (6) atrium. (page 298)

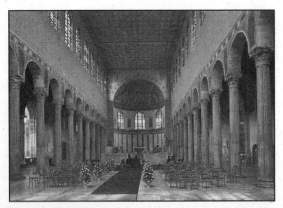

FIG. 11-10 Interior of Santa Sabina, Rome, Italy, 422–432. (page 299)

Lat.: 41°53′3.89″N Long.: 12°28′47.27″E

FIG. 11-10A West doors, Santa Sabina, Rome, ca. 432. Cypress wood, large panels 2′ 9 1/2″ X 1′ 3 3/4″. (page 299)

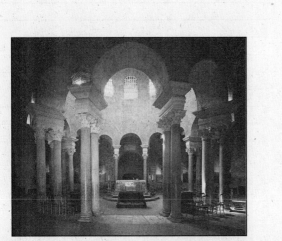

FIG. 11-11 Interior of Santa Costanza, Rome, Italy, ca. 337–351. (page 300)

Lat.: 41°55′21.34″N Long.: 12°31′2.45″E

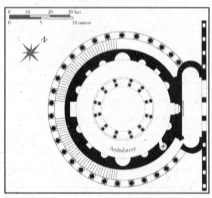

FIG. 11-12 Plan of Santa Costanza, Rome, Italy, ca. 337–351. (page 300)

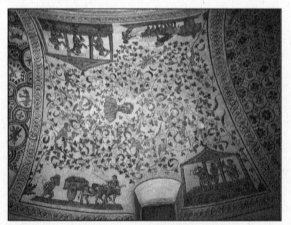

FIG. 11-13 Detail of vault mosaic in the ambulatory of Santa Costanza, Rome, Italy, ca. 337–351. (page 300)

FIG. 11-13A Christ as Sol Invictus, detail of the mosaic in the vault of the Mausoleum of the Julii (tomb M), Vatican Necropolis, Rome, Italy, late third century. (page 301)

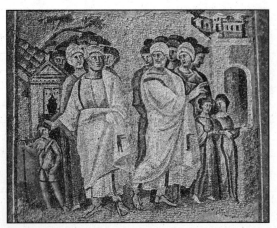

FIG. 11-14 The parting of Abraham and Lot, nave of Santa Maria Maggiore, Rome, Italy, 432–440. Mosaic, 3′ 4″ high. (page 301)

Lat.: 41°53′51.60″N Long.: 12°29′55.09″E

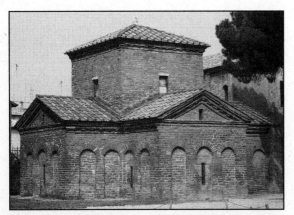

FIG. 11-15 Mausoleum of Galla Placidia, Ravenna, Italy. ca. 425. (page 302)

Lat.: 44°25′15.64″N Long.: 12°11′49.54″E

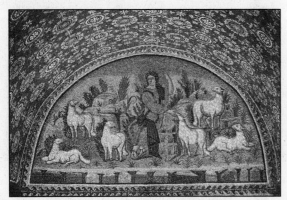

FIG. 11-16 Christ as the Good Shepherd, mosaic from the entrance wall of the Mausoleum of Galla Placidia, Ravenna, Italy, ca. 425. (page 302)

Lat.: 44°25′15.64″N Long.: 12°11′49.54″E

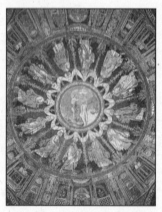

FIG. 11-16A Mosaic decoration of the dome of the Orthodox Baptistery (San Giovanni in Fonte), Ravenna, Italy, ca. 458. (page 302)

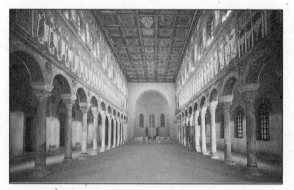

FIG. 11-17 Interior of Sant'Apollinare Nuovo, Ravenna, Italy, dedicated 504. (page 303)

Lat.: 44°25′15.64″N Long.: 12°11′49.54″E

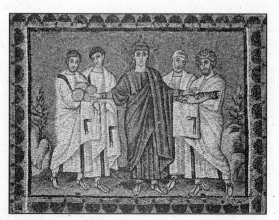

FIG. 11-18 Miracle of the loaves and fishes, mosaic from the top register of the nave wall (above the clerestory windows in FIG. 11-17) of Sant'Apollinare Nuovo, Ravenna, Italy, ca. 504. (page 304)

Lat.: 44°25′0.32″N Long.: 12°12′17.97″E

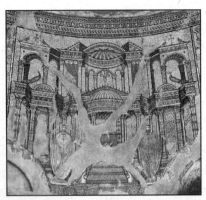

FIG. 11-18A Two saints, detail of mosaic frieze of the lower zone of the dome, Hagios Georgios (Church of Saint George), Thessaloniki, Greece, ca. 390–450. (page 304)

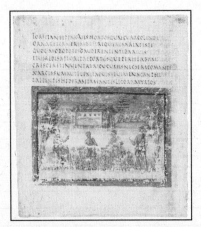

FIG. 11-19 The old farmer of Corycus, folio 7 verso of the *Vatican Vergil,* ca. 400–420. Tempera on parchment, 1′ 1/2″ × 1′. Biblioteca Apostolica Vaticana, Rome. (page 305)

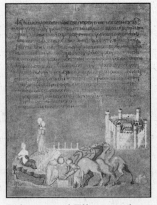

FIG. 11-20 Rebecca and Eliezer at the well, folio 7 recto of the *Vienna Genesis,* early sixth century. Tempera, gold, and silver on purple vellum, 1′ 1/4″ × 9 1/4″. Österreichische Nationalbibliothek, Vienna. (page 305)

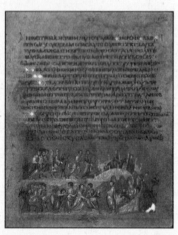

FIG. 11-20A The story of Jacob, folio 12 verso of the Vienna Genesis, early sixth century. Tempera, gold, and silver on purple vellum, 1′ 1 1/4″ X 9 1/4″. Österreichische Nationalbibliothek, Vienna. (page 304)

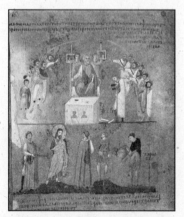

FIG. 11-21 Christ before Pilate, folio 8 verso of the *Rossano Gospels,* early sixth century. Tempera on purple vellum, 11″ × 10 1/4″. Museo Diocesano d'Arte Sacra, Rossano. (page 306)

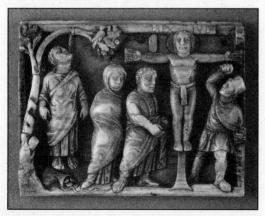

FIG. 11-22 Suicide of Judas and Crucifixion of Christ, plaque from a box, ca 420. Ivory, 3″ × 3 7/8″. British Museum, London. (page 307)

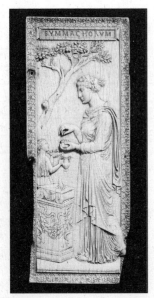

FIG. 11-23 Woman sacrificing at an altar, right leaf of the diptych of the Nicomachi and the Symmachi, ca. 400. Ivory, 11 3/4″ × 5 1/2″. Victoria & Albert Museum, London. (page 308)

1. Compare and contrast the mosaic depictions of Christ from the Mausleum of Galla Placidia (located at 44°25′15.64″N, 12°11′49.54″E and depicted in FIG. 11-16) and from the palace basilica of Sant'Apollinare Nuovo (located at 44°25′0.32″N, 12°12′17.97″E and depicted in FIG. 11-18). What stylistic changes appear between the two depictions? What aspects of the narratives do the mosaicists emphasize?

2. Describe the architectural plan for the Mausoleum of Galla Placidia, located at 44°25′15.64″N, 12°11′49.54″E. Explain why this structure is considered to be a fusion of the two basic Late Antique church plans?

3. What architectural elements of Santa Sabina, located at 41°53′3.89″N, 12°28′47.27″E, resemble Early Christian designs?

4. What structural type did early Christian architects chose to model Old Saint Peter's (FIG. 11-9) after? What factors influenced this decision?

5. Consider the narrative devices used on the Parting of Lot and Abraham mosaic located in the nave of Santa Maria Maggiore (located at 41°53′51.60″N, 12°29′55.09″E). What methods are employed to tell the story as clearly and concisely as possible?

6. Describe the scenes depicted on the sarcophagus of Junius Bassus (FIG. 11-7). What part of Christ's life is conspicuously omitted?

7. What term is used to describe the architectural design of Santa Costanza (located at 41°55′21.34″N, 12°31′2.45″E)? Identify the common features of this church plan.

8. What distinguishes the Vienna Genesis (FIG. 11-19) manuscript? From what materials was this work produced?

9. Describe the architectural design of Sant'Apollinare Nuovo, located at 44°25′15.64″N, 12°11′49.54″E.

10. What distinguishes the plaque from a 5th century ivory box depicted in FIG. 11-22?

Chapter 12

Byzantium

Goals

- Understand Constantine's move to the east and the extent of the Roman Empire in the east.
- Understand the cultural mix of Roman, Christian, and eastern influences in the art of Byzantium.
- Define distinct characteristics in art from various periods of the Byzantine Empire.
- Define distinct characteristics in architecture of this period.

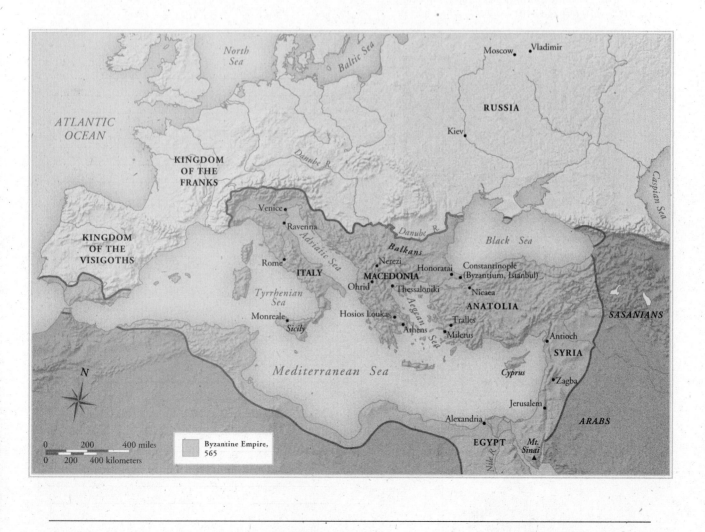

Byzantine Empire, 565

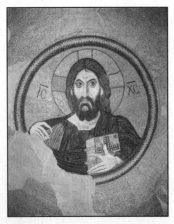

FIG. 12-01 Christ as Pantokrator, dome mosaic in the Church of the Dormition, Daphni, Greece, ca. 1090–1100. (page 310)

Lat.: 38°0′46.34″N Long.: 23°38′9.52″E

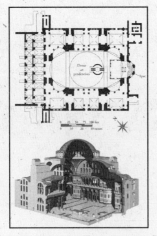

FIG. 12-02 ANTHEMIUS OF TRALLES AND ISIDORUS OF MILETUS, aerial view of Hagia Sophia (looking north), Constantinople (Istanbul), Turkey, 532–537. (page 313)

Lat.: 41°0′30.21″N Long.: 28°58′48.19″E

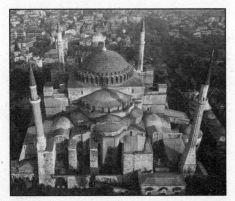

FIG. 12-03 ANTHEMIUS OF TRALLES AND ISIDORUS OF MILETUS, plan *(top)* and restored cutaway view *(bottom)* of Hagia Sophia, Constantinople (Istanbul), Turkey, 532–537 (John Burge). (page 313)

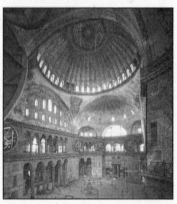

FIG. 12-04 ANTHEMIUS OF TRALLES and ISIDORUS OF MILETUS, interior of Hagia Sophia (looking southwest), Constantinople (Istanbul), Turkey, 532–537. (page 314)

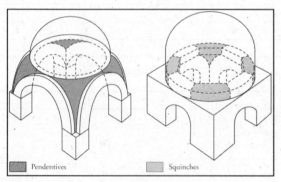

Pendentives Squinches

FIG. 12-05 Dome on pendentives *(left)* and on squinches *(right)*. (page 315)

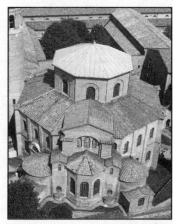

FIG. 12-06 Aerial view of San Vitale (looking northwest), Ravenna, Italy, 526–547. (page 316)

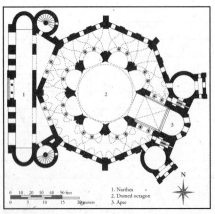

FIG. 12-07 Plan of San Vitale, Ravenna, Italy, 526–547. (page 316)

Lat.: 44°25′14.13″N Long.: 12°11′46.89″E

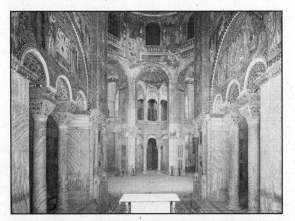

FIG. 12-08 Interior of San Vitale (looking from the apse into the choir), Ravenna, Italy, 526–547. (page 317)

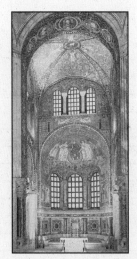

FIG. 12-09 Choir and apse of San Vitale with mosaic of Christ between two angels, Saint Vitalis, and Bishop Ecclesius, Ravenna, Italy, 526–547. (page 318)

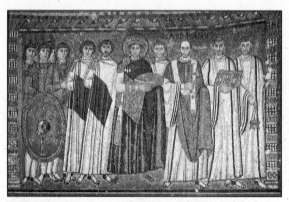

FIG. 12-10 Justinian, Bishop Maximianus, and attendants, mosaic on the north wall of the apse, San Vitale, Ravenna, Italy, ca. 547. (page 319)

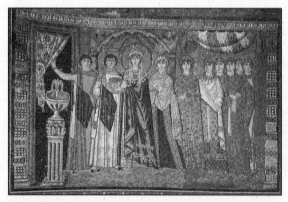

FIG. 12-11 Theodora and attendants, mosaic on the south wall of the apse, San Vitale, Ravenna, Italy, ca. 547. (page 319)

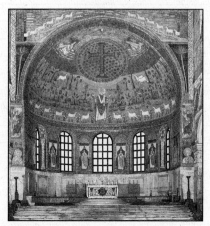

FIG. 12-12 Saint Apollinaris amid sheep, apse mosaic, Sant'Apollinare in Classe, Ravenna, Italy, ca. 533–549. (page 321)

Lat.: 44°22'48.64"N Long.: 12°13'59.81"E

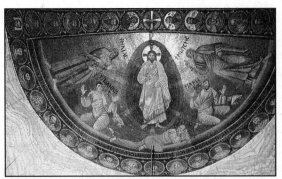

FIG. 12-13 *Transfiguration of Jesus,* apse mosaic, Church of the Virgin, monastery of Saint Catherine, Mount Sinai, Egypt, ca. 548–565. (page 322)

Lat.: 28°33′20.52″N Long.: 33°58′34.58″E

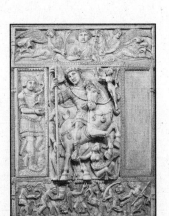

FIG. 12-14 Justinian as world conqueror *(Barberini Ivory),* mid-sixth century. Ivory, 1′ 1 1/2″ × 10 1/2″. Louvre, Paris. (page 323)

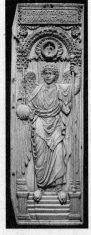

FIG. 12-15 Saint Michael the Archangel, right leaf of a diptych, early sixth century. Ivory, 1′ 5″ × 5 1/2″. (page 324)

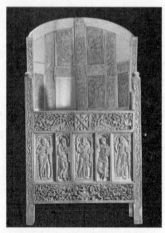

FIG. 12-15A Throne of Maximianus, ca. 546–556. Ivory and wood, 4′ 11″ X 1′ 11 1/2″. Museo Arcivescovile, Ravenna. (page 324)

FIG. 12-16 Anicia Juliana between Magnanimity and Prudence, folio 6 verso of the *Vienna Dioskorides,* from Honoratai, near Constantinople (Istanbul), Turkey, ca. 512. Tempera on parchment, 1′ 3″ × 1′ 11″. Österreichische Nationalbibliothek, Vienna. (page 325)

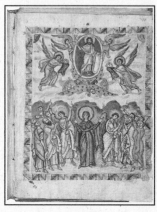

FIG. 12-17 *Ascension of Christ,* folio 13 verso of the *Rabbula Gospels,* from Zagba, Syria, 586. Tempera on parchment, 1′ 1″ × 10 1/2″. Biblioteca Medicea-Laurenziana, Florence. (page 325)

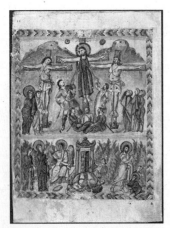

FIG. 12-17A Crucifixion and Resurrection, folio
13 recto of the Rabbula Gospels, from Zagba, Syria,
586. Tempera on parchment, 1′ 1″ X 10 1/2″.
Biblioteca Medicea-Laurenziana, Florence.
(page 325)

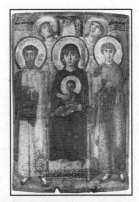

FIG. 12-18 Virgin (Theotokos) and Child between
Saints Theodore and George, icon, sixth or early
seventh century. Encaustic on wood, 2′ 3″ ×
1′ 7 3/8″. Monastery of Saint Catherine, Mount Sinai,
Egypt. (page 326)

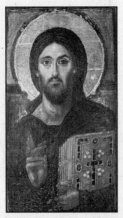

FIG. 12-18A Christ blessing, icon, Monastery of
Saint Catherine, Mount Sinai, Egypt, sixth century.
Encaustic on wood, 2′ 9″ X 1′ 6″. (page 327)

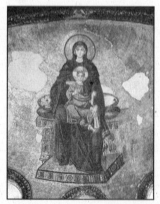

FIG. 12-19 Virgin (Theotokos) and Child enthroned, apse mosaic, Hagia Sophia, Constantinople (Istanbul), Turkey, dedicated 867. (page 327)

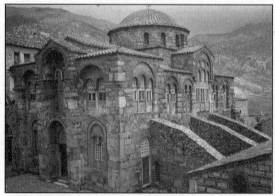

FIG. 12-20 Katholikon, Hosios Loukas, Greece, first quarter of 11th century. (page 328)

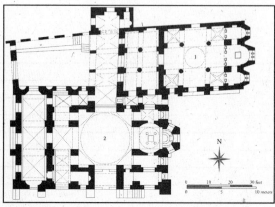

FIG. 12-21 Plan of the Church of the Theotokos *(top)* and the Katholikon *(bottom),* Hosios Loukas, Greece, second half of 10th and first quarter of 11th centuries. (1) Dome on pendentives, (2) dome on squinches. (page 328)

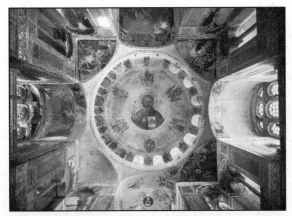

FIG. 12-22 Interior of the Katholikon (looking into the dome), Hosios Loukas, Greece, first quarter of 11th century. (page 329)

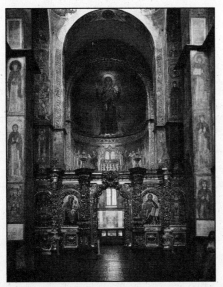

FIG. 12-22A Interior (looking east) of Saint Sophia, Kiev, Ukraine, begun 1037. (page 329)

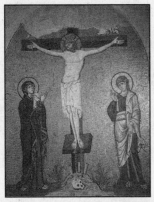

FIG. 12-23 Crucifixion, mosaic in the Church of the Dormition, Daphni, Greece, ca. 1090–1100. (page 330)

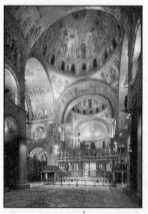

FIG. 12-24 Interior of Saint Mark's (looking east), Venice, Italy, begun 1063. (page 331)

Lat.: 45°26′4.06″N Long.: 12°20′22.35″E

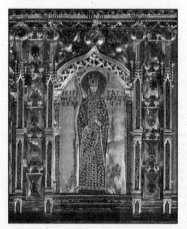

FIG. 12-24A Empress Irene, detail of the Pala d'Oro, Saint Mark's Venice, Italy, ca. 1105. Gold cloisonné inlaid with precious stones, 7″ X 4 1/2″. (page 331)

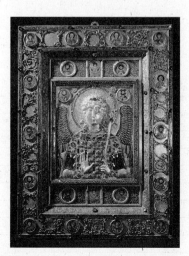

FIG. 12-24B Archangel Michael, icon, from Constantinople, late 10th or early 11th century. Gold, silver gilt, and cloisonné enamel, 1′ 7″ X 1′ 2″. Tesoro di San Marco, Venice. (page 331)

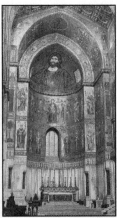

Lat.: 38°4′55.15″N Long.: 13°17′31.93″E

FIG. 12-25 Pantokrator, Theotokos and Child, angels and saints, apse mosaic in the cathedral at Monreale (Sicily), Italy, ca. 1180–1190. (page 332)

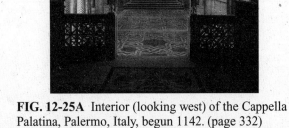

FIG. 12-25A Interior (looking west) of the Cappella Palatina, Palermo, Italy, begun 1142. (page 332)

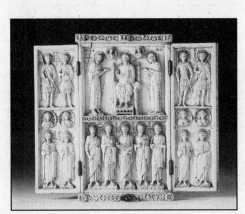

FIG. 12-26 Christ enthroned with saints *(Harbaville Triptych),* ca. 950. Ivory, central panel 9 1/2″ × 5 1/2″. Louvre, Paris. (page 333)

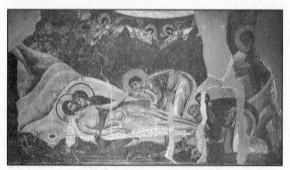

FIG. 12-27 Lamentation over the dead Christ, wall painting, Saint Pantaleimon, Nerizi, Macedonia, 1164. (page 334)

FIG. 12-28 David composing the Psalms, folio 1 verso of the *Paris Psalter,* ca. 950–970. Tempera on vellum, 1′ 2 1/8″ × 10 1/4″. Bibliothèque Nationale, Paris. (page 334)

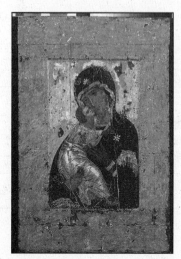

FIG. 12-29 Virgin (Theotokos) and Child, icon *(Vladimir Virgin),* late 11th to early 12th centuries. Tempera on wood, original panel 2′ 6 1/2″ × 1′ 9″. Tretyakov Gallery, Moscow. (page 335)

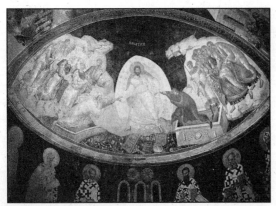

FIG. 12-30 Anastasis, apse fresco in the parekklesion of the Church of Christ in Chora (now the Kariye Museum), Constantinople (Istanbul), Turkey, ca. 1310–1320. (page 336)

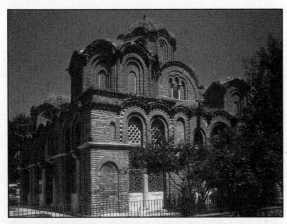

FIG. 12-30A Saint Catherine, Thessaloniki, Greece, ca. 1280. (page 336)

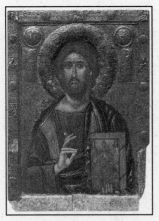

FIG. 12-31 Christ as Savior of Souls, icon from Saint Clement, Ohrid, Macedonia, early 14th century. Tempera, linen, and silver on wood, 3′ 1/4″ × 2′ 2 1/2″. Icon Gallery of Saint C;ement, Ohrid. (page 337)

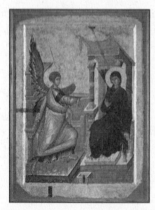

FIG. 12-32 Annunciation, reverse of two-sided icon from Saint Clement, Ohrid, Macedonia, early 14th century. Tempera and linen on wood 3′ 1/4″ × 2′ 2 3/4″. Icon Gallery of Saint Clement, Ohrid. (page 337)

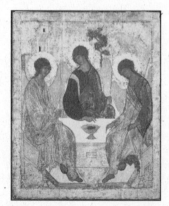

FIG. 12-33 ANDREI RUBLYEV, Three angels (Old Testament Trinity), ca. 1410. Tempera on wood, 4′ 8″ × 3′ 9″. Tretyakov Gallery, Moscow. (page 338)

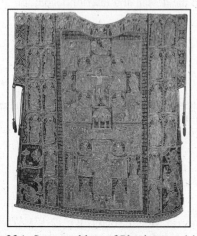

FIG. 12-33A Large sakkos of Photius, ca. 1417. Satin embroidered with gold and silver thread and silk with pearl ornament, 4′ 5″ long. Kremlin Armory, Moscow. (page 338)

1. Why is Hagia Sophia (located at 41° 0′30.21″N, 28°58′48.19″E) considered a supreme accomplishment of world architecture? Describe Hagia Sophia's structural feats. How does the structure's exterior compare to its interior?

2. What term is used to describe the type of image found on the dome of the Church of the Dormition (located at 38° 0′46.34″N, 23°38′9.52″E)? To what other type of Christian image does this type relate? What function did it serve installed on the ceiling of the church?

3. Consider the crucial role light plays in the interior of Saint Mark's (located at 45°26′4.06″N, 12°20′22.35″E). How does the light entering the building take on a mystical quality? How is this aesthetic particularly Byzantine in nature?

4. What features make the architectural design of San Vitale (located at 44°25′14.13″N, 12°11′46.89″E) complex and unusual?

5. Compare and contrast the mosaic image of Christ created for the Church of the Dormition at Daphni (FIG. 12-23) with the earlier image of the Crucifixion created on an ivory box lid (FIG. 11-22). How do the artist's approaches to form and narrative differ?

6. Identify and describe the Early Christian and Byzantine elements to the design and interior decoration of Saint Apollinaris (located at 44°22′48.64″N, 12°13′59.81″E).

7. What political overtones does the image of Christ as Pantokrater suggest in the context of the cathedral at Monreale, located at 38° 4′55.15″N, 13°17′31.93″E and depicted in FIG. 12-25?

8. Compare and contrast the iconography of the Anastasis fresco in the Church of Christ in Chora (FIG. 12-30) with that of the Transfiguration of Jesus from the Church of the Virgin at Mount Sinai (FIG. 12-13). What attention, if any, is paid to setting a scene and suggesting the spiritual nature of the narratives represented?

9. What type of image is the Valdimir Virgin (FIG. 12-29)? How does this image maintain tradition and identify specific elements that maintain tradition as well as particular traits that deviate from convention.

10. What type of structure was the Church of the Virgin, located at 28°33′20.52″N, 33°58′34.58″E, originally? According to the Bible, what event does this site mark?

Chapter 13

The Islamic World

Goals

- Examine the origins and roots of the Islamic faith that are manifest in the art and architecture.
- Understand the near Eastern artistic traditions that shape original forms in the art of Islam.
- Understand and cite architectural developments and the terminology of Islamic religious, funerary and other structures.
- Examine the media, techniques and designs that are specific to the art of Islam, particularly in the 'luxury' arts.
- Understand the contributions of Islamic art and ideas to later western art and culture.

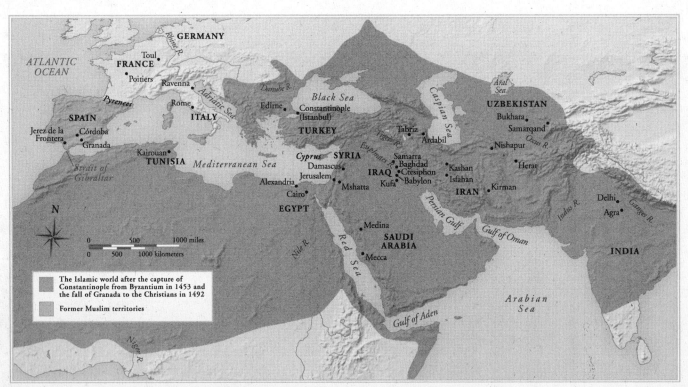

Map 13-1 The Islamic world around 1500. (page 342)'

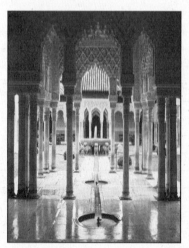

Lat.: 37°10'37.88"N Long.: 3°35'21.39"W

FIG. 13-01 Court of the Lions, Palace of the Lions, Alhambra, Granada, Spain, 1354–1391. (page 340)

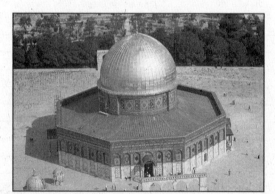

Lat.: 31°46'40.55"N Long.: 35°14'8.79"E

FIG. 13-02 Aerial view of the Dome of the Rock, Jerusalem, 687–692. (page 343)

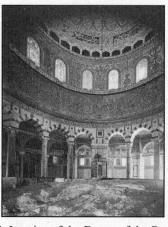

Lat.: 31°46'40.55"N Long.: 35°14'8.79"E

FIG. 13-03 Interior of the Dome of the Rock, Jerusalem, 687–692. (page 344)

FIG. 13-04 Detail of a mosaic in the courtyard arcade of the Great Mosque, Damascus, Syria, 706–715. (page 344)

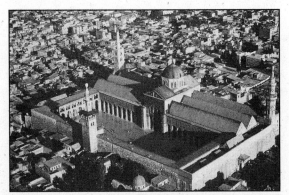

FIG. 13-05 Aerial view of the Great Mosque, Damascus, Syria, 706–715. (page 345)

Lat.: 33°30′41.91″N Long.: 36°18′24.26″E

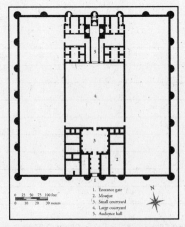

FIG. 13-06 Plan of the Umayyad palace, Mshatta, Jordan, ca. 740–750 (after Alberto Berengo Gardin). (page 346)

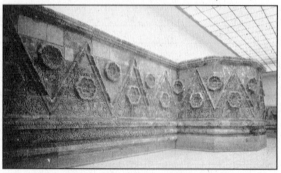

FIG. 13-07 Frieze of the Umayyad palace, Mshatta, Jordan, ca. 740–750. Limestone, 16′ 7″ high. Museum für Islamische Kunst, Staatliche Museen, Berlin. (page 346)

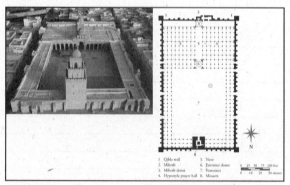

FIG. 13-08 Aerial view *(left)* and plan *(right)* of the Great Mosque, Kairouan, Tunisia, ca. 836–875. (page 347)

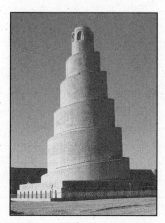

FIG. 13-09 Malwiya Minaret, Great Mosque, Samarra, Iraq, 848–852. (page 347)

Lat.: 34°12′25.40″N Long.: 43°52′48.43″E

225

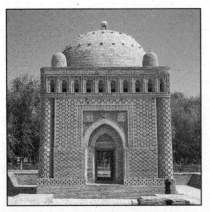

FIG. 13-10 Mausoleum of the Samanids, Bukhara, Uzbekistan, early 10th century. (page 348)

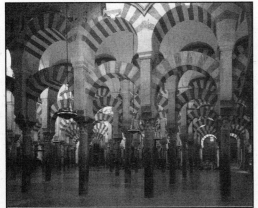

FIG. 13-11 Prayer hall of the Great Mosque, Córdoba, Spain, 8th to 10th centuries. (page 348)

Lat.: 37°52′44.54″N Long.: 4°46′46.18″W

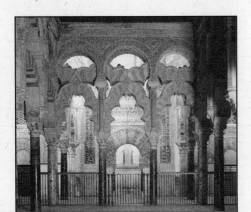

FIG. 13-12 Maqsura of the Great Mosque, Córdoba, Spain, 961–965. (page 349)

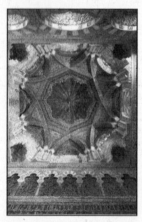

FIG. 13-13 Dome in front of the mihrab of the Great Mosque, Córdoba, Spain, 961–965. (page 349)

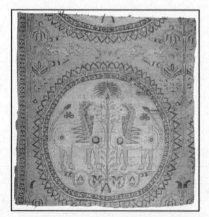

FIG. 13-14 Confronting lions and palm tree, fragment of a textile said to be from Zandana, near Bukhara, Uzbekistan, eighth century. Silk compound twill, 2′ 11″ × 2′ 9 1/2″. Musée Historique de Lorraine, Nancy. (page 350)

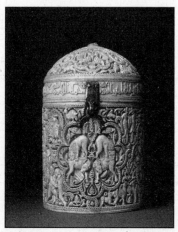

FIG. 13-14A Pyxis of al-Mughira, from Medina al-Zahra, near Córdoba, Spain, 968. Ivory, 5 7/8″ high. Lourvre, Paris. (page 350)

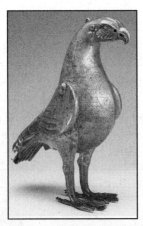

FIG. 13-15 SULAYMAN, Ewer in the form of a bird, 796. Brass with silver and copper inlay, 1′ 3″ high. Hermitage, Saint Petersburg. (page 350)

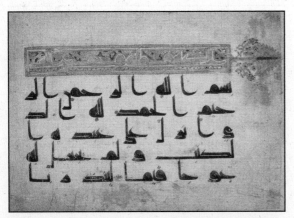

FIG. 13-16 Koran page with the beginning of surah 18, "Al-Kahf" (The Cave), 9th or early 10th century. Ink and gold on vellum 7 1/4″ × 10 1/4″. Chester Beatty Library and Oriental Art Gallery, Dublin. (page 351)

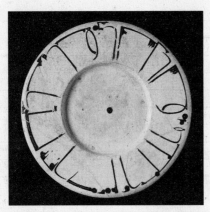

FIG. 13-16A Dish with Arabic proverb, from Nishapur, Iran, 10th century. Painted and glazed earthenware, 1′ 2 1/2″ diameter. Louvre, Paris. (page 351)

FIG. 13-16B Folio from the Blue Koran with
15 lines of surah 2, from Kairouan, Tunisia, 9th to
mid-10th century. Ink, gold, and silver on blue-dyed
vellum, 11 5/16″ X 1″ 2 13/16″. Arthur M. Sackler
Museum, Harvard University, Cambridge
(Francis H. Burr Memorial Fund). (page 351)

FIG. 13-17 Muqarnas dome, Hall of the Two Sisters,
Palace of the Lions, Alhambra, Granada, Spain,
1354–1391. (page 352)

Lat.: 37°10′37.89″N Long.: 3°35′21.05″W

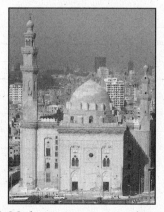

FIG. 13-18 Madrasa-mosque-mausoleum complex
of Sultan Hasan (looking northwest with the
mausoleum in the foreground), Cairo, Egypt, begun
1356. (page 353)

Lat.: 30°1′54.85″N Long.: 31°15′23.91″E

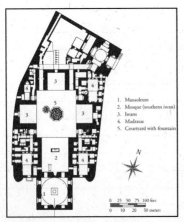

FIG. 13-19 Plan of the madrasa-mosque-mausoleum complex of Sultan Hasan, Cairo, Egypt, begun 1356. (page 353)

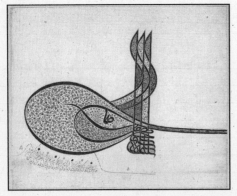

FIG. 13-20 SINAN, Mosque of Selim II, Edirne, Turkey, 1568–1575. (page 354)

Lat.: 41°40′41.39″N Long.: 26°33′33.99″E

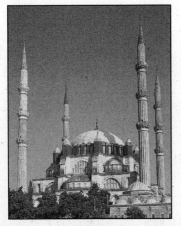

FIG. 13-20A Illuminated tughra of Suleyman the Magnificent, from Constantinople (Istanbul), Turkey, ca. 1555–1560. Ink, paint, and gold on paper, 1′ 8 1/2″ X 2′ 1 3/8″. Metropolitan Museum of Art, New York (Rogers Fund, 1938). (page 355)

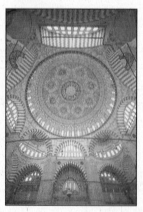

FIG. 13-21 SINAN, interior of the Mosque of Selim II, Edirne, Turkey, 1568–1575. (page 354)

Lat.: 41°40′40.93″N Long.: 26°33′33.99″E

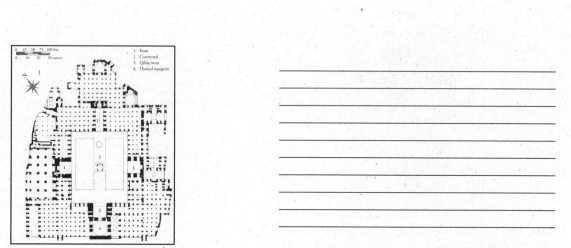

FIG. 13-22 Aerial view (looking southwest) of the Great Mosque, Isfahan, Iran, 11th to 17th centuries. (page 355)

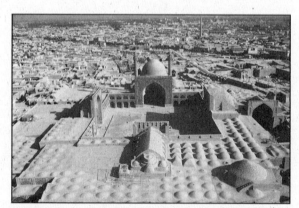

FIG. 13-23 Plan of the Great Mosque, Isfahan, Iran, 11th to 17th centuries. (page 356)

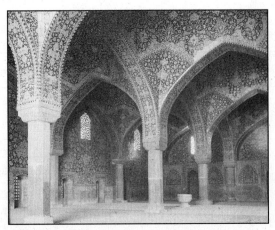

FIG. 13-24 Winter prayer hall of the Shahi (Imam) Mosque, Isfahan, Iran, 1611–1638. (page 356)

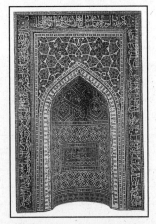

FIG. 13-25 Mihrab from the Madrasa Imami, Isfahan, Iran, ca. 1354. Glazed mosaic tilework, 11′ 3″ × 7′ 6″. Metropolitan Museum of Art, New York. (page 357)

FIG. 13-26 BIHZAD, *Seduction of Yusuf,* folio 52 verso of the *Bustan* of Sultan Husayn Mayqara, from Herat, Afghanistan, 1488. Ink and color on paper, 11 7/8″ × 8 5/8″. National Library, Cairo. (page 358)

FIG. 13-27 SULTAN-MUHAMMAD, *Court of Gayumars,* folio 20 verso of the *Shahnama* of Shah Tahmasp, from Tabriz, Iran, ca. 1525–1535. Ink, watercolor, and gold on paper, 1′ 1″ × 9″. Prince Sadruddin Aga Khan Collection, Geneva. (page 359)

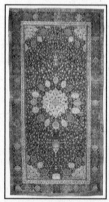

FIG. 13-28 MAQSUD OF KASHAN, carpet from the funerary mosque of Shaykh Safi al-Din, Ardabil, Iran, 1540. Knotted pile of wool and silk, 34′ 6″ x 17′ 7″. Victoria & Albert Museum, London. (page 360)

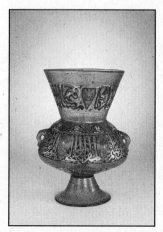

FIG. 13-29 Mosque lamp of Sayf al-Din Tuquztimur, from Egypt, 1340. Glass with enamel decoration, 1′ 1″ high. British Museum, London. (page 361)

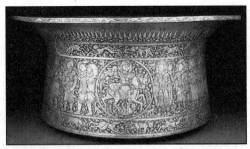

FIG. 13-30 MUHAMMAD IBN AL-ZAYN, basin *(Baptistère de Saint Louis),* from Egypt, ca. 1300. Brass, inlaid with gold and silver, 8 3/4″ high. Louvre, Paris. (page 361)

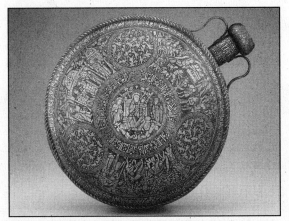

FIG. 13-31 Canteen with episodes from the life of Christ, from Syria, ca. 1240–1250. Brass, inlaid with silver, 1′ 2 1/2″ high. Freer Gallery of Art, Washington, D.C. (page 362)

1. What purpose did the Malwiya minaret (located at 34°12′25.40″N, 43°52′48.43″E) serve?

2. Explore the exterior of the Dome of the Rock, located at 31°46′40.55″N, 35°14′8.79″E. What religious significance does this monument mark for Muslims and Christians? What Muslim and what Christian architectural features are evident?

3. Explore the interior of the Dome of the Rock, located at 31°46′40.55″N, 35°14′8.79″E and depicted in FIG. 13-3. Being original to the monument, what do the decorative elements that cover the interior surface tell us about how the exterior surface once looked?

4. Identify the section of the madrasa complex built by Sultan Hasan and located at 30°1′54.85″N, 31°15′23.91″E. What function did this area of the building serve? Why is the placement of this section considered to have been carefully calculated?

5. What did the architect Sinan accomplish in the design of the Mosque of Selim II, located at 41°40′40.93″N, 26°33′33.99″E?

6. What Greco-Roman and Early Christian elements are evident in the architecture of the Great Mosque of Damascus, located at 33°30′41.91″N, 36°18′24.26″E?

7. What feature distinguishes the minarets of the Mosque of Selim II, located at 41°40′41.39″N, 26°33′33.99″E?

8. From what architectural feature does the Court of the Lions at the Alhambra (located at 37°10′37.88″N, 3°35′21.39″W) derive its name? Why is this particular element unusual in the Islamic world?

9. Describe the architectural form of the Great Mosque at Córdoba (located at 37°52′44.54″N, 4°46′46.18″W). What features distinguish this mosque?

10. From what material is the decorative surface of the ceiling of the Hall of the Two Sisters in the Alhambra palace (37°10′37.89″N, 3°35′21.05″W) made of? What effect does the use of this material have in the space?

Chapter 14

Native Arts of the Americas Before 1300

Goals

- Understand the early history of peoples in the Americas in Paleolithic and Neolithic lifestyles.
- Identify the various Mesoamerican cultures, their chronology, geographic locations.
- Explore the common threads in styles, form, and media throughout Mesoamerican art.
- Examine the cultural commonalities of the various Mesoamerican cultures.
- Explore the visual qualities and media of the early pre-Inka South American cultures.
- Explore the visual qualities and media of the early native North American cultures.

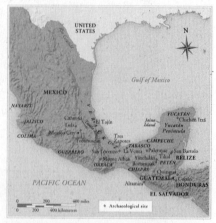

Map 14-1 Early sites in Mesoamerica. (page 366)

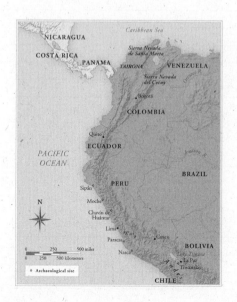

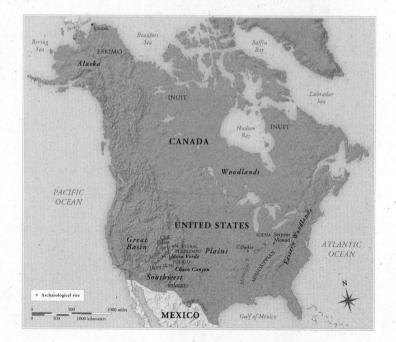

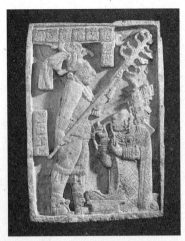

FIG. 14-01 Shield Jaguar and Lady Xoc, Maya, lintel 24 of temple 23, Yaxchilán, Mexico, ca. 725 CE. Limestone, 3′ 7″ × 2′ 6 1/2″. (page 364)

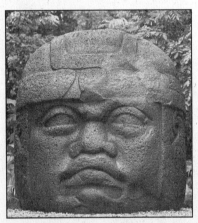

FIG. 14-02 Colossal head, Olmec, La Venta, Mexico, ca. 900–400 BCE. Basalt, 9′ 4″ high. Museo-Parque La Venta, Villahermosa. (page 367)

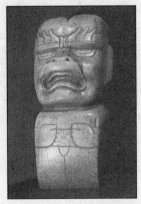

FIG. 14-03 Ceremonial ax in the form of a were-jaguar, Olmec, from La Venta, Mexico, ca. 900–400 BCE. Jadeite, 11 1/2″ high. British Museum, London. (page 367)

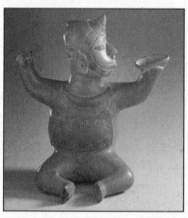

FIG. 14-04 Drinker (seated figure with raised arms), from Colima, Mexico, ca. 200 BCE–500 CE. Clay with orange and red slip, 1′ 1″ high. Los Angeles County Museum of Art (Proctor Stafford Collection, purchased with funds provided by Mr. and Mrs. Allan C. Balch). (page 368)

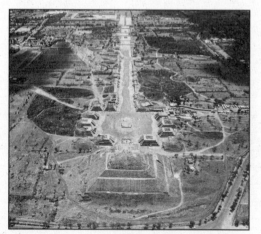

Lat.: 19°41′22.80″N Long.: 98°50′43.73″W

FIG. 14-05 Aerial view of Teotihuacan (looking south), Mexico. Pyramid of the Moon *(foreground),* Pyramid of the Sun *(top left),* and the Citadel *(background),* all connected by the Avenue of the Dead; main structures ca. 50–250 CE. (page 369)

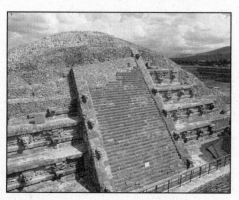

FIG. 14-06 Partial view of the Temple of Quetzalcoatl, the Citadel, Teotihuacan, Mexico, third century CE. (page 370)

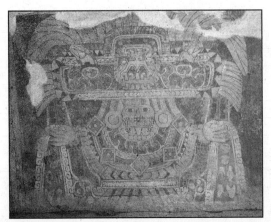

FIG. 14-07 Goddess, mural painting from the Tetitla apartment complex at Teotihuacan, Mexico, 650–750 CE. Pigments over clay and plaster. (page 371)

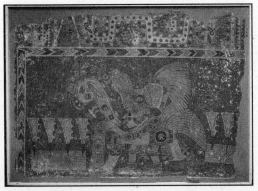

FIG. 14-07A Priest(?) performing a bloodletting rite, mural painting from Teotihuacan, Mexico, ca. 600–700 CE. Pigments over clay and plaster, 2′ 8 1/2″ X 3′ 9 1/2″. Cleveland Museum of Art, Cleveland (J.H. Wade Fund purchase). (page 370)

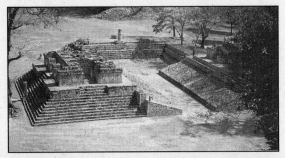

FIG. 14-08 Ball court (view looking north), Maya, Middle Plaza, Copán, Honduras, 738 CE. (page 372)

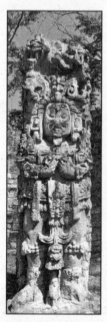

FIG. 14-09 Stele D portraying Ruler 13 (Waxaklajuun-Ub'aah-K'awiil), Maya, Great Plaza, Copán, Honduras, 736 CE. Stone, 11′ 9″. (page 373)

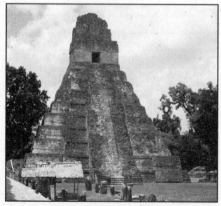

FIG. 14-10 Temple 1 (Temple of the Giant Jaguar), Maya, Tikal, Guatemala, ca. 732 CE. (page 373)

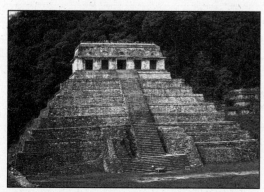

FIG. 14-10A Temple of the Inscriptions (looking south), Maya, Palenque, Mexico, ca. 675–690 CE. (page 373)

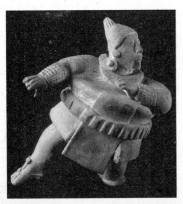

FIG. 14-11 Ball player, Maya, from Jaina Island, Mexico, 700–900 CE. Painted clay, 6 1/4″ high. Museo Nacional de Antropología, Mexico City. (page 374)

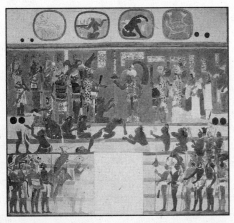

FIG. 14-12 Presentation of captives to Lord Chan Muwan, Maya, room 2 of structure, 1, Bonampak, Mexico, ca. 790 CE. Mural, 17′ × 15′; watercolor copy by Antonio Tejeda. Peabody Museum, Harvard University, Cambridge. (page 375)

FIG. 14-12A Enthroned Maya lord and attendants, cylinder vase, Maya, from Altamira, Mexico, ca. 672–830 CE. Polychrome ceramic, 8″ high. Dumbarton Oaks Research Library and Collections, Washington, D.C. (page 374)

FIG. 14-13 Pyramid of the Niches, Classic Veracruz, El Tajín, Mexico, sixth century CE. (page 376)

Lat.: 20°26′52.52″N Long.: 97°22′40.77″W

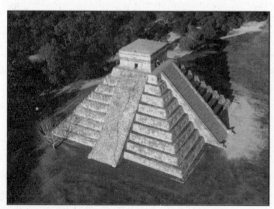

FIG. 14-14 Aerial view (looking southwest) of the Castillo, Maya, Chichén Itzá, Mexico, ca. 800–900 CE. (page 377)

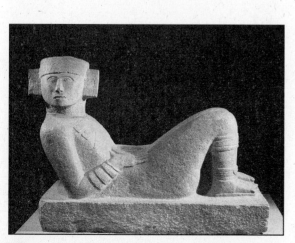

FIG. 14-15 Chacmool, Maya, from the Platform of the Eagles, Chichén Itzá, Mexico, ca. 800–900 CE. Stone, 4′ 10 1/2″ high. Museo Nacional de Antropología, Mexico City. (page 377)

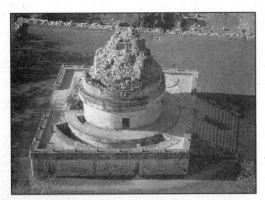

FIG. 14-16 Aerial view (looking south) of the
Caracol, Maya, Chichén Itzá, Mexico,
ca. 800–900 CE. (page 378)

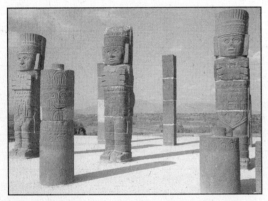

FIG. 14-17 Colossal atlantids, pyramid B, Toltec,
Tula, Mexico, ca. 900–1180 CE. Stone, each 16′ high.
(page 379)

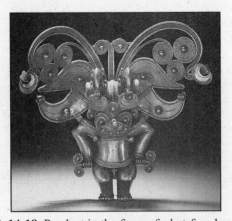

FIG. 14-18 Pendant in the form of a bat-faced man,
Tairona, from northeastern Colombia, after 1000 CE.
Gold, 5 1/4″ high. Metropolitan Museum of Art, New
York (Jan Mitchell and Sons Collection). (page 380)

FIG. 14-19 *Raimondi Stele,* from the main temple, Chavín de Huántar, Peru, ca 800–200 BCE. Incised green diorite, 6′ high. Instituto Nacional de Cultura, Lima. (page 381)

FIG. 14-20 Embroidered funerary mantle, Paracas, from the southern coast of Peru, first century CE. Plain-weave camelid fiber with stem-stitch embroidery of camelid wool, 4′ 7 7/8″ × 7′ 10 7/8″. Museum of Fine Arts, Boston (William A. Paine Fund). (page 382)

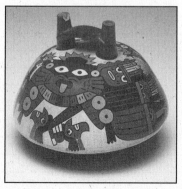

FIG. 14-21 Bridge-spouted vessel with flying figures, Nasca, from Nasca River valley, Peru, ca. 50–200 CE. Painted ceramic, 5 1/2″ high. Art Institute of Chicago, Chicago (Kate S. Buckingham Endowment). (page 383)

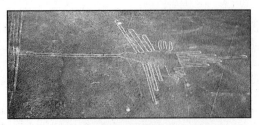

FIG. 14-22 Hummingbird, Nasca, Nasca plain, Peru, ca. 500 CE. Dark layer of pebbles scraped aside to reveal lighter clay and calcite beneath. (page 383)

Lat.: 14°41′32.15″S Long.: 75°8′56.89″W

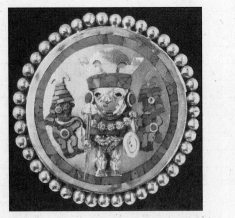

FIG. 14-23 Vessel in the shape of a portrait head, Moche, from the northern coast of Peru, fifth to sixth century, CE. Painted clay, 1′ 1/2″ high. Museo Arqueológico Rafael Larco Herrera, Lima. (page 384)

FIG. 14-24 Ear ornament, Moche, from a tomb at Sipán, Peru, ca. 300 CE. Gold and turquoise, 4 4/5″. Bruning Archaeological Museum, Lambayeque. (page 384)

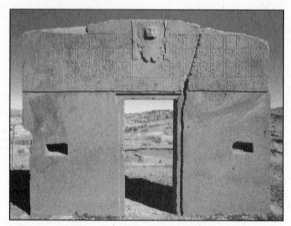

FIG. 14-25 Gateway of the Sun, Tiwanaku, Bolivia, ca. 375–700 CE. Stone, 9′ 10″ high. (page 385)

Lat.: 16°33′17.18″S Long.: 68°40′24.35″W

FIG. 14-26 *Lima Tapestry* (tunic), Wari, from Peru, ca. 500–800 CE. 3′ 3 3/8″ × 2′ 11 3/8″. Museo Nacional de Antropoligía Arqueología e Historia del Perú, Lima. (page 386)

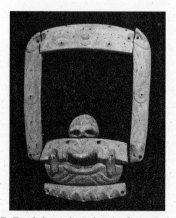

FIG. 14-27 Burial mask, Ipiutak, from Point Hope, Alaska, ca 100 CE. Ivory, greatest width 9 1/2″. American Museum of Natural History, New York. (page 388)

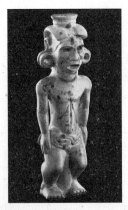

FIG. 14-28 Pipe, Adena, from a mound in Ohio, ca 500–1 BCE. Stone, 8″ high. Ohio Historical Society, Columbus. (page 388)

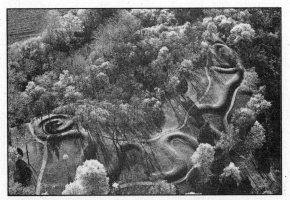

FIG. 14-29 Serpent Mound, Mississippian, Ohio, ca. 1070 CE. 1,200′ long, 20′ wide, 5′ high. (page 389)

Lat.: 39°1′44.75″N Long.: 83°25′32.57″W

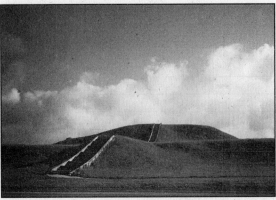

FIG. 14-29A Monk's Mound (looking northwest), Mississippian, Cahokia (East St. Louis), Illinois, ca. 1050–1200. (page 388)

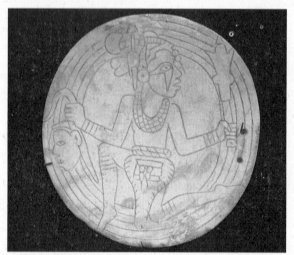

FIG. 14-30 Incised gorget with running warrior, Mississippian, from Sumner County, Tennessee, ca. 1250–1300 CE. Shell, 4″ wide. National Museum of the American Indian, Smithsonian Institution, Washington, D.C. (page 389)

FIG. 14-31 Bowl with two cranes and geometric forms, Mimbres, from New Mexico, ca. 1250 CE. Ceramic, black-on-white, 1′ 1/2″ diameter. Art Institute of Chicago, Chicago (Hugh L. and Mary T. Adams Fund). (page 390)

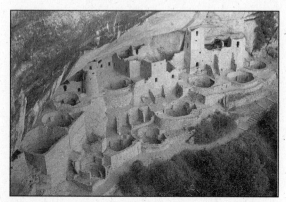

FIG. 14-32 Cliff Palace, Ancestral Puebloan, Mesa Verde National Park, Colorado, ca. 1150–1300 CE. (page 390)

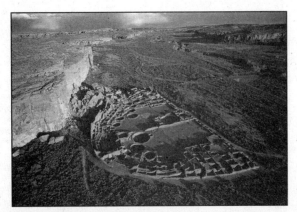

FIG. 14-32A Pueblo Bonito, Ancestral Puebloan, Chaco Canyon, New Mexico, mid-9th to mid-11th centuries. (page 390)

1. Identify the Mesoamerican site located at 19°41'22.80"N, 98°50'43.73"W. Describe the organization of this place. Does it compare to any western cites from around the same time?

2. Describe the three geographic zones that comprise the Central Andean region of South America? (Use Google Earth coordinates, 1°21'50.75"S, 77°32'51.65"W to see the region, and zoom out to analyze the terrain.)

3. From what material was the Gateway of the Sun (located at 16°33'17.18"S, 68°40'24.35"W and depicted in FIG. 14-25) carved? Describe the depictions on the surface of the monolith.

4. What present-day countries did the Mesoamerican region encompass? How did the geographical features of this territory encourage the growth of several civilizations? (Use Google Earth coordinates, 19°52'28.02"N, 95°20'47.28"W to see the region, and zoom out to analyze the terrain.)

5. Describe the structure and architectural features of the Temple of the Giant Jaguar (FIG. 14-10). What function did this monument serve?

6. Discuss the size of the hummingbird image found at 14°41'32.15"S, 75°8'56.89"W. How were such images created and what purpose did they serve?

7. Describe the distinguishing features of Caracol (FIG. 14-16).

8. Identify the pyramid located at 19°40'54.26"N, 98°50'47.28"W and discuss the extraordinary decorative features on its exterior.

9. Describe the structure of the Mesoamerican ball court found in Copán, Honduras (FIG. 14-8). How was this game played? For what possible reasosns was it played?

10. Identify and describe the monument located at 39°1′44.75″N, 83°25′32.57″W. What possible reasons do scholars speculate inspired its construction and form?

11. Describe the image forming the Raimondi Stele (FIG. 14-19). What compositional and stylistic features distinguish this image? What Andean artistic tendencies does it exemplify?

12. Discuss the unusual form of the Pyramid of the Niches (located at 20°26′52.52″N, 97°22′40.77″W) and its relationship to Mesoamerican measurements of time and astronomical observation.

Chapter 15

Africa Before 1800

Goals

- Understand the early history of African peoples and their shared core of beliefs and cultural practices.
- Examine the styles and subject matter of early African rock art and other media used to create art.
- Explore the artistic differences between Central, Western and Southern African art.
- Examine the architecture of Zimbabwe and Ethiopia.
- Evaulate the influx of Islamic and Christian cultures in the art of Africa.

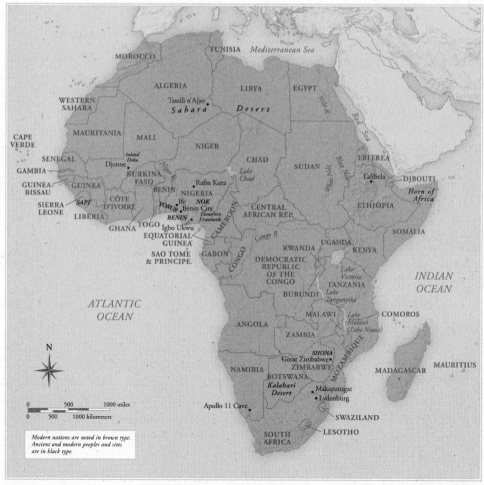

Map 15-1 African peoples and sites before 1800. (page 394)

FIG. 15-01 Detail of the eastern facade of the Great Mosque (FIG. 15-8), Djenne, Mali, begun 13th century, rebuilt 1906–1907. (page 392)

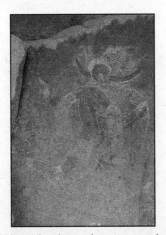

FIG. 15-02 Running horned woman, rock painting, from Tassili n'Ajjer, Algeria, ca. 6000–4000 BCE. (page 395)

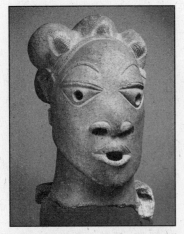

FIG. 15-03 Nok head, from Rafin Kura, Nigeria, ca. 500 BCE–200 CE. Terracotta, 1′ 2 3/16″ high. National Museum, Lagos. (page 396)

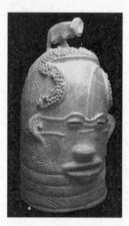

FIG. 15-04 Head, from Lydenburg, South Africa, ca. 500 CE. Terracotta, 1′ 2 15/16″ high. South African Museum, Iziko Museums of Cape Town, Cape Town. (page 396)

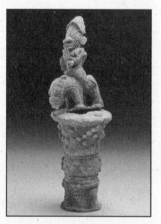

FIG. 15-05 Equestrian figure on fly-whisk hilt, from Igbo Ukwu, Nigeria, 9th to 10th century CE. Copper-alloy bronze, figure 6 3/16″ high. National Museum, Lagos. (page 397)

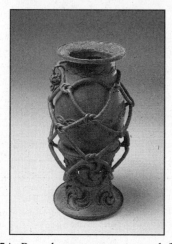

FIG. 15-05A Roped water pot on a stand, from Igbo-Ukwu, Nigeria, 9th to 10th century. Leaded bronze, 1′ 11/16″ high. National Museum, Lagos. (page 397)

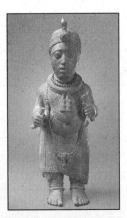

FIG. 15-06 King, from Ita Yemoo (Ife), Nigeria, 11th to 12th century. Zinc-brass, 1′ 6 1/2″ high. Museum of Ife Antiquities, Ife. (page 398)

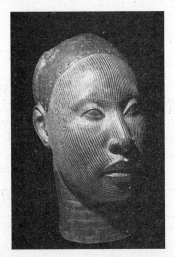

FIG. 15-06A Head of an Ife king, from the Wunmonije Compound, Ile-Ife, Nigeria, 12th to 13th century. Zinc brass, 1′ 1/4″ high. Museum of Ife Antiquities, Ife. (page 399)

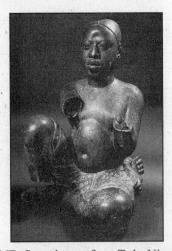

FIG. 15-06B Seated man, from Tada, Nigeria, 13th to 14th century. Copper, 1′ 9 1/8″ high. National Museum, Lagos. (page 399)

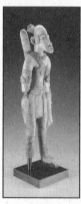

FIG. 15-07 Archer, from Djenne, Mali, 13th to 15th century. Terracotta, 2′ 3/8″ high. National Museum of African Art, Washington, D.C. (page 399)

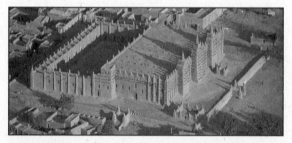

FIG. 15-08 Aerial view of the Great Mosque, Djenne, Mali, begun 13th century, rebuilt 1906–1907. (page 400)

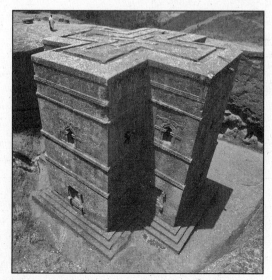

FIG. 15-09 Beta Giorghis (Church of Saint George), Lalibela, Ethiopia, 13th century. (page 400)

Lat.: 12°1′53.52″N Long.: 39°2′28.04″E

257

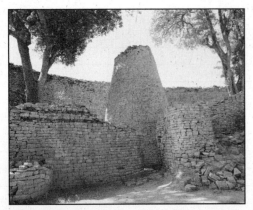

FIG. 15-10 Walls and tower, Great Enclosure, Great Zimbabwe, Zimbabwe, 14th century. (page 401)

Lat.: 20°17′33.56″S Long.: 30°56′20.71″E

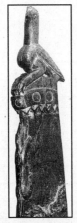

FIG. 15-11 Monolith with bird and crocodile, from Great Zimbabwe, Zimbabwe, 15th century. Soapstone, bird image 1′ 2 1/2″ high. Great Zimbabwe Site Museum, Great Zimbabwe. (page 401)

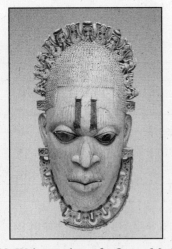

FIG. 15-12 Waist pendant of a Queen Mother, from Benin, Nigeria, ca. 1520. Ivory and iron, 9 3/8″ high. Metropolitan Museum of Art, New York (Michael C. Rockefeller Memorial Collection, gift of Nelson A. Rockefeller, 1972). (page 402)

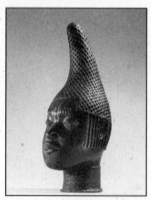

FIG. 15-12A Head of a Queen Mother, from Benin,
Nigeria, ca. 1520–1550. Bronze, 1′ 3 1/3″ high.
British Museum, London. (page 402)

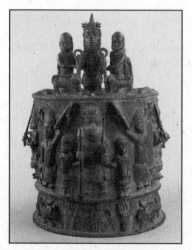

FIG. 15-13 Altar to the Hand and Arm *(ikegobo)*,
from Benin, Nigeria, 17th to 18th century. Bronze,
1′ 5 1/2″ high. British Museum, London. (page 403)

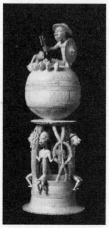

FIG. 15-14 MASTER OF THE SYMBOLIC EXECUTION,
saltcellar, Sapi-Portuguese, from Sierra Leone, ca.
1490–1540. Ivory, 1′ 4 7/8″ high. Museo Nazionale
Preistorico e Etnografico Luigi Pigorini, Rome.
(page 404)

1. What do the figures on the saltcellar illustrated in FIG. 15-14 depict? Under what circumstance was this object most likely created? From what material is it carved?

2. On what part of the body would the ivory masquette illustrated in FIG. 15-12 have been worn?

3. Discuss the structure and possible iconography of the Great Enclosure, located at 20°17′33.56″S, 30°56′20.71″E?

4. Describe how Beta Giorghis (located at 12°1′53.52″N, 39°2′28.04″E) was built. What unique demands did this building method involve? What other architectural forms inspired its form?

5. Discuss the proportions and features of the archer figure from Djenne (FIG. 15-7).

6. Describe and explain the imagery and symbolism incorporated into the Altar to the Hand and Arm (FIG. 15-13)?

7. Discuss the stylistic and compositional features of the running woman from Tassili (FIG. 15-2)?

8. Discuss the idealized naturalism evident in the sculpture of a King from Ife (FIG. 15-6). What features make the style of this depiction unusual when compared to the majority of human depictions African art?

9. Discuss the general features of Nok sculptures, as exemplified by the work depicted in FIG. 15-3? What distin-
 guishes these type of sculpture?

10. Discuss the iconography of the stone monolith from Great Zimbabwe illustrated in FIG. 15-11.

Chapter 16

Early Medieval Europe

Goals

- Understand the distinctive artistic traditions of the European peoples beyond the Roman Empire.
- Know the different types of art, media, and their respective cultures.
- Trace influences of medieval art styles.
- Examine the secular and religious architectural forms in the early middle ages.

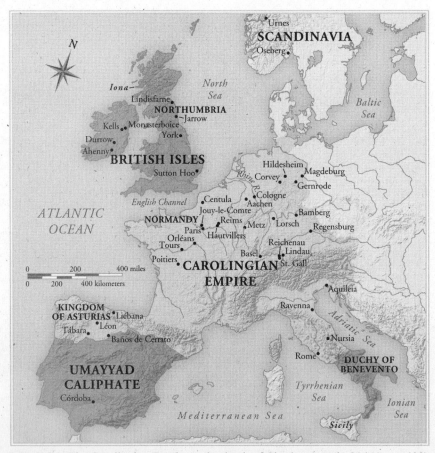

Map 16-1 The Carolingian Empire at the death of Charlemagne in 814. (page 408)

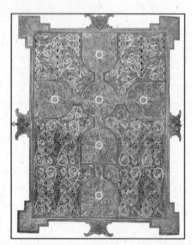

FIG. 16-01 Cross-inscribed carpet page, folio 26 verso of the *Lindisfarne Gospels,* from Northumbria, England, ca. 698–721. Tempera on vellum, 1′ 1 1/2″ × 9 1/4″. British Library, London. (page 406)

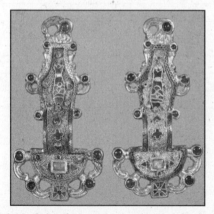

FIG. 16-02 Pair of Merovingian looped fibulae, from Jouy-le-Comte, France, mid-sixth century. Silver gilt worked on filigree, with inlays of garnets and other stones, 4″ high. Musée d'Archéologie nationale, Saint-Germain-en-Laye.(page 408)

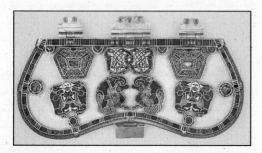

FIG. 16-03 Purse cover, from the Sutton Hoo ship burial in Suffolk, England, ca. 625. Gold, glass, and cloisonné garnets, 7 1/2″ long. British Museum, London. (page 409)

FIG. 16-03A Belt buckle, from the Sutton Hoo ship burial in Suffolk, England, ca. 625. Gold, 5 1/4″ long. British Museum, London. (page 409)

FIG. 16-04 Animal-head post, from the Viking ship burial, Oseberg, Norway, ca. 825. Wood, head 5″ high. University Museum of National Antiquities, Oslo. (page 410)

FIG. 16-04A Viking ship burial, Oseberg, Norway, ca. 815–820. Wood, 70′ 10 3/8″ long. Viking Ship Museum, University of Oslo, Bygdoy. (page 410)

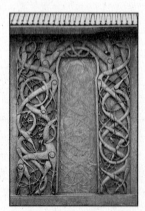

FIG. 16-05 Wooden portal of the stave church at Urnes, Norway, ca. 1050–1070. (page 411)

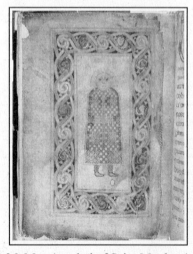

FIG. 16-06 Man (symbol of Saint Matthew), folio 21 verso of the *Book of Durrow*, possibly from Iona, Scotland, ca. 660–680. Ink and tempera on parchment, 9 5/8″ × 6 1/8″. Trinity College Library, Dublin. (page 412)

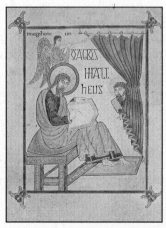

FIG. 16-07 Saint Matthew, folio 25 verso of the *Lindisfarne Gospels,* from Northumbria, England, ca. 698–721. Tempera on vellum, 1′ 1/2″ × 9 1/4″. British Library, London. (page 413)

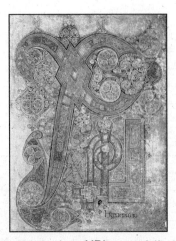

FIG. 16-08 Chi-rho-iota (XPI) page, folio 34 recto of the *Book of Kells,* probably from Iona, Scotland, late eighth or early ninth century. Tempera on vellum, 1′ 1″ × 9 1/2″. Trinity College Library, Dublin. (page 414)

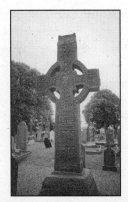

FIG. 16-09 *High Cross of Muiredach* (east face), Monasterboice, Ireland, 923. Sandstone, 18′ high. (page 414)

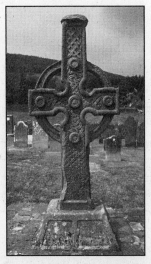

FIG. 16-09A South Cross, Ahenny, Ireland, late 8th century. Sandstone, 12′ 9 1/2″ high. (page 414)

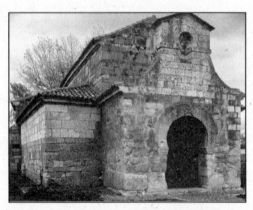

FIG. 16-10 San Juan Bautista, Baños de Cerrato, Spain, 661. (page 415)

Lat.: 41°55′15.32″N Long.: 4°28′21.57″W

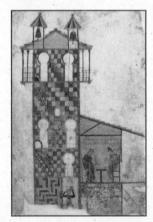

FIG. 16-11 EMETERIUS, the tower and scriptorium of San Salvador de Tábara, colophon (folio 168) of the *Commentary on the Apocalypse* by Beatus, from Tábara, Spain, 970. Tempera on parchment, 1′ 2 1/8″ × 10″. Archivo Histórico Nacional, Madrid. (page 415)

FIG. 16-12 Equestrian portrait of Charlemagne or Charles the Bald, from Metz, France, ninth century. Bronze, originally gilt, 9 1/2″ high. Louvre, Paris. (page 416)

FIG. 16-13 Saint Matthew, folio 15 recto of the *Coronation Gospels (Gospel Book of Charlemagne),* from Aachen, Germany, ca. 800–810. Ink and tempera on vellum, 1′ 3/4″ × 10″. Schatzkammer, Kunsthistorisches Museum, Vienna. (page 417)

FIG. 16-13A Christ enthroned, folio 3 recto of the Godescalc Lectionary, 781–783. Ink, gold, and colors on vellum, 1′ 5/8″ X 8 1/4″. Bibliothèque Nationale, Paris. (page 417)

FIG. 16-14 Saint Matthew, folio 18 verso of the *Ebbo Gospels (Gospel Book of Archbiship Ebbo of Reims),* from Hautvillers (near Reims), France, ca. 816–835. Ink and tempera on vellum, 10 1/4″ × 8 3/4″. Bibliothèque Municipale, Épernay. (page 417)

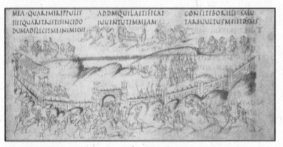

FIG. 16-15 Psalm 44, detail of folio 25 recto of the *Utrecht Psalter,* from Hautvillers (near Reims), France, ca. 820–835. Ink on vellum, full page, 1′ 1″ × 9 7/8″; detail, 4 1/2″ high. University Library, Utrecht. (page 418)

FIG. 16-15A Psalm 57, folio 13 recto of the Utrecht Psalter, from Hautvillers (near Reims), France, ca. 820–835. Ink on vellum, 1′ 1″ X 9 7/8″. University Library, Utrecht. (page 418)

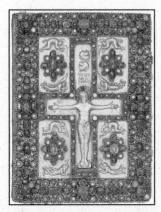

FIG. 16-16 Crucifixion, front cover of the *Lindau Gospels,* from Saint Gall, Switzerland, ca. 870. Gold, precious stones, and pearls, 1′ 1 3/8″ × 10 3/8″. Pierpont Morgan Library, New York. (page 418)

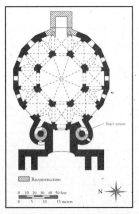

FIG. 16-17 Restored plan of the Palatine Chapel of Charlemagne, Aachen, Germany, 792–805. (page 419)

Lat.: 50°46′29.13″N Long.: 6°5′2.86″E

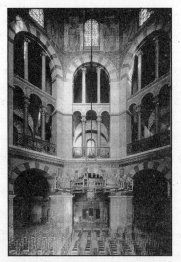

FIG. 16-18 Interior of the Palatine Chapel of Charlemagne, Aachen, Germany, 792–805. (page 419)

FIG. 16-19 Schematic plan for a monastery at Saint Gall, Switzerland, ca. 819. Red ink on parchment, 2′ 4″ x 3′ 8 1/8″. Stiftsbibliothek, Saint Gall. (page 420)

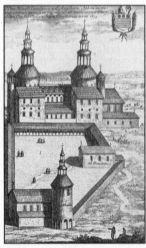

FIG. 16-19A Abbey of Saint-Riquier, Centula, France, 790–799, in an engraving of 1612 after a lost 11th-century manuscript illumination. Bibliothèque Nationale, Paris. (page 421)

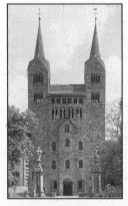

FIG. 16-20 Westwork of the abbey church, Corvey, Germany, 873–885. (page 421)

Lat.: 51°46′41.36″N Long.: 9°24′36.93″E

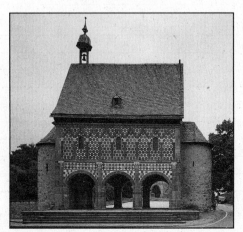

FIG. 16-20A Torhalle, Lorsch, Germany, late eighth or ninth century. (page 421)

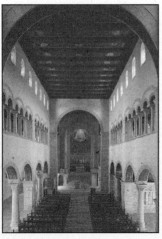

FIG. 16-21 Nave of the church of Saint Cyriakus, Gernrode, Germany, 961–973. (page 422)

Lat.: 51°43′27.13″N Long.: 11°8′10.80″E

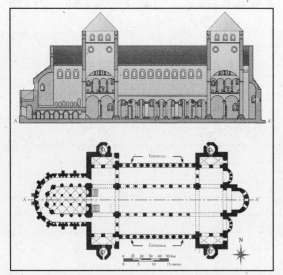

FIG. 16-22 Saint Michael's, Hildesheim, Germany, 1001–1031. (page 423)

Lat.: 52°9′10.28″N Long.: 9°56′36.77″E

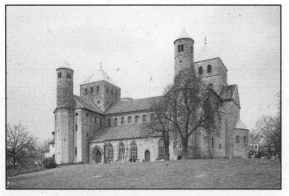

FIG. 16-23 Longitudinal section *(top)* and plan *(bottom)* of the abbey church of Saint Michael's, Hildesheim, Germany, 1001–1031. (page 423)

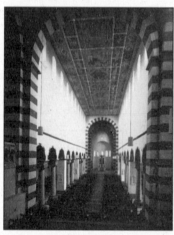

FIG. 16-23A Nave (looking east) of Saint Michael's, Hildesheim, 1001–1031. (page 423)

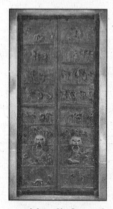

FIG. 16-24 Doors with relief panels (Genesis, left door; life of Christ, right door), commissioned by Bishop Bernward for Saint Micheael's, Hildesheim, Germany, 1015. Bronze, 16′ 6″ high. Dom-Museum, Hildesheim. (page 424)

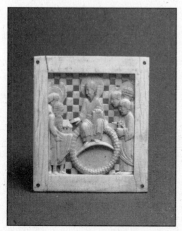

FIG. 16-24A Otto I presenting Magdeburg Cathedral to Christ, from Magdeburg Cathedral, Magdeburg, Germany, 962–968. Ivory, 5″ X 4 1/2″. Metropolitan Museum of Art, New York (gift of George Blumenthal, 1941). (page 424)

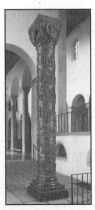

FIG. 16-25 Column with reliefs illustrating the life of Christ, commissioned by Bishop Bernward for Saint Michael's, Hildesheim, Germany, ca. 1015–1022. Bronze, 12′ 6″ tall. Dom-Museum, Hildesheim. (page 425)

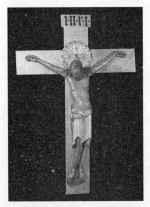

FIG. 16-26 Crucifix commissioned by Archbishop Gero for Cologne Cathedral, Cologne, Germany, ca. 970. Painted wood, height of figure 6′ 2″. Cathedral, Cologne. (page 425)

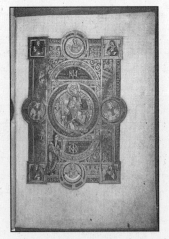

FIG. 16-27 Abbess Uta dedicating her codex to the Virgin, folio 2 recto of the *Uta Codex,* from Regensburg, Germany, ca. 1025. Tempera on parchment, 9 5/8″ × 5 1/8″. Bayerische Staatsbibliothek, Munich. (page 426)

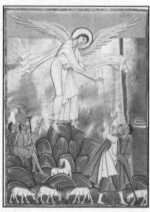

FIG. 16-28 Annunciation to the Shepherds, folio in the *Lectionary of Henry II,* from Reichenau, Germany, 1002–1014. Tempera on vellum, 1′ 5″ × 1′ 1″. Bayerische Staatsbibliothek, Munich. (page 427)

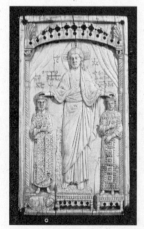

FIG. 16-28A Christ blessing Otto II and Theophanu, 972–973. Ivory, 7 1/8″ X 4″. Musée National du Moyen Age, Paris. (page 428)

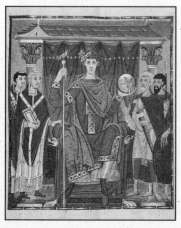

FIG. 16-29 Otto III enthroned, folio 24 recto of the *Gospel Book of Otto III,* from Reichenau, Germany, 997–1000. Tempera on vellum, 1′ 1″ × 9 3/8″. Bayerische Staatsbibliothek, Munich. (page 428)

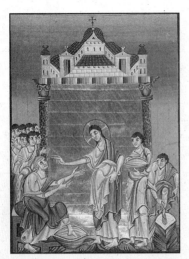

FIG. 16-29A Jesus washing the feet of Saint Peter, folio 237 recto of the Gospel Book of Otto III, 997–1000. Tempera on vellum, 1′ 1″ X 9 3/8″. Bayerische Staatsbibliothek, Munich. (page 428)

1. Compare and contrast the depictions of the crucifixion on the front cover of the Lindau Gospels (FIG. 16-16) and the Gero Crucifix (FIG. 16-26). What factors may account for the distinct differences in these depictions?

2. What architectural precedent may have inspired the plan and location of the entrances of Saint Michael's at Hildesheim (located at 52° 9'10.28"N, 9°56'36.77"E)?

3. Compare, contrast and describe the design and architectural features of the Palatine Chapel of Charlemagne (located at 50°46'29.13"N, 6°5'2.86"E and depicted in FIG. 16-17 & 16-18) with that of San Vitale (located at 44°25'14.13"N, 12°11'46.89"E and depicted in FIG. 12-6).

4. From what artistic tradition does the design on the portal of the stave church at Urnes derive (FIG. 16-5)?

5. What functions did the westwork of the abbey church at Corvey (located at 51°46'41.36"N, 9°24'36.93"E and depicted in FIG. 16-20) serve?

6. Consider why the Book of Kells (FIG. 16-8) is considered the greatest achievement of Hiberno-Saxon art. What features make the manuscript remarkable?

7. Who built the church of San Juan Bautista, located at 41°55'15.32"N, 4°28'21.57"W? What architectural features associate the building with this group?

8. Compare, contrast and describe the depictions of Saint Matthew from the Coronation Gospels (FIG 16-13) with that in the Ebbo Gospels (FIG. 16-14). What factors may account for the remarkable differences in approach between these two author portraits?

9. Identify and describe the Ottonian architectural elements in the church of Saint Cyriakus, located at 51°43'27.13"N, 11°8'10.80"E.

10. Describe and explain the imagery employed on the Sutton Hoo purse cover depicted in FIG. 16-3. What artistic tradition does this work represent? What technique and materials were used to create it?

Chapter 17

Romanesque Europe

Goals

- Understand the term "Romanesque" in designating the artistic style of an historic period.
- Examine the need for large scale pilgrimage churches, the growth of architecture and urban centers.
- Understand the 'millennial' and apocalyptic mood of the Romanesque era and their impact on artistic themes.
- Understand the role of relics and the artistic objects designed to contain relics.
- Recognize differences and similarities in regional Romanesque architecture and artistic styles.
- Understand the narrative function of the human figure in Romanesque sculpture.

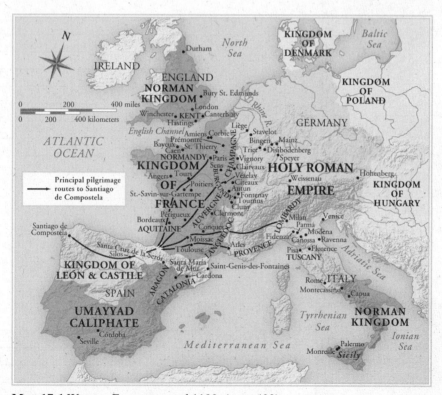

Map 17-1 Western Europe around 1100. (page 432)

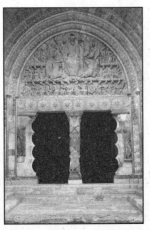

FIG. 17-01 South portal of Saint-Pierre, Moissac, France, ca. 1115–1135. (page 430)

Lat.: 44°6′20.13″N Long.: 1°5′5.10″E

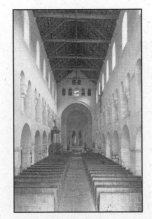

FIG. 17-02 Interior of Saint-Étienne, Vignory, France, 1050–1057. (page 433)

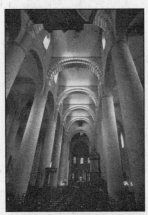

FIG. 17-02A Interior (looking east) of Saint-Philibert, Tournus, France. Vaults, ca. 1060. (page 433)

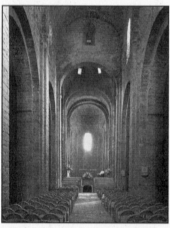

FIG. 17-02B Interior (looking east) of Sant Vicenç, Cardona, Spain, ca. 1029–1040. (page 433)

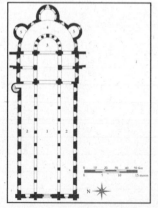

FIG. 17-03 Plan of Saint-Étienne, Vignory, France, 1050–1057. (1) nave, (2) aisles, (3) choir, (4) ambulatory, (5) radiating chapels. (page 433)

Lat.: 48°16′39.53″N Long.: 5°6′17.57″E

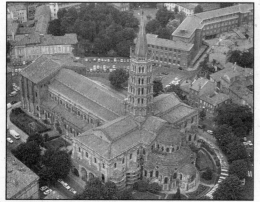

FIG. 17-04 Aerial view (looking northwest) of Saint-Sernin, Toulouse, France, ca. 1070–1120. (page 434)

Lat.: 43°36′30.59″N Long.: 1°26′31.86″E

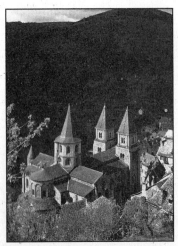

FIG. 17-04A Aerial view (looking southwest) of Sainte-Foy, Conques, France, mid 11th to early 12th century. (page 434)

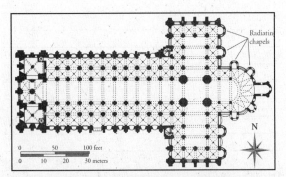

FIG. 17-05 Plan of Saint-Sernin, Toulouse, France, ca. 1070–1120 (after Kenneth John Conant). (page 434)

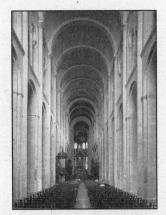

FIG. 17-06 Interior of Saint-Sernin, Toulouse, France, ca. 1070–1120. (page 434)

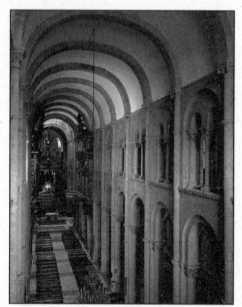

FIG. 17-06A Interior (looking east) of Saint James, Santiago de Compostela, Spain, ca. 1075–1120. (page 435)

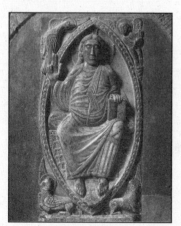

FIG. 17-07 BERNARDUS GELDUINUS, Christ in Majesty, relief in the ambulatory of Saint-Sernin, Toulouse, France, ca. 1096. Marble, 4′ 2″ high. (page 436)

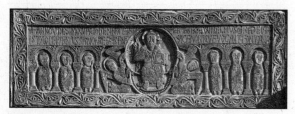

FIG. 17-07A Christ in Majesty (Maiestas Domini) with apostles, lintel over the doorway of the abbey church, Saint-Genis-des-Fontaines, France, 1019–1020. Marble, 2′ × 7′. (page 436)

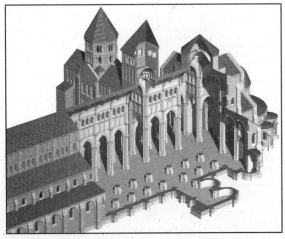

FIG. 17-08 Restored cutaway view of the third abbey church (Cluny III), Cluny, France, 1088–1130 (John Burge). (page 437)

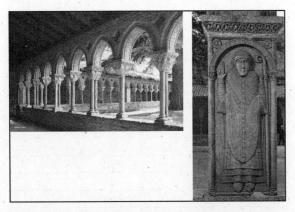

FIG. 17-09 General view of the cloister *(left)* and detail of the pier with the relief of Abbot Durandus *(right),* Saint-Pierre, Moissac, France, ca. 1100–1115. Relief: limestone, 6′ high. (page 438)

Lat.: 44°6′20.13″N Long.: 1°5′5.10″E

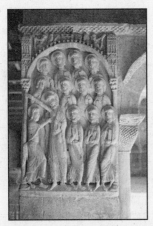

FIG. 17-09A Christ, Doubting Thomas, and apostles, pier relief in the cloister of the abbey church of Santo Domingo, Silos, Spain, ca. 1090–1100. (page 438)

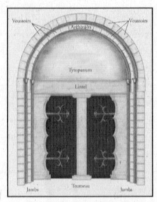

FIG. 17-10 The Romanesque church portal. (page 439)

FIG. 17-11 Lions and Old Testament prophet (Jeremiah or Isaiah?), trumeau of the south portal of Saint-Pierre, Moissac, France, ca. 1115–1130. (page 440)

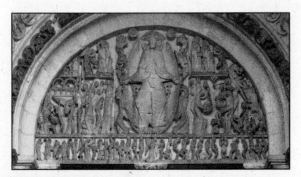

FIG. 17-12 GISLEBERTUS, Last Judgment, west tympanum of Saint-Lazare, Autun, France, ca. 1120–1135. Marble, 21′ wide at base. (page 441)

FIG. 17-12A GISLEBERTUS, Suicide of Judas, historiated capital from the nave of Saint-Lazare, Autun, France, ca. 1120–1135. Musée Lapidaire, Autun. (page 440)

FIG. 17-12B GISLEBERTUS, Eve, detail of the lintel of the north portal of Saint-Lazare, Autun, France, ca. 1120–1135. Stone, 2′ 4 1/2″ × 4′ 3″. Musée Rolin, Autun. (page 440)

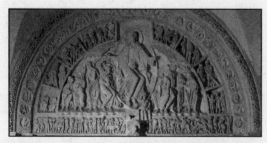

FIG. 17-13 Pentecost and Mission of the Apostles, tympanum of the center portal of the narthex of La Madeleine, Vézelay, France, 1120–1132. (page 441)

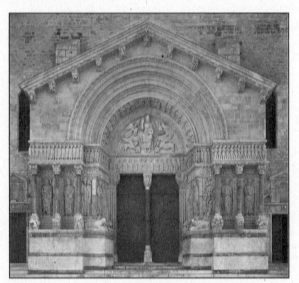

FIG. 17-13A Central portal of the west facade of Saint-Trophîme, Arles, France, mid-12th century. (page 442)

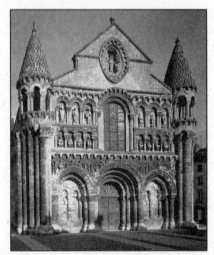

FIG. 17-13B West facade, Notre-Dame-la-Grande, Poitiers, France, ca. 1130–1150. (page 442)

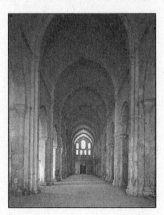

FIG. 17-14 Interior of the abbey church of Notre-Dame, Fontenay, France, 1139–1147. (page 443)

Lat.: 47°38′23.52″N Long.: 4°23′23.03″E

FIG. 17-15 Initial *R* with knight fighting dragons, folio 4 verso of the *Moralia in Job,* from Cîteaux, France, ca. 1115–1125. Ink and tempera on vellum, 1′ 1 3/4″ × 9 1/4″. Bibliothèque Municipale, Dijon. (page 443)

FIG. 17-15A Initial L and Saint Matthew, folio 10 recto of the Codex Colbertinus, from Moissac, France, ca. 1100. Tempera on vellum, 7 1/2″ × 4″. Bibliothèque Nationale, Paris. (page 443)

FIG. 17-15B Saint Mark, folio 53 recto of the Corbie Gospels, from Corbie, France, ca. 1120. Tempera on vellum, 10 3/4″ × 7 7/8″. Bibliothèque Municipale, Amiens. (page 444)

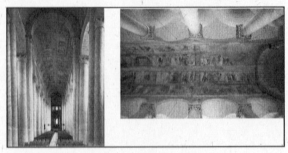

FIG. 17-16 Nave *(left)* and painted nave vault *(right)* of the abbey church, Saint-Savin-sur-Gartempe, France, ca. 1100. (page 444)

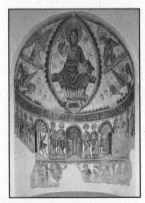

FIG. 17-17 Christ in Majesty, apse, Santa María de Mur, near Lérida, Spain, mid-12th century. Fresco, 24′ × 22′. Museum of Fine Arts, Boston. (page 444)

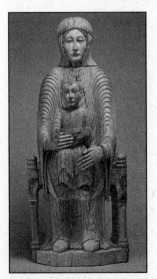

FIG. 17-18 Virgin and Child *(Morgan Madonna),* from Auvergne, France, second half of 12th century. Painted wood, 2′ 7″ high. Metropolitan Museum of Art. New York (gift of J. Pierpont Morgan, 1916). (page 445)

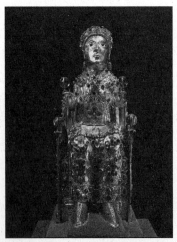

FIG. 17-18A Reliquary statue of Sainte-Foy, late 10th to early 11th century with later additions. Gold, silver gilt, jewels, and cameos over a wooden core, 2′ 9 1/2″ high. Treasury, Sainte-Foy, Conques. (page 445)

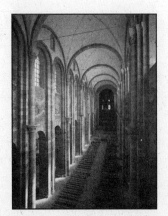

FIG. 17-19 Interior of Speyer Cathedral, Speyer, Germany, begun 1030; nave vaults, ca. 1082–1105. (page 446)

Lat.: 49°19′1.55″N Long.: 8°26′33.16″E

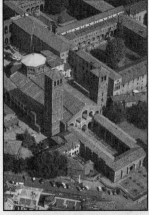

FIG. 17-20 Aerial view of Sant'Ambrogio, Milan, Italy, late 11th to early 12th century. (page 446)

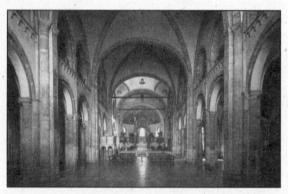

FIG. 17-21 Interior of Sant'Ambrogio, Milan, Italy, late 11th to early 12th century. (page 447)

FIG. 17-22 Hildegard receives her visions, detail of a facsimile of a lost folio in the Rupertsberger *Scivias* by Hildegard of Bingen, from Trier or Bingen, Germany, ca. 1150–1179. Abbey of St. Hildegard, Rüdesheim/Eibingen. (page 448)

FIG. 17-22A RUFILLUS, Initial L, folio 224 recto of a Passional, from Weissenau, Germany, ca. 1170–1200. Ink and tempera on vellum, full page 1′ 3 7/8″ × 1′. Bibliotheca Bodmeriana, Geneva.

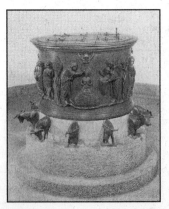

FIG. 17-23 RAINER OF HUY, baptism of Christ, baptismal font from Notre-Dame-des-Fonts, Liège, Belgium, 1118. Bronze, 2′ 1″ high. Saint-Barthélémy, Liège. (page 449)

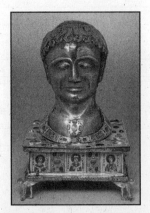

FIG. 17-24 Head reliquary of Saint Alexander, from Stavelot Abbey, Belgium, 1145. Silver repoussé (partly gilt), gilt bronze, gems, pearls, and enamel, 1′ 5 1/2″ high. Musées Royaux d'Art et d'Histoire, Brussels. (page 449)

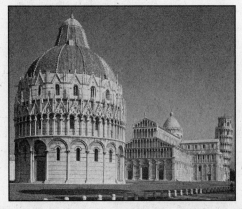

FIG. 17-25 Cathedral complex, Pisa, Italy; cathedral begun 1063; baptistery begun 1153; campanile begun 1174. (page 450)

Lat.: 43°43′24.60″N Long.: 10°23′42.72″E

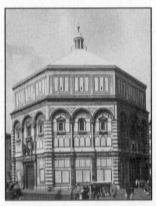

FIG. 17-26 Baptistery of San Giovanni, Florence, Italy, dedicated 1059. (page 451)

Lat.: 43°46′23.69″N Long.: 11°15′17.02″E

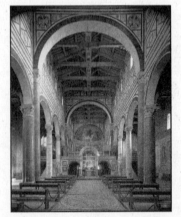

FIG. 17-27 Interior of San Miniato al Monte, Florence, Italy, ca. 1062–1090. (page 452)

Lat.: 43°45′35.58″N Long.: 11°15′53.47″E

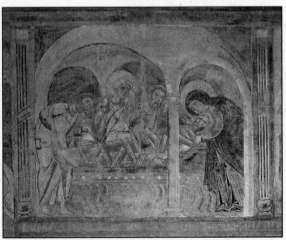

FIG. 17-27A Entombment of Christ, fresco above the nave arcade, Sant'Angelo in Formis, near Capua, Italy, ca. 1085. (page 452)

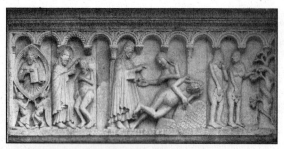

FIG. 17-28 Wiligelmo, creation and temptation of Adam and Eve, detail of the frieze on the west facade, Modena Cathedral, Modena, Italy, ca. 1110. Marble, 3′ high. (page 452)

Lat.: 44°38′47.30″N Long.: 10°55′32.80″E

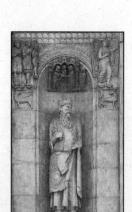

FIG. 17-29 Benedetto Antelami, King David, statue in a niche on the west facade of Fidenza Cathedral, Fidenza, Italy, ca. 1180–1190. Marble, life-size. (page 453)

Lat.: 44°51′59.25″N Long.: 10°3′28.17″E

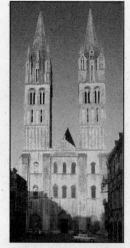

FIG. 17-30 West facade of Saint-Étienne, Caen, France, begun 1067. (page 453)

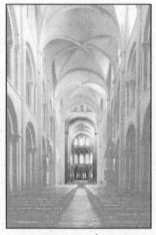

FIG. 17-31 Interior of Saint-Étienne, Caen, France, vaulted ca. 1115–1120. (page 454)

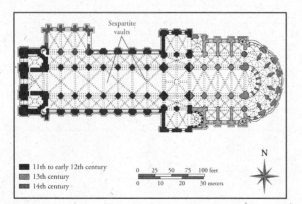

FIG. 17-32 Plan of Saint-Étienne, Caen, France. (page 454)

Lat.: 49°10′54.51″N Long.: 0°22′22.22″W

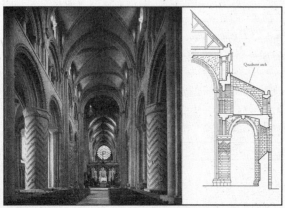

FIG. 17-33 Interior *(left)* and lateral section *(right)* of Durham Cathedral, England, begun ca. 1093. (page 455)

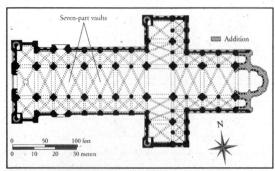

FIG. 17-34 Plan of Durham Cathedral, England (after Kenneth John Conant). (page 455)

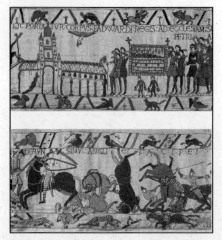

FIG. 17-35 Funeral procession to Westminster Abbey *(top)* and Battle of Hastings *(bottom),* details of the *Bayeux Tapestry,* from Bayeux Cathedral, Bayeux, France, ca. 1070–1080. Embroidered wool on linen, 1′ 8″ high (entire length of fabric 229′ 8″). Centre Guillaume le Conquérant, Bayeux. (page 456)

FIG. 17-36 Master Hugo, Moses expounding the Law, folio 94 recto of the *Bury Bible,* from Bury Saint Edmunds, England, ca. 1135. Ink and tempera on vellum, 1′ 8″ × 1′ 2″. Corpus Christi College, Cambridge. (page 457)

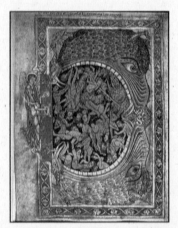

FIG. 17-36A Mouth of Hell, folio 39 recto of the Winchester Psalter, from Winchester, England, ca. 1145–1155. Tempera and ink on vellum, 1′ 3/4″ × 9 1/8″. British Library, London. (page 457)

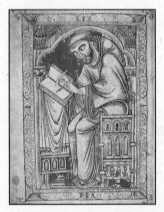

FIG. 17-37 EADWINE THE SCRIBE, Eadwine the Scribe at work, folio 283 verso of the *Eadwine Psalter*, ca. 1160–1170. Ink and tempera on vellum. Trinity College, Cambridge. (page 458)

1. Discuss the design of Saint-Etienne at Vignory (located at 48°16′39.53″N, 5°6′17.57″E and depicted in FIG. 17-3). What features were inspired by previous models? What features reflect the developing Romanesque style?

2. Discuss how the plan, size and architectural features of Saint-Sernin, located at 43°36′30.59″N, 1°26′31.86″E, accommodated the large numbers of pilgrims and worshippers who regularly visited the church?

3. Identify and describe the architectural features of the cathedral at Pisa (located at 43°43′24.60″N, 10°23′42.72″E and depicted in FIG. 17-25) that are in keeping with the Romanesque style and those features that diverge from the Romanesque.

4. What functions do the diaphragm arches in the abbey church of San Miniato al Monte (located at 43°45′35.58″N, 11°15′53.47″E and depicted in FIG. 17-27) serve?

5. Identify and describe the distinguishing features of the frieze on the façade of the Modena Cathedral, located at 44°38′47.30″N, 10°55′32.80″E and depicted in FIG. 17-28.

6. What architectural features make Sant'Ambrogio (FIG. 17-20) remarkable? What previous styles seem to have inspired its plan?

7. What architectural problem did the design of Speyer Cathedral (located at 49°19′1.55″N, 8°26′33.16″E and depicted in FIG. 17-19) successfully address and resolve?

8. What spiritual activities did the cloister of Saint-Pierrre (located at 44°6′20.13″N, 1°5′5.10″E) facilitate and encourage?

9. What elements of the design of Saint-Étienne (located at 49°10′54.51″N, 0°22′22.22″W) make it an extraordinary example of Norman Romanesque architecture?

10. What important religious and civic functions did freestanding Italian baptisteries, like that of San Giovanni in Florence, located at 43°46′23.69″N, 11°15′17.02″E, serve?

11. Why are the Old Testament figures (FIG. 17-29) carved for the west façade of Fidenza Cathedral (located at 44°51′59.25″N, 10°3′28.17″E) considered unusual?

12. What Cistercian beliefs are reflected in the form and approach to architectural design of the church of Notre-Dame at Fontenay (located at 47°38′23.52″N, 4°23′23.03″E)?

Chapter 18

Gothic Europe

Goals

- Understand the origins and spread of the Gothic style.
- Understand the changes in European religious concepts that make Gothic art and architecture possible.
- Understand the art, architecture and architectural decoration of the Gothic style in France.
- Examine the variations of the Gothic Style in England, Germany and Italy.
- Examine the development of sculpture, book arts, and other media in the Gothic era.
- Name and identify important Gothic cathedrals.

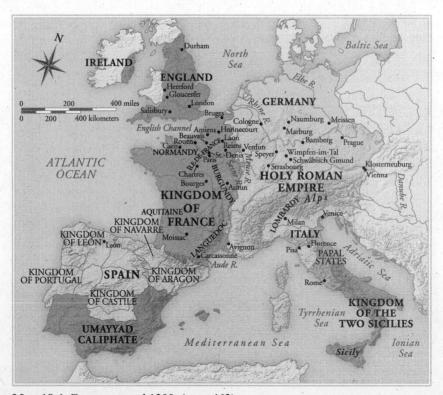

Map 18-1 Europe around 1200. (page 462)

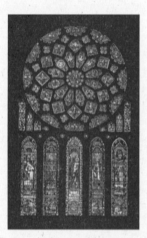

FIG. 18-01 Rose window and lancets, north transept, Chartres Cathedral, Chartres, France, ca. 1220. Stained glass, rose window 43′ in diameter. (page 460)

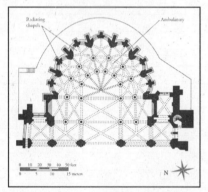

FIG. 18-02 Plan of the east end, abbey church, Saint-Denis, France, 1140–1144 (after Sumner Crosby). (page 462)

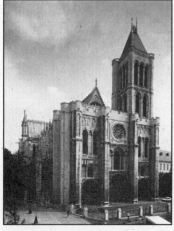

FIG. 18-02A West facade of the abbey church, Saint-Denis, France, 1135–1140. (page 463)

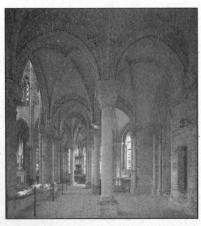

Lat.: 48°56'7.90"N Long.: 2°21'35.01"E

FIG. 18-03 Ambulatory and radiating chapels, abbey church, Saint-Denis, France, 1140–1144. (page 463)

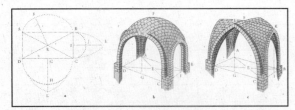

FIG. 18-04 Diagram (*a*) and drawings of rib vaults with semicircular (*b*) and pointed (*c*) arches. (page 464)

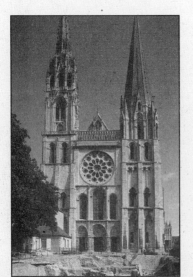

FIG. 18-05 West facade, Chartres Cathedral, Chartres, France, ca. 1145–1155. (page 465)

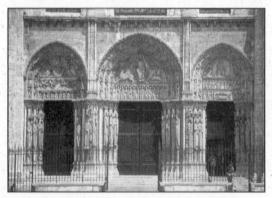

FIG. 18-06 Royal Portal, west facade, Chartres Cathedral, Chartres, France, ca. 1145–1155. (page 465)

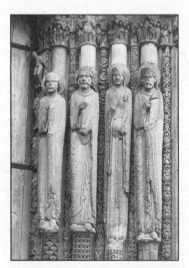

FIG. 18-07 Old Testament kings and queen, jamb statues, central doorway of Royal Portal, Chartres Cathedral, Chartres, France, ca. 1145–1155. (page 467)

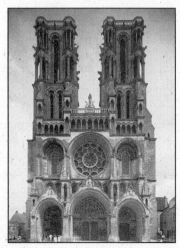

FIG. 18-08 West facade of Laon Cathedral, Laon, France, begun ca. 1190. (page 467)

FIG. 18-09 Interior of Laon Cathedral (looking northeast), Laon, France, begun ca. 1190. (page 467)

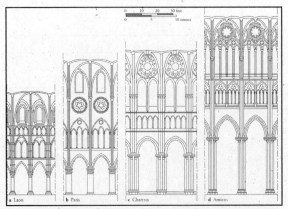

FIG. 18-10 Nave elevations of four French Gothic cathedrals at the same scale (after Louis Grodęcki). (page 468)

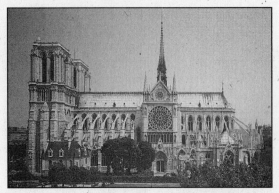

FIG. 18-11 Notre-Dame (looking north), Paris, France, begun 1163; nave and flying buttresses, ca. 1180–1200; remodeled after 1225. (page 468)

Lat.: 48°51'10.56"N Long.: 2°20'59.98"E

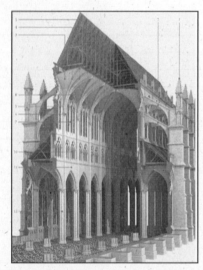

FIG. 18-12 Cutaway view of a typical French Gothic cathedral (John Burge). (1) pinnacle, (2) flying buttress, (3) vaulting web, (4) diagonal rib, (5) transverse rib, (6) springing, (7) clerestory, (8) oculus, (9) lancet, (10) triforium, (11) nave arcade, (12) compound pier with responds. (page 469)

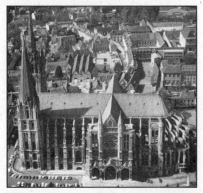

FIG. 18-13 Aerial view of Chartres Cathedral (looking north) Chartres, France, as rebuilt after 1194. (page 470)

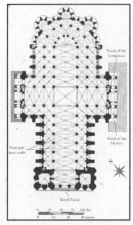

FIG. 18-14 Plan of Chartres Cathedral, Chartres, France, as rebuilt after 1194 (after Paul Frankl). (page 470)

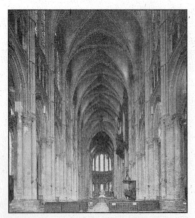

FIG. 18-15 Interior of Chartres Cathedral (looking east), Chartres, France, begun 1194. (page 470)

FIG. 18-16 Virgin and Child and angels *(Notre Dame de la Belle Verrière)*, detail of a window in the choir of Chartres Cathedral, Chartres, France, ca. 1170, with 13th-century side panels. Stained glass, full height 16′. (page 471)

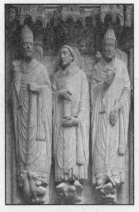

FIG. 18-17 Saints Martin, Jerome, and Gregory, jamb statues, Porch of the Confessors (right doorway), south transept, Chartres Cathedral, Chartres, France, ca. 1220–1230. (page 473)

FIG. 18-18 Saint Theodore, jamb statue, Porch of the Martyrs (left doorway), south transept, Chartres Cathedral, Chartres, France, ca. 1230. (page 473)

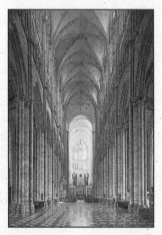

FIG. 18-19 ROBERT DE LUZARCHES, THOMAS DE CORMONT, and RENAUD DE CORMONT, interior of Amiens Cathedral (looking east), Amiens, France, begun 1220. (page 474)

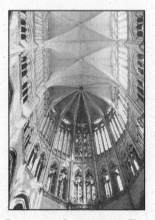

FIG. 18-20 ROBERT DE LUZARCHES, THOMAS DE CORMONT, and RENAUD DE CORMONT, vaults, clerestory, and triforium of the choir of Amiens Cathedral, Amiens, France, begun 1220. (page 474)

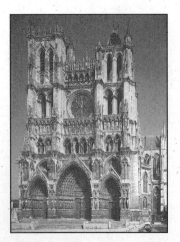

FIG. 18-21 ROBERT DE LUZARCHES, THOMAS DE CORMONT, and RENAUD DE CORMONT, west facade of Amiens Cathedral, Amiens, France, begun 1220. (page 475)

Lat.: 49°53'40.43"N Long.: 2°18'8.26"E

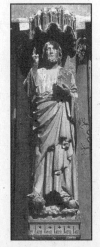

FIG. 18-22 Christ *(Beau Dieu),* trumeau statue of central doorway, west facade, Amiens Cathedral, Amiens, France, ca. 1220–1235. (page 475)

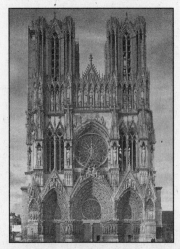

FIG. 18-23 West facade of Reims Cathedral, Reims, France, ca. 1225–1290. (page 476)

Lat.: 49°15'12.88"N Long.: 4°2'2.30"E

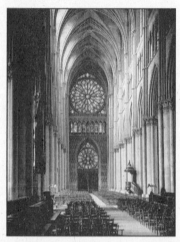

FIG. 18-23A Nave (looking west) of Reims Cathedral, Reims, France, begun 1211; west end ca. 1260–1290. (page 476)

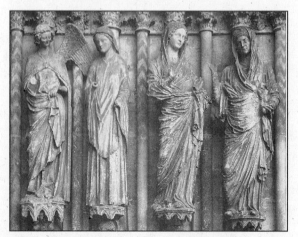

FIG. 18-24 *Annunciation and Visitation,* jamb statues of central doorway, west facade, Reims Cathedral, Reims, France, ca. 1230–1255. (page 477)

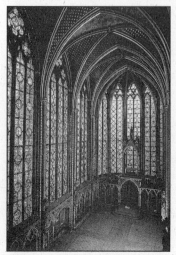

FIG. 18-25 Interior of the upper chapel, Sainte-Chapelle, Paris, France, 1243–1248. (page 477)

Lat.: 47°51′19.27″N Long.: 2°20′42.12″E

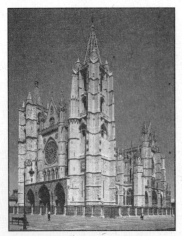

FIG. 18-25A Cathedral of Santa María (looking northeast), León, Spain, begun 1254. (page 477)

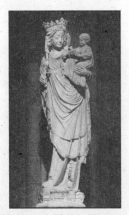

FIG. 18-26 Virgin and Child *(Virgin of Paris),* Notre-Dame, Paris, France, early 14th century. (page 478)

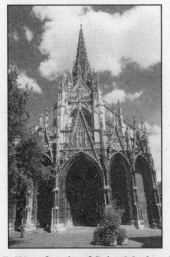

FIG. 18-27 West facade of Saint-Maclou, Rouen, France, ca. 1500–1514. (page 478)

Lat.: 49°26′23.00″N Long.: 1°5′54.40″E

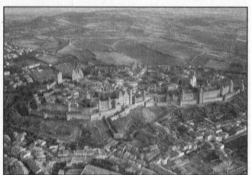

FIG. 18-28 Aerial view of the fortified town of Carcassonne, France. Bastions and towers, 12th–13th centuries, restored by EUGÈNE VIOLLET-LE-DUC in the 19th century. (page 479)

Lat.: 43°12′23.04″N Long.: 2°21′56.40″E

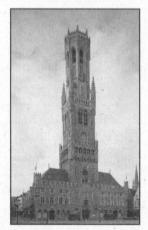

FIG. 18-29 Hall of the cloth guild, Bruges, Belgium, begun 1230. (page 479)

Lat.: 47°5′3.48″N Long.: 2°23′37.57″E

FIG. 18-30 House of Jacques Coeur, Bourges, France, 1443–1451. (page 480)

FIG. 18-31 VILLARD DE HONNECOURT, figures based on geometric shapes, folio 18 verso of a sketchbook, from Paris, France, ca. 1220–1235. Ink on vellum, 9 1/4″ × 6″. Bibliothèque Nationale, Paris. (page 481)

FIG. 18-32 God as architect of the world, folio 1 verso of a moralized Bible, from Paris, France, ca. 1220–1230. Ink, tempera, and gold leaf on vellum, 1′ 1 1/2″ × 8 1/4″. Österreichische Nationalbibliothek, Vienna. (page 481)

FIG. 18-33 Blanche of Castile, Louis IX, and two monks, dedication page (folio 8 recto) of a moralized Bible, from Paris, France, 1226–1234. Ink, tempera, and gold leaf on vellum, 1′ 3″ × 10 1/2″. Pierpont Morgan Library, New York. (page 482)

FIG. 18-34 Abraham and the three angels, folio 7 verso of the *Psalter of Saint Louis,* from Paris, France, 1253–1270. Ink, tempera, and gold leaf on vellum, 5″ × 3 1/2″. Bibliothèque Nationale, Paris. (page 483)

FIG. 18-35 MASTER HONORÉ, David anointed by Samuel and battle of David and Goliath, folio 7 verso of the *Breviary of Philippe le Bel,* from Paris, France, 1296. Ink and tempera on vellum, 7 7/8″ × 4 7/8″. Bibliothèque Nationale, Paris. (page 484)

FIG. 18-36 JEAN PUCELLE, David before Saul, folio 24 verso of the *Belleville Breviary,* from Paris, France, ca. 1325. Ink and tempera on vellum, 9 1/2″ × 6 3/4″. Bibliothèque Nationale, Paris. (page 485)

FIG. 18-36A JEAN PUCELLE, Betrayal of Christ and Annunciation, folios 15 verso and 16 recto of the Hours of Jeanne d'Evreux, from Paris, France, ca. 1325–1328. Ink and tempera on vellum, each page 3 1/2″ X 2 1/2″. Metropolitan Museum of Art, New York (Cloisters Collection). (page 484)

FIG. 18-37 *Virgin of Jeanne d'Evreux,* from the abbey church of Saint-Denis, France, 1339. Silver gilt and enamel, 2′ 3 1/2″ high. Louvre, Paris. (page 485)

FIG. 18-38 The Castle of Love and knights jousting, lid of a jewelry casket, from Paris, France, ca. 1330–1350. Ivory and iron, 4 1/2″ × 9 3/4″. Walters Art Museum, Baltimore. (page 486)

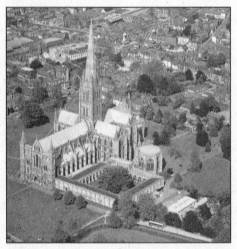

Lat.: 51°3′52.92″N Long.: 1°47′50.66″E

FIG. 18-39 Aerial view of Salisbury Cathedral, Salisbury, England, 1220–1258; west facade completed 1265; spire ca. 1320–1330. (page 487)

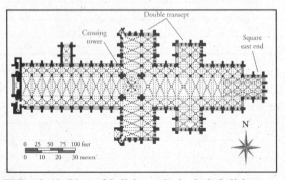

FIG. 18-40 Plan of Salisbury Cathedral, Salisbury, England, 1220–1258. (page 487)

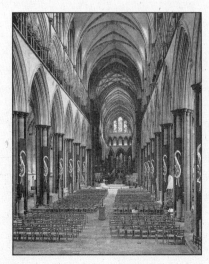

FIG. 18-41 Interior of Salisbury Cathedral (looking east), Salisbury, England, 1220–1258. (page 487)

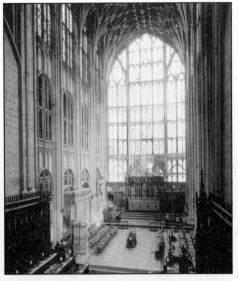

FIG. 18-42 Choir of Gloucester Cathedral (looking east), Gloucester, England, 1332–1357. (page 488)

Lat.: 51°52′3.26″N Long.: 2°14′47.30″W

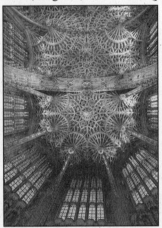

FIG. 18-43 ROBERT and WILLIAM VERTUE, fan vaults of the chapel of Henry VII, Westminster Abbey, London, England, 1503–1519. (page 488)

Lat.: 51°29′57.66″N Long.: 0°7′35.69″W

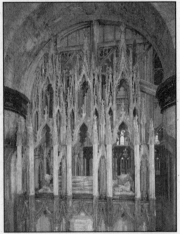

FIG. 18-44 Tomb of Edward II, Gloucester Cathedral, Gloucester, England, ca. 1330–1335. (page 489)

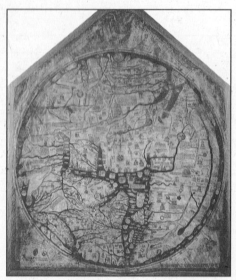

FIG. 18-44A Richard De Bello(?), Mappamundi (world map) of Henry III, ca. 1277–1289. Tempera on vellum, 5′ 2″ X 4′ 4″. Hereford Cathedral, Hereford, England. (page 489)

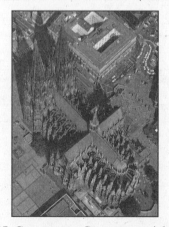

FIG. 18-45 Gerhard of Cologne, aerial view of Cologne Cathedral (looking northwest), Cologne, Germany, begun 1248; nave, facade, and towers completed 1880. (page 490)

Lat.: 50°56′29.28″N Long.: 6°57′30.19″E

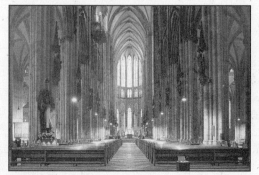

FIG. 18-46 Gerhard of Cologne, interior of Cologne Cathedral (looking east), Cologne, Germany, choir completed 1322. (page 490)

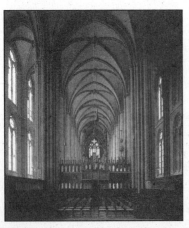

FIG. 18-47 Interior of Saint Elizabeth (looking west), Marburg, Germany, 1235–1283. (page 490)

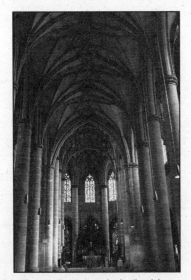

FIG. 18-47A PETER PARLER, choir (looking east) of Heiligkreuzkirche (Church of the Holy Cross), Schwäbisch Gmünd, Germany, begun 1351. (page 490)

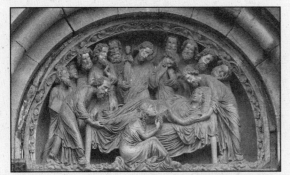

FIG. 18-48 Death of the Virgin, tympanum of left doorway, south transept, Strasbourg Cathedral, Strasbourg, France, ca. 1230. (page 491)

Lat.: 48°34′54.66″N Long.: 7°45′4.80″E

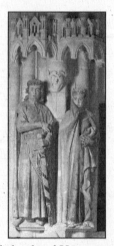

FIG. 18-49 Ekkehard and Uta, statues in the west choir, Naumburg Cathedral, Naumburg, Germany, ca. 1249–1255. Painted limestone, Ekkehard 6′ 2″ high. (page 491)

Lat.: 51°9′16.09″N Long.: 11°48′14.86″E

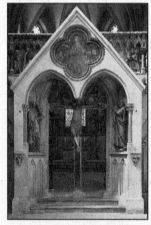

FIG. 18-49A Crucifixion, west choir screen of Naumburg Cathedral, Naumburg, Germany, ca. 1249–1255. (page 491)

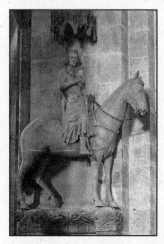

FIG. 18-50 Equestrian portrait *(Bamberg Rider)*, statue in the east choir, Bamberg Cathedral, Germany, ca. 1235–1240. Sandstone, 7′ 9″ high. (page 492)

Lat.: 49°53′26.01″N Long.: 10°52′58.01″E

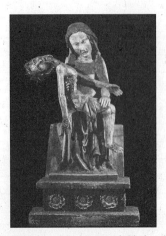

FIG. 18-51 Virgin with the Dead Christ *(Röttgen Pietà),* from the Rhineland, Germany, ca. 1300–1325. Painted wood, 2′ 10 1/2″ high. Rheinisches Landemuseum, Bonn. (page 493)

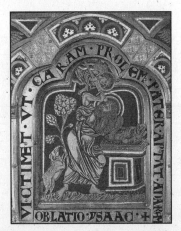

FIG. 18-52 NICHOLAS OF VERDUN, sacrifice of Isaac, detail of the *Klosterneuburg Altar,* from the abbey church at Klosterneuburg, Austria, 1131. Gilded copper and enamel, 5 1/2″ high. Stiftsmuseum, Klosterneuburg. (page 493)

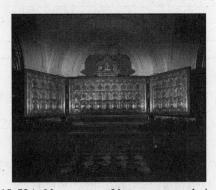

FIG. 18-52A NICHOLAS OF VERDUN, general view of the Klosterneuburg Altar, from the abbey church at Klosterneuburg, Austria, 1181; refashioned after 1330. Gilded copper and enamel in wooden frames, 3′ 6 3/4″ high. Stiftsmuseum, Klosterneuburg. (page 493)

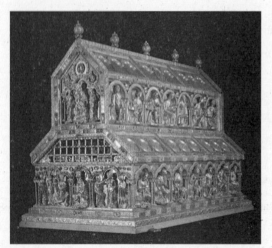

FIG. 18-53 NICHOLAS OF VERDUN, *Shrine of the Three Kings,* from Cologne Cathedral, Cologne, Germany, begun ca. 1190. Silver, bronze, enamel, and gemstones, 5′ 8″ × 6′ × 3′ 8″. Cathedral Treasury, Cologne. (page 494)

1. What elements of the Bamberg Rider statue in the east choir of Bamberg Cathedral (49°53′26.01″N, 10°52′58.01″E) lead experts to believe that it is a true portrait modeled after a live person?

2. Why was the town of Carcassonne (located at 43°12′23.04″N, 2°21′56.40″E) fortified?

3. Discuss the long building history of Cologne Cathedral (located at 50°56′29.28″N, 6°57′30.19″E). With this history in mind, consider why the building's style is characterized as both Gothic and Gothic revival.

4. What function do the fan vaults and pendants used in on the ceiling of Henry VII's chapel in Westminster Abbey (located at 51°29′57.66″N, 0°7′35.69″W and depicted in FIG. 18-43) serve?

5. What innovative feature of the remodeled portions of St. Denis (located at 48°56′7.90″N, 2°21′35.01″E) represent a sharp break from previous church architecture?

6. What style is the chapel of Saint-Chapelle (located at 48°51′19.27″N, 2°20′42.12″E and depicted in FIG. 18-25) associated with? Identify and describe the building's distinguishing architectural features.

7. What features distinguish the statues of Ekkehard and Uta from the west choir of Naumburg Cathedral (51°9′16.09″N, 11°48′14.86″E)? What approach did the artist give to depicting the human body?

8. Compare and contrast the design and structural features of Amiens Cathedral (located at 49°53′40.43″N, 2°18′8.26″E and depicted in FIG. 18-21) with that of Salisbury Cathedral (located at 51°3′52.92″N, 1°47′50.66″W and depicted in FIG. 18-39). What consideration is given to the height of each building? What specific features distinguish Amiens as French Gothic and Salisbury as English Gothic in style?

9. Discuss how the builders of Reims Cathedral (located at 49°15′12.88″N, 4°2′2.30″E and depicted in FIG. 18-23) further developed the High Gothic style. How was the approach to tympanum decoration at Reims particularly inventive?

10. What innovative architectural feature was introduced by the architect of Notre-Dame (located at 48°51′10.56″N, 2°20′59.98″E) to hold up the cathedral's tall, thin walls?

11. What kind of structure is located at 47°5′3.48″N, 2°23′37.57″E and depicted in FIG. 18-30? Identify and describe the Late Gothic features present on its façade.

12. How are the sacred figures on the left tympanum of Strasbourg Cathedral (located at 48°34′54.66″N, 7°45′4.80″E) humanized? How do these representations differ from previous depictions of similar sacred scenes?

13. Identify and discuss the Flamboyant architectural features of Saint-Maclou (located at 49°26′23.00″N, 1°5′54.40″E and depicted in FIG. 18-27).

14. The Choir of Gloucester Cathedral (located at 51°52′3.26″N, 2°14′47.30″W) is representative of the transition between what styles?

Chapter 19

Italy, 1200 to 1400

Goals

- Understand the influence of the Byzantine and classical worlds on the art and architecture.
- Understand the rejection of medieval artistic elements and the growing interest in the natural world.
- Examine the revival of classical values, in particular, the growth of humanism.
- Examine elements of the patronage system that developed at that time, and the patronage rivalries among the developing city states.
- Examine the architecture and art as responsive to the growing European power structures at that time.

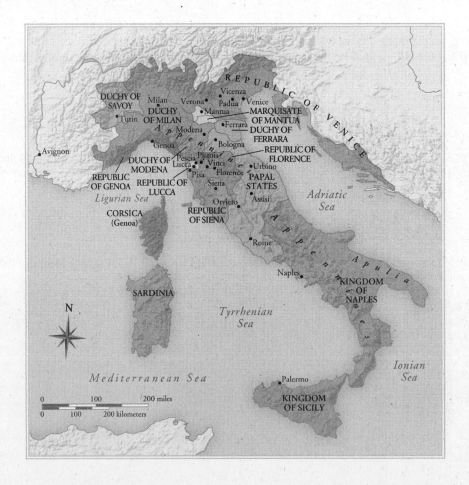

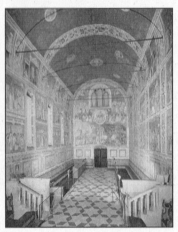

Lat.: 45°24′42.85″N Long.: 11°52′46.44″E

FIG. 19-01 Giotto di Bondone, Arena Chapel (Cappella Scrovegni; interior looking west), Padua, Italy, 1305–1306. (page 496)

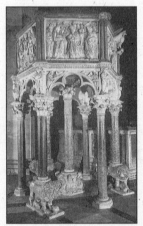

FIG. 19-02 Nicola Pisano, pulpit of the baptistery, Pisa, Italy, 1259–1260. Marble, 15′ high. (page 499)

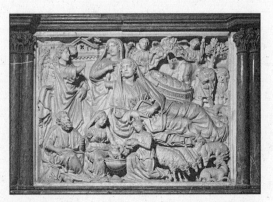

FIG. 19-03 Nicola Pisano, *Annunciation, Nativity, and Adoration of the Shepherds,* relief panel on the baptistery pulpit, Pisa, Italy, 1259–1260. Marble 2′ 10″ × 3′ 9″. (page 499)

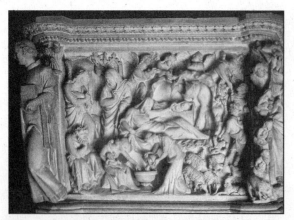

FIG. 19-04 GIOVANNI PISANO, *Annunciation, Nativity, and Adoration of the Shepherds,* relief panel on the pulpit of Sant'Andrea, Pistoia, Italy, 1297–1301. Marble, 2′ 10″ x 3′ 4″. (page 499)

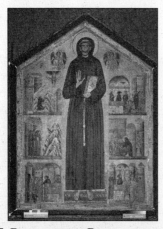

FIG. 19-05 BONAVENTURA BERLINGHIERI, panel from the *Saint Francis Altarpiece*, San Francesco, Pescia, Italy, 1235. Tempera on wood, 5′ × 3′ × 6″. (page 500)

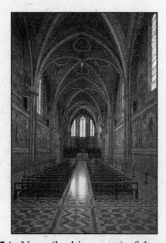

FIG. 19-05A Nave (looking west) of the upper church, San Francesco, Assisi, Italy, 1228–1253. (page 500)

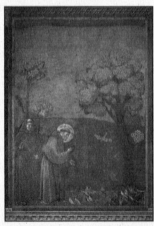

FIG. 19-05B SAINT FRANCIS MASTER, Saint Francis Preaching to the Birds, upper church, San Francesco, Assisi, Italy, ca. 1290–1300. Fresco. (page 500)

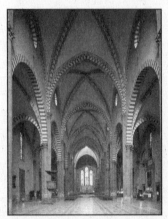

FIG. 19-06 Nave of Santa Maria Novella, Florence, Italy, ca. 1246–1470. (page 501)

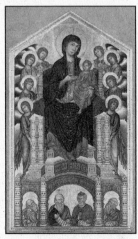

FIG. 19-07 CIMABUE, *Madonna Enthroned with Angels and Prophets,* from Santa Trinità, Florence, Italy, ca 1280–1290. Tempera and gold leaf on wood, 12′ 7″ × 7′ 4″. Galleria degli Uffizi, Florence. (page 502)

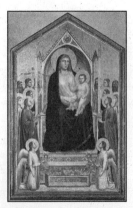

FIG. 19-08 GIOTTO DI BONDONE, *Madonna Enthroned,* from the Church of Ognissanti, Florence, Italy, ca. 1310. Tempera and gold leaf on wood, 10′ 8″ × 6′ 8″. Galleria degli Uffizi, Florence. (page 503)

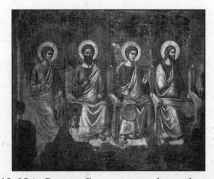

FIG. 19-08A PIETRO CAVALLINI, enthroned apostles, detail of Last Judgment, Santa Cecilia in Trastevere, Rome, Italy, ca. 1290–1295. Fresco. (page 503)

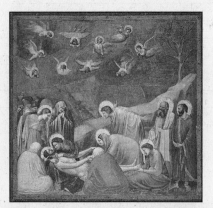

FIG. 19-09 GIOTTO DI BONDONE, *Lamentation*, Arena Chapel (Cappela Scrovegni), Padua, Italy, ca. 1305. Fresco, 6′ 6 3/4″ × 6′ 3/4″. (page 504)

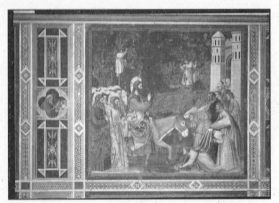

FIG. 19-09A GIOTTO DI BONDONE, Entry into Jerusalem, Arena Chapel (Cappella Scrovegni), Padua, Italy, ca. 1305. Fresco, 6′ 6 3/4″ × 6′ 3/4″. (page 505)

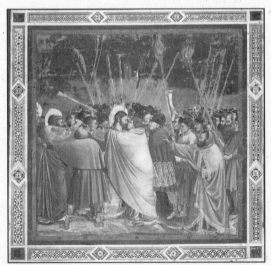

FIG. 19-09B GIOTTO DI BONDONE, Betrayal of Jesus, Arena Chapel (Cappella Scrovegni), Padua, Italy, ca. 1305. Fresco, 6′ 6 3/4″ × 6′ 3/4″. (page 505)

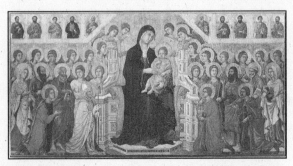

FIG. 19-10 DUCCIO DI BUONINSEGNA, *Virgin and Child Enthroned with Saints,* principal panel of the *Maestà* altarpiece, from Siena Cathedral, Siena, Italy, 1308–1311. Tempera and gold leaf on wood, 7′ × 13′ (center panel). Museo dell'Opera del Duomo, Siena, (page 507)

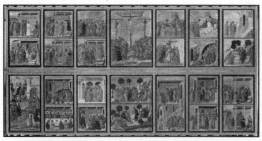

FIG. 19-10A Duccio di Buoninsegna, Life of Jesus, 14 panels from the back of the Maestà altarpiece, from Siena Cathedral, Siena, Italy, 1308–1311. Tempera and gold leaf on wood, 7′ × 13′. Museo dell'Opera del Duomo, Siena. (page 507)

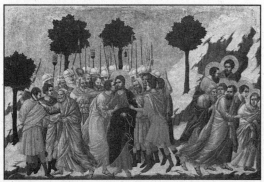

FIG. 19-11 Duccio di Buoninsegna, *Betrayal of Jesus,* detail from the back of the *Maestà* altarpiece, from Siena Cathedral, Siena, Italy, 1309–1311. Tempera and gold leaf on wood, detail 1′ 10 1/2″ × 3′ 4″. Museo dell'Opera del Duomo, Siena. (page 508)

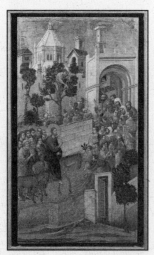

FIG. 19-11A Duccio di Buoninsegna, Entry into Jerusalem, panel from the back of the Maestà altarpiece, from Siena Cathedral, Siena, Italy, 1308–1311. Tempera and gold leaf on wood, 3′ 4 1/2″ × 1′ 9 1/8″. Museo dell'Opera del Duomo, Siena. (page 508)

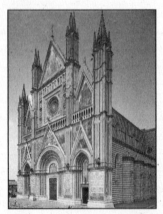

FIG. 19-12 LORENZO MAITANI, west facade of Orvieto Cathedral, Orvieto, Italy, begun 1310. (page 508)

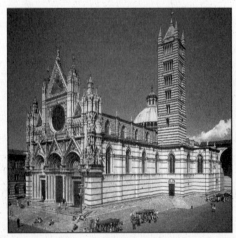

FIG. 19-12A Siena Cathedral (looking northeast), Siena, Italy, begun ca. 1226; nave vaults, ca. 1260–1270; lower west facade designed by GIOVANNI PISANO, 1284–1299; enlarged and completed, 1355–1386. (page 509)

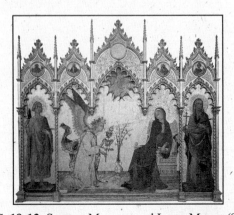

FIG. 19-13 SIMONE MARTINI and LIPPO MEMMI(?), *Annunciation* altarpiece, from Siena Cathedral, Siena, Italy, 1333 (frame reconstructed in the 19th century). Tempera and gold leaf on wood, center panel 10′ 1″ × 8′ 8 3/4″. Galleria degli Uffizi, Florence. (page 509)

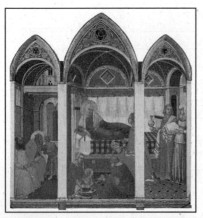

FIG. 19-14 Pietro Lorenzetti, *Birth of the Virgin,* from the altar of Saint Savinus, Siena Cathedral, Siena, Italy, 1342. Tempera on wood, 6′ 1″ × 5′ 11″. Museo dell'Opera del Duomo, Siena. (page 511)

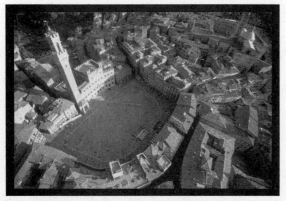

FIG. 19-15 Aerial view of the Campo with the Palazzo Pubblico, Siena, Italy, 1288–1309. (page 511)

Lat.: 43°19′6.11″N Long.: 11°19′55.06″E

FIG. 19-16 Ambrogio Lorenzetti, *Peaceful City,* detail from *Effects of Good Government in the City and the Country,* Sala della Pace, Palazzo Pubblico, Siena, Italy, 1338–1339. Fresco. (page 512)

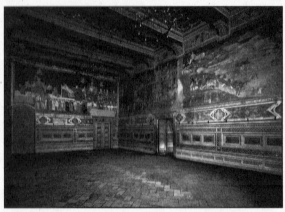

FIG. 19-16A AMBROGIO LORENZETTI, Allegory of Good Government, north (left) and east (right) walls of the Sala della Pace, Palazzo Pubblico, Siena, Italy, 1338–1339. Fresco, north wall 25′ 3′ wide, east wall 46′ wide. (page 512)

FIG. 19-17 AMBROGIO LORENZETTI, P*eaceful Country,* detail from *Effects of Good Government in the City and in the Country,* Sala della Pace, Palazzo Pubblico, Siena, Italy, 1338–1339. Fresco. (page 512)

FIG. 19-18 ARNOLFO DI CAMBIO and others, Florence Cathedral (aerial view looking northeast), Florence, Italy, begun 1296. (page 513)

Lat.: 43°46′23.88″N Long.: 11°15′22.42″E

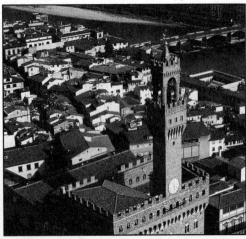

FIG. 19-18A A<small>RNOLFO</small> <small>DI</small> C<small>AMBIO</small>, Palazzo della Signoria (Palazzo Vecchio, looking southeast), Piazza della Signoria, Florence, Italy, 1299–1310. (page 513)

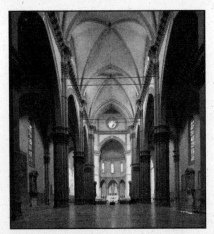

FIG. 19-19 A<small>RNOLFO</small> <small>DI</small> C<small>AMBIO</small> and others, interior of Florence Cathedral (looking east), Florence, Italy, begun 1296. (page 514)

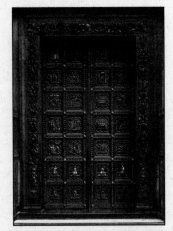

FIG. 19-19A A<small>NDREA</small> P<small>ISANO</small>, south doors of the Baptistery, Florence, Italy, 1330–1336. Gilded bronze, doors 16′ × 9′ 2″; individual panels 1′ 7 1/4″ × 1′ 5″. (The door frames date to the mid-15th century.) (page 514)

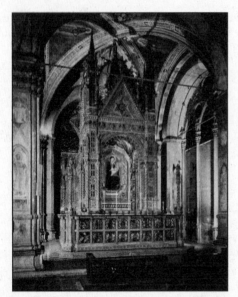

FIG. 19-19B ANDREA ORCAGNA, tabernacle,
Or San Michele, Florence, Italy, 1355–1359. Mosaic,
gold, marble, lapis lazuli, with inset painting by
BERNARDO DADDI, Madonna and Child Enthroned
with Saints, 1346–1347. Tempera and gold on wood.
(page 514)

FIG. 19-20 FRANCESCO TRAINI or BUONAMICO
BUFFALMACCO, two details of *Triumph of Death,*
1330s. Full fresco, 18′ 6″ × 49′ 2″. Camposanto,
Pisa. (page 515)

1. Discuss how the architectural form of the Arena Chapel (located at 45°24′42.85″N, 11°52′46.44″E) coalesces with the frescoes adorning its interior (FIG. 19-1). Describe the innovative features in the decorative program and the approach to rendering forms employed by Giotto.

2. Discuss the illusionistic and structural advances made by Pietro Lorenzetti in The Birth of the Virgin panel (FIG. 19-14) from the Altar of Saint Savinus.

3. Compare and contrast Martini's and Memmi's (?) Annunciation scene (FIG. 19-13) with Giotto's Madonna Enthroned (FIG. 19-8). What stylistic and representational concerns does each of the works reflect?

4. Compare and contrast the Cathedral of Florence (located at 43°46′23.88″N, 11°15′22.42″E and depicted in FIG. 19-18) with the contemporaneous Cathedral of Cologne (located at 50°56′29.28″N, 6°57′30.19″E and depicted in FIG. 18-45). Identify and discuss particular features in the design and decoration of the Florentine cathedral that introduce a Renaissance approach.

5. Identify and describe specific elements of Cimabue's Madonna Enthroned with Angels and Prophets (FIG. 19-7) that offer a new way of seeing and representing the world. How does the artist envision the figure compared to his medieval predecessors?

6. Compare and contrast the Saint Francis Altarpiece by Bonaventura Berlinghieri (FIG. 19-5) with the Betrayal of Jesus panel from the Maestà altarpiece (FIG. 19-11) by Duccio Di Buoninsegna. How does each artist represent several stories at once? Discuss the very different compositional and modeling approaches that each artist employs.

7. Identify and describe the Late Gothic and classicizing Renaissance elements in the design and decorative elements used on the Milan Cathedral, located at 45°27′50.59″N, 9°11′30.41″E.

8. What kind of building is the Palazzo Pubblico of Siena (located at 43°19′6.11″N, 11°19′55.06″E)?

9. For what group was the church of Santa Maria Novella (FIG. 19-19) constructed? How was the building's form and structure influenced by the needs of its patrons?

10. What new devices does Giotto Di Bondone develop within the Lamentation fresco from the Arena Chapel to suggest emotion, spatial depth and dramatic narrative?

11. Identify and discuss the remarkable features of the Doge's Palace, located at 45°26′2.17″N, 12°20′24.97″E and depicted in FIG. 19-21?